PLAN

ALSO BY SHERRI SHEPHERD

Permission Slips

PLAN

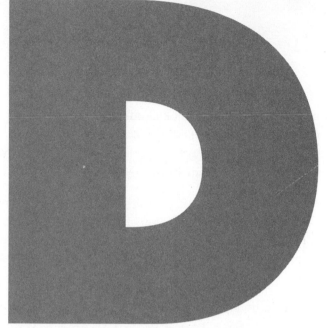

How to

Lose Weight and Beat Diabetes
(Even If You Don't Have It)

SHERRI SHEPHERD

with Billie Fitzpatrick

itbooks

AN IMPRINT OF HARPERCOLLINS PUBLISHERS

*it***books**

This book is written as a source of information only. The information contained in this book should by no means be considered a substitute for the advice of a qualified medical professional, who should always be consulted before beginning any new diet, exercise, or other health program.

All efforts have been made to ensure the accuracy of the information contained in this book as of the date published. The author and the publisher expressly disclaim responsibility for any adverse effects arising from the use or application of the information contained herein.

HarperCollins books may be purchased for educational, business, or sales promotional use. For information please e-mail the Special Markets Department at SPsales@harpercollins.com.

FIRST EDITION

Designed by Lorie Pagnozzi

Library of Congress Cataloging-in-Publication Data is available upon request.

ISBN 978-0-06-222624-2

13 14 15 16 17 OV/RRD 10 9 8 7 6 5 4 3 2 1

To my mom, LaVerne Shepherd, who was not truly aware of the deadliness of diabetes. You left this world too soon, but your spirit still lives within me. I love you, Mama.

ACKNOWLEDGMENTS

No book is written alone, and this one, my second, is no exception. I want to thank first and foremost my husband, Lamar (Sal) Sally, who has stood by my side every inch of the way toward health. Thank you, Sal, for encouraging me to eat healthy even when I would get mad at you—you stayed strong and didn't let my tantrums affect your concern for my well-being. My son, Jeffrey Charles, who was and is my first and forever inspiration. My trainer, Kira Stokes, who continues to whip my body into shape. Kira, you are my "bartender/psychologist" and have done the miracle of making a workout fun—get stoked! My dance partner and friend, Val Chmerkovskiy, who helped me fulfill a dream on *DWTS*. And the team of doctors who helped me save my own life—my endocronologist, Dr. Daniel Donovan; my cardiologist, Dr. Jerry Glicklich; my podiatrist, Dr. William Releford—thank you, Dr. Releford, for giving so much of yourself and being so passionate about keeping people with diabetes alive—and Dr. Watson, who first diagnosed me with diabetes. And a special thank-you to Billie Fitzpatrick, who helped me articulate my passion for helping people with diabetes live victoriously. Thank you to my literary agent, Yfat Reiss Gendell, for your tireless efforts on my behalf, and to one of the best managers in the world, Darris Hatch—everyone should have someone who believes in them like Darris believes in me. Thank you to my editor, Carrie Thornton, for giving me a chance. And I really want to say a special thank-you to all my Twitter supporters. Your constant encouragement kept me on my healthy track. Thank you for the 140 characters of love.

PLAN

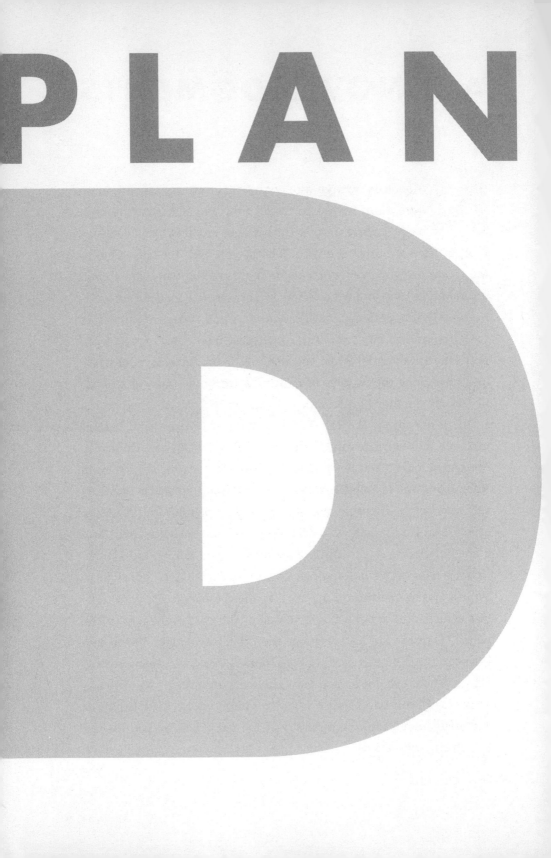

Contents

Introduction xi

One
Me and Diabetes: My Story 1

Two
What You Need to Know about Diabetes: The Facts 29

Three
The Three Keys to Plan D 67

Four
Eating for Balance and Weight Loss: An Easy Plan 85

Five
Get Moving: Exercise Reverses Insulin Resistance 133

Six
The Sherri Steps:
Changing Your Relationship with Food 163

Seven
Motivation 183

Eight
Forgiveness 207

Nine
Putting It Together:
Living Like Sherri for a Week 225

Ten
Making It Your Own 273

Afterword 295
Index 299

INTRODUCTION

To be honest with you, having my name attached to a book about eating right and having a "healthy diet" makes me chuckle. Like so many things that I have experienced in my life, I never imagined anything like this for myself. Kind of like all those years I spent doing the couch-shimmy in my apartment, watching and cheering for the couples on *Dancing with the Stars*. Then one day—*I'm* on *Dancing with the Stars*.

My life has been a series of dreaming big and seeing big things happen. I've been performing in one way or another since I was a kid organizing talent shows with my sisters and my cousins. I was still a secretary in a law office when I started doing stand-up and got my first jobs in TV. Those accomplishments felt like stepping into a dream world.

But nothing compared to getting the job with *The View*. By that point, I'd been an actress and a stand-up comic for years. I was no longer a newbie in show business. I knew how to step on set and make my way, hit my marks, dig deep, and find my funny. (And yeah, I also knew how to do some serious damage at the craft services table, but we'll get to that later!) Nothing in my past had prepared me for stepping up to a seat at the

View table. This was no acting job, with a prepared script: this was me, the real me, sitting next to four amazingly strong and smart women, talking about everything from politics to cultural issues to motherhood and marriage.

Let's just say I had some serious learning to do. Before I joined *The View*, I knew almost nothing about politics and current events. I was raised as a Jehovah's Witness, and since Jehovah's Witnesses don't believe in voting or participating in government, politics were never discussed in our home. And as an adult, I just didn't pay attention. Until, that is, I got the call offering me the biggest job of my career. Because there's nothing like the pressure of occupying a seat next to Barbara Walters to make you start learning about the affairs of the world, *quick*. I had all the motivation I needed to start asking questions and paying attention to the issues. I stayed up late into the night to read the newspaper. (I still do.) I went from sitcom-rerun junkie to cable-news fiend.

At first my motivation was very simple: don't blow this gig! I'd gotten the job, but I still felt that I needed to earn my seat at that table, and I had to work hard to keep up with Barbara, Joy, Whoopi, and Elisabeth, all incredibly informed women with strong opinions.

It took some time, and a few pretty embarrassing flub-ups along the way that everyone in the world knows about, but over time I started to feel more confident. I realized that it was okay—a good thing, even—to be honest about what I didn't know. To speak up about the questions I had, rather than to try to bluff my way through a conversation.

As I grew more comfortable in my role, my motivation began to change and grow. It was no longer just about me and mak-

ing sure I could hang on to my job. I wanted to contribute to the conversation. I wanted to engage with the audience, many of whom, I knew, were a lot like me—busy, consumed with the everyday activities of their lives, interested in the world but sometimes overwhelmed by the task of keeping up. I came to believe it was my responsibility as a woman, and a citizen, to stay informed and engaged and to speak up. Maybe I could even be a role model for some of the women who watched us every day. It wasn't just about a job. Being informed became a way of life.

Something similar happened to me with diabetes and my weight. I spent years not thinking about diabetes and my risk at all, despite it running rampant in my family, even after it took my mother's life. Those same years were spent wanting to lose weight but never really educating myself about what was involved in actually doing it. It took the threat of my own premature death to wake me up from the fog of denial and ignorance I'd been living in for so long.

At first I just needed to focus on myself, as I struggled to make basic changes to my life. I had a lot to learn. Glucose, insulin, low- and high-glycemic foods—these were foreign concepts to me, the domain of doctors. I had to make them my own. Before I learned how to eat differently, to exercise for the first time in my life, I had to learn why it was so important for me to maintain my blood sugar levels, how combining foods and exercise would enable me to stabilize my metabolism and reset my body's response to insulin. This was a lot of learning in a hurry.

As I began to feel more comfortable in my new life as a diabetic who was actually dealing with being diabetic (as op-

posed to ignoring the warnings from my doctor that I was prediabetic), I began to look beyond my bathroom scale and realized just how many people were affected by the disease. Now you're probably saying, *Sherri, didn't you grow up in a family full of diabetics, part of a social network where having diabetes was about as common as having the sniffles?* I'm not kidding when I tell you that I didn't really want to think that what was happening to my community, including my own mother, would ever happen to me. It took me a very long time to fully take responsibility for myself, and that took an enormous wake-up call. More on that soon. The good news is that I may be slow to the start, but when I get going, I catch up quick.

I realized that the plan I have come up with for myself—me, the willpower-less wonder—could work for others suffering from diabetes, too. People who wanted to be well but felt overwhelmed by the wholesale changes that have to take place for them to live well with this disease. When I finally found a way to achieve my big goals—like exercising regularly for the first time—by breaking them into small, manageable pieces and gradually working new routines into my busy life, my entire outlook changed. I had found a way to lose weight and control my diabetes without feeling deprived, or chained to a strict, lifeless plan.

The plan I have created for myself is *flexible*. It *feels simple*, down-to-earth. It is sensible and straightforward, with no gimmicks or quick fixes. But it has worked for me more than I ever thought possible, so it just makes sense to share my plan with you.

I created this plan for myself first, so it comes with one big,

important guarantee: it lets you be *less than perfect*. After years of trying and failing to stick 100 percent to the rules of eating and exercise, only to feel guilty, tired, and ashamed, I finally realized: **Sometimes a little rule-breaking and forgiveness along the way is okay, especially if it will keep you on the right path for the long haul.** This is where we all need to be if we're going to dance our way to old age.

So this is my Plan D—it works, it's flexible, and it will keep your prediabetes away or keep your diabetes under control. Doctor's orders.

Me and Diabetes: My Story

Diabetes could have killed me. Instead, it saved my life.

Without diabetes, I'd most surely be obese.

I'd probably be stressed out most of the time—a lot more than I am today.

I *know* I'd be hungry *all* the time, and on the hunt for food like a starving cat.

I'd probably be alone, and I'd most surely be unhappy.

I'd also be very, very sick.

This is where I was headed, until diabetes pulled a U-turn into my life and forced me to change everything.

Instead, I'm living a truly blessed life. I've found happiness again after devastating heartbreak. I'm married to a man—my Sal—who loves me and loves my son, who makes me laugh and keeps me sane, who rolls with me every day through the tornado that is my life. I'm busier than ever with work, and at the same time I meet a daily challenge raising a child with special needs. Time is often hard for me to find. I wake up each morning and go to work at my dream job, as a cohost of *The View*, where I walk a crazy tightrope every day, gabbing with four of the smartest, sassiest, most in-your-face women

I know. Last year I fulfilled a dream I didn't even think was *possible*, when I spent several magical, crazy weeks on *Dancing with the Stars*. I am a fortunate woman. This was a dream come true, something that I had wanted to do for a very long time, and finally, finally, I could say yes to the request. Why? Because physically, emotionally, and mentally I was up to the challenge. I knew I could compete. And I probably would not have been able to say that almost six years ago, before I changed the way I ate.

I'm also in the best shape of my life at forty-five years old. After spending decades struggling to lose weight, dropping pounds and picking them right up again—with some extra for good measure—I am living at a healthy weight for the first time in my life. I have more energy than I did when I was in my twenties (though everything's hanging a bit lower than it was back then). And I'm sticking to a daily regimen of healthy eating and exercise that makes me feel great—sexy, capable, strong—and will help me protect my health for the long haul.

For these things, I have diabetes to thank.

How did diabetes get me to this place? Getting my diagnosis of diabetes forced me to take a cold, hard look at the way I was living. It forced me to make some fundamental changes to my diet, to incorporate regular exercise into my life for the first time, to change my essential relationship to food. But this did not happen right away. After I got my diagnosis of the big D, I was in shock. I had to mourn. I had to go out to the Pancake House and eat a plate of waffles dripping with butter and syrup. I was trying to drown my sorrows, and then I got the call from *The View*: they wanted me on as a permanent host. That was my first wake-up call.

I did not, as you'll soon see, easily come to the changes I began making. I ignored the signs of my deteriorating health for many years. Even after I got a diagnosis of prediabetes, I brushed that warning off in favor of clinging to my old favorites—which in my case came in the form of elaborate pork loin dinners, barbecue takeout with all the fixings—mac and cheese, sweet potatoes, and buttered corn bread—and half-gallon servings of ice cream. Yeah, when I do something—anything—I do it big. And for a very long time, that included food. At the time when my doctor told me I had prediabetes, I simply thought, *Oh, good, I don't have diabetes yet; I don't have to change a thing I do or eat.* I didn't know then what I know so clearly now—that prediabetes should be treated like an enormous warning bell that screams to every ounce of your being: *if you don't stop what you're doing and change the way you eat, you're asking for a life-changing disease named DIABETES!*

After many years of ignoring the warnings of my prediabetes, I had to make a decision: if I wanted to stay alive—and I did, not just for myself but most certainly for my son—I had to change. So I did. Step by step, day by day, I remade my life, my eating and exercise, and my entire relationship to food, which entailed not only what I thought about food but also the triggers behind why I reached for food when I felt distressed, lonely, or sometimes just plain ol' bored. My relationship with food was a messy, confused tangle of many emotions, and it took me a while to understand just what I needed to change about it.

So, I guess I'm doing that thing you're not supposed to do when you tell a story: I'm giving away the ending. I found a way to take hold of my health, lose weight, and bring my dia-

betes under control. Of course, when it comes to managing diabetes or keeping to a healthy weight, there is no real ending: it's a lifelong process. The good news is if you stick with it—making this your way of life as opposed to a "diet"—your life can indeed be long. And fit. You will live right and happy, even with the shadow of diabetes. And if you have prediabetes, then these steps can show you a way to avoid the Big D.

Let's Go Back to the Beginning

Me and diabetes, we go waaay back. Back to childhood, back to family. Diabetes is part of my lineage, part of my history on the South Side of Chicago. My son may have inherited my sweet tooth (along with my penchant for being silly and fondness for dancing), but I'm telling you this: he will not inherit my diabetes. I come from a family of diabetics and I am determined to be the last Shepherd to get this destructive and dangerous disease.

My community is like the Diabetes Hall of Fame. Aunts, uncles, grandparents, cousins, neighbors, neighborhoods— almost everyone got it eventually. When I was a kid, I actually thought limbs, toes, and feet just went away. Going blind or losing a limb seemed like a kind of weird rite of passage. I'm serious. For many years, I just assumed that losing parts of your body was like going gray, or getting excited about a four-thirty dinner buffet, or developing a fondness for flannel loungewear—it was an inevitable part of getting old. Little did my naïve brain realize that these people around me had a serious disease. At that time, there just wasn't that kind of awareness of where diabetes came from—a scary thought when I think back on it.

Diabetes was everywhere when I was a kid—including right in my very own house. Though at first we didn't even know it, my mom got diabetes early, when she was in her late twenties or early thirties. My mom's fatigue, lack of energy, and irritability just seemed normal to me as a kid. I mean, I knew she wasn't well a lot of the time, but I also thought everyone's mom shot themselves up with needles. She would ask us to rub her perpetually cold feet and hold her ice-cold hands.

And my family was no different than a lot of the others in my predominantly African American neighborhood. Somebody's auntie or cousin was always showing up missing a part of themselves, or on somebody's arm because of their blurry vision; some had even lost their sight completely. We kids were always hearing the adults talk about how this person down the street or that person from the other side of town got "the sugar." It sounded harmless and we were clearly not making the connection between the disease and its consequences—the amputations, the loss of sight, the heart disease.

Meanwhile, I wasn't the prettiest kid or the smartest kid. I wasn't the shyest kid and I wasn't the bravest. I wasn't the fattest kid and I wasn't the skinniest. What I was, more than anything, was the kid who wanted to belong. I lived in fear of getting into trouble with my parents or the elders at our strict Jehovah's Witness church. I left school at two forty-five and had to arrive home by three. I had no social life. I was not allowed to participate in any extracurricular activities. I had to simply follow the JW rules: prepare for the next life by doing nothing in this one. All I wanted was to be a cheerleader—

that's definitely why even today I am a devoted Dallas Cowboys cheerleader fan. I even got to live my cheerleading dream, when I danced with the New York Knicks City Dancers.

But I had pretty, popular friends, and I wasn't so afraid that I wouldn't tag along with them to sneak out at night, or kiss a boy on the sly. (Okay, you got me: I did a lot more than kissing.) I wanted to be a good daughter, a good child of God, *and* a good kisser of squirrelly lipped, hormone-fueled middle-school boys. I wanted to belong everywhere all at once.

From the time I was a young kid, I've relied on three things to make me feel okay, less alone, more full, and closer to complete: faith, funny, and food. I was raised in a very religious household and, of course, I rebelled against it. The church of my birth was a church where I never quite felt at home. For a long time I thought that meant I didn't have a home with *God*. I learned, to my eternal relief and gratitude, that that wasn't true at all. As you'll soon see, I found my way back to faith and to God. But Lord was it a crooked path!

Funny? I used being funny to make friends. Funny came in handy when we moved from our mostly black South Side neighborhood to a mostly white suburb of Chicago. I used funny to help me push back against the racism I sometimes encountered at my new school. Kids, I learned, were less likely to lob insults if they were laughing. Funny helped me bridge the social gaps. Funny gave me a way to belong. Funny helped again, after my parents divorced, when I moved with my mom and my sisters to Los Angeles. (My mom wanted to get as far away as she could from my father and live in a warm climate. To her, that meant either Atlanta or Los Angeles. So after playing eenie, meenie, minie, moe, LA won.)

Eventually, funny became even more important to me, as my actual livelihood. But it has always stayed a way for me to feel a part of something bigger than myself.

If I used funny to help me belong, I used food to comfort myself during all the times I felt alone, sad, or stressed. Funny helped me feel good. Food helped me avoid feeling bad. Food helped fill a hole inside me I couldn't quite locate but always knew was there. Except food didn't *really* fill that hole, because I was always eating and never full. It took me years to figure this out.

I was in middle school when my mom and dad divorced, and my sisters and I moved to Los Angeles with my mother. Watching my parents split and saying goodbye to my beloved dad was tough. It made me angry. And when I think back to that time in my life, I remember that the anger made me eat.

I took my anger with me to California. I was mad at my mom for the changes in our family, and I took it out on her by being as trying a teenager as I could possibly be. In Los Angeles, no less, where trouble lurks around every palm-treed corner. I did a lot of silly, foolhardy, even dangerous stuff as a teenager and young adult in Los Angeles. I dated the bad boys and gave the runaround to the good ones. I dressed like a hooker-in-training and ran around town at night, sneaking into clubs with my friends.

As I got a little older, I traded dance clubs for comedy clubs, and boys for men. I still dressed like a tramp. I got bored with the men who had time for me, who treated me right, who wanted more than a good time. But as soon as one of those guys who was a little bad (not big B, little b) looked at me with any interest, I'd find myself hightailing it over the other

side. I was intrigued and entranced by any good-looking guy who had just a touch of the seamy side, even if it meant he'd spent time in county lockup. I cheated on the nice men and let the bad ones directly into my heart. What was going on with me?

But little did I know that the most dangerous relationship of all was forming right under my nose. On my plate. During those years, my relationship to food was forming—and it wasn't a good one. My indulgences—you know, those little treats you give yourself—were treading closer and closer to straight-up binges. I lived on fast food and junk from the convenience store and the vending machines at work. If I could go back and say anything to that mixed-up girl, it would be this: *Put down those chips. Don't fill yourself up with a double cheeseburger.* I'd also introduce her to salad and tell her to pull down her darn skirt. Whew—she was a little floozy!

What would I eat in any given day? I'd start out with bacon and pancakes, if I could get 'em. I'd move on to chips and dip and corn bread slathered with butter. I'd snack on more fake food from a vending machine. Then I'd sit down to a dinner cooked in butter or cheese—mac and cheese was one of my favorites.

I really should have known that I wasn't doing my body any favors, even then. We moved to LA when I was eleven, and I could no longer remember when my mom wasn't sick. When I became a teenager, I began to watch my mom suffer. By that time, I understood that she had diabetes. But I still didn't understand that how she ate was actually making her symptoms worse. As busy as she was taking care of me and my sisters, she never really learned how to take care of herself. Maybe she was too tired to think about it. Maybe she didn't real-

ize that the high-sugar, high-fat foods she ate were making her life painful. Maybe she thought those sugary foods she adored—the Hi-C and the frosted oatmeal cookies—were her treat after taking care of me and my sisters all day as a more or less single mom. I don't really know what she was thinking because she never told me.

It took a while, but the complications from her diabetes inevitably came. When I was barely in my twenties, my mom's health took a turn that she wouldn't recover from. Her blood sugar was out of control. Her blood pressure went through the roof. She lost the feeling in her feet. Her vision began to deteriorate. Her in-and-out trips to the ER turned into longer hospital stays. When she was home, she was exhausted, in pain (probably because her organs had begun to shut down), and basically housebound because even walking was painful. She also had a terrible time calming down enough to sleep, so after work at one of my temp jobs or even late at night if I had a gig at a comedy club, I would gently load Mom in my car and drive around LA for hours late into the night. The motion of the moving car and the rhythm of the engine running helped her to sleep, just like a newborn baby. I was glad to be able to give her this small comfort, but there was nothing I—or anyone else—could do to make my mom better.

During her last trip to the hospital, she slipped into a coma. Doctors told us that her feet were such a mess she'd need amputations: first her toes, but eventually her feet. The doctors gave my sisters and me a choice: keep our mom alive on machines, go forward with the amputations, and try to keep her comfortable. Or let her go. My mom's wishes were always to let her go—she didn't want to live in a vegetative state. So we made the hardest choice anyone ever has to make.

Still Didn't Get It

My mom died from complications of diabetes when she was only forty-one. I was twenty-three years old when my sisters and I made the decision to take our mom off life support and spare her the pain of a slow death. Her passing was a shock to me, a loss that cut deeply. But even her death from a disease exacerbated by poor food choices didn't stop me from eating badly. It didn't force me to make the connection between how my mom ate and how and why she died so young. Nor did my mother's death make me take an interest in diabetes, or think about my own risk, or my sisters'.

Nope.

It made me eat.

I numbed my grief with fried chicken and milkshakes. With comfort food that bathed my body in fat, sugar, and millions of calories my 5'1" body did what it could to take in. By that point in my life, eating to stifle difficult emotions was an automatic response, deeply built into every cell of my being. Faced with any situation that called for me to feel something, I took care of that situation with food.

This was the first of two times in my life when my eating truly went out of control. We'll get to the second time in a bit. That hole I was always trying to fill? It had suddenly, with my mother's death, become a crater.

I say my mother's death was a shock, and I remember feeling that way, but to be truthful it wasn't a shock at all—or it shouldn't have been. My mother had diabetes for a long time before she died from it. All my life I'd watched her cope with ill health from diabetes. I watched her inability to stay away from sugar, despite the fact it was killing her. I watched her

energy being sapped, her health whittle away, and the life slowly but surely seep out of her. We didn't understand the full scope of diabetes back then. In fact, like many people at the time, we assumed the insulin injections were taking care of things. We assumed that the medicine was counteracting the damage done with bad food choices. We didn't understand that the most essential problem to change is the way we eat.

Well, we were wrong. Way wrong. Millions of Americans have made this same assumption.

But I didn't think about any of that. I just kept right on eating, right on sabotaging my own body, without a care about what the future might hold.

I was just starting my comedy career when my mom's health really went into decline. After her death, I threw myself right back into the two things that grounded me the most: food and funny. I worked all day as a secretary, including pushing papers at a Beverly Hills law firm, and I hit the comedy clubs at night, working my way onstage, learning the ropes, trying to find my voice as a comedienne. I eventually started going to auditions and landing acting jobs.

And the warnings from my doctor about my own health risks? I was too busy for doctors in those days. Truth be told, I was too scared. But those warnings, they were coming. As you'll see, even those weren't enough to make me stop in my tracks and change my using food as an emotional crutch.

Not at first, anyway.

Ups and Downs: Career and Weight

Building a career in Hollywood takes time. At least it did for me. I worked temp jobs for years while I was performing at night and sneaking off for auditions during the workday. I got

the performing bug pretty early. My dad had always wanted to be an entertainer—he even did stand-up for fellow soldiers at Okinawa—though he never pursued it. He is, to this day, one of my biggest fans and is so proud that I made being funny into my career. He still goes around his neighborhood in Chicago and signs pictures of my headshots with his own name— Sherri Shepherd's dad!

As a kid, I knew I wanted to do something different with my life but didn't know what. I loved performing skits and shows with my sisters and cousins for my family. But over the years, I've had a lot of ups and downs. There were times when work was plentiful—I was making people laugh, booking gigs, and paying the bills. (Late, but still . . .) There were also times when I went months without booking a job or even getting a callback. Those were stressful, scary days, especially since I had a bit of a spending problem. I spent first, asked questions later. The notion of a balanced checkbook or a monthly budget? Please, I had it covered. That's what plastic is for! At least that's what I thought at the time.

To accompany me through this time of career stress and financial worry—and let's not forget the troubles that came from my good man–bad man gymnastics—I had wandered into a cycle of bingeing and starving myself. The more I got into show business and aspired to a—dare I say it?—acting career, I began to worry about my weight, whereas before I didn't mind the extra pounds. But looking back, I know that I was also holding on to food as my security blanket. My mom was dead. I had no stable career. No trusting relationship. I was really alone and running scared in my own funny way.

If you've ever tried this yo-yo cycle of eating too much and

then trying to starve yourself, you know that it makes you feel crazy. You think you are in control, but that is the last thing you are. And, of course, the last thing it does is actually help you lose or maintain your weight.

My weight was the opposite of "under control." Instead, it constantly went up and down. I'd pig out on pizza and soda and ice cream and then not eat for two days to "make up for it." Of course at that point I'd be so hungry from NOT eating that I'd just binge once more, starting the whole dang cycle over again.

I tried every diet I came across. Lots of them made me lose weight. Sometimes quickly. But it never stayed off for long because I never stayed on the diets for very long. And it seemed every time I gained it back, that number—you know what number I'm talking about—crept a little higher. I was 135 one week, three weeks later I could reach 155. I could make it to 160 if you gave me another week. No matter where my body was, I never felt right. I spent some time skinny—but I was never skinny enough. And I was hungry, which was no fun. I get cranky when I'm hungry and I was a first-class bitch for a lot of that time. I spent some time fat. Try being fat in Hollywood. Most of those folks treat body fat like a communicable disease. In Hollywood, they want you at your birth weight.

Fat, skinny, somewhere in between. No matter where I was at any given time, I was riding a roller coaster. I wasn't in charge of food. Food was controlling me.

Hello, God, It's Me, Sherri

For years I rebelled against religion. I was raised a Jehovah's Witness, in a house of strict faith. I managed to break every

rule they set out for me. When my parents divorced, my father was disfellowshipped from the church. According to the church rules, when someone is disfellowshipped, the rest are supposed to shun him. My mom followed the rules to the letter. So did my two sisters. But me? No way. Shun my dad, the guy who worked three jobs to keep us fed and clothed, who could turn an ordinary weeknight dinner into a party by breaking into song? Uh, I don't think so. This whole disfellowshipping and shunning business made me angry. I hung in for a while longer with the church when we moved to LA, but truth be told, that was mostly because Michael Jackson was a member there. As I got older, I drifted. God, though, was always in the back of my mind, and over my shoulder.

I spent my twenties doing my best to impersonate a hedonist. My life was filled with lots of shopping, lots of sex. Oh, and lots of food. Man, was I lonely. Life felt empty; I felt empty. I ate to fill that void. It took me a while to get back to God, but I did it. He has his ways and I have mine, and it took me some time to find him again. I spent a lot of time worrying that it was too late, that I'd messed up too much: too many mistakes, too many bad choices. When I finally stopped drumming up reasons why I wasn't good enough and just started listening, I heard this: *Welcome back. I love you, girl. Now, what in my name are you wearing today? You expecting people to be sticking dollar bills down that shirt, or what?* That was the beginning of my new relationship with God, a conversation that started and hasn't stopped since!

The presence of God back in my life filled a hole I desperately needed filled. But it didn't fix everything, especially when it came to food. I still binged. I still used food to try

to calm and comfort myself, as a high-calorie buffer against stress and sorrow. God was very much in my life, but I could still ignore him from time to time.

My relationship with God is a conversational one. I talk to him about everything from motherhood to diet cola to dancing and bowling, and he talks right back. God warned me for many years about my health. *Slow down*, he'd say when I was plowing through a cheesy pizza. *Ease up*, he'd tell me when I would binge on a whole box of cookies. Later, the warnings from him grew more grave and serious. As you'll see, I ignored them until they couldn't be ignored anymore.

My Life Becomes a Jerry Springer Episode *and* I Get Offered My Dream Job

As soon as I turned thirty, a bell went off in my head: I need to get married! I need a child! I looked at the good guys versus bad guys in my life and decided on one in particular. I don't want to go into all the good things about the man I ended up marrying, just suffice it to say he was a little bad but not all bad. He was very charming. He was very supportive of my career. But he ended up not being nice enough. More on that later.

After I married my first husband, we set our sights on having a baby. We knew what needed to be done, and we did it. Again and again. We had lots of sex during those days, but no baby. We couldn't get pregnant. So, like everyone else at the time, we started fertility treatments, which meant that for the first time in my life I had to deal regularly with doctors. Doc-

tors scared me, but I wanted a baby so much I was willing to do it. I remember I asked my fertility doc what I could do to better my odds of getting pregnant. He told me to lose weight. I took that sensible advice and went on a liquid diet for six months. I went from a size 14 to a size 4. Not so sensible. And since I wasn't prepared to drink my calories for the rest of my life, I did eventually gain it all back. Plus a little extra.

After a year of fertility treatments, my husband and I were given the news we'd prayed for: we were pregnant. With twins. I was thrilled, overjoyed. And terrified.

I was so scared of something going wrong, I wouldn't even have sex with my husband! Something did go wrong, but not because of sex. I took a fall while walking a friend's dog. I landed flat on my back, and was rushed straight to the hospital. I lost one of the twins that day, a daughter. We were still pregnant, but I was diagnosed with placenta previa, which means that the placenta was sitting on top of my cervix. Now we had a high-risk, complicated pregnancy.

Boy, I didn't know the half of it. Because it turns out that the "we" who were pregnant, well, that wasn't just me and my husband. That was me and my husband, AND my husband and the woman he'd been seeing on the sly. You read that right. My husband had decided to time our high-risk pregnancy with an affair, which itself resulted in another pregnancy. The biggest difference between me and the other woman? She looked like J-Lo with a cute baby bump and I was starting to look like Aunt Jemima. Oh, those were good times.

I managed to carry my baby for five and a half months. When my son, Jeffrey, was born, he weighed one pound and ten ounces. He had holes all over—in his heart, in his intestines.

His lungs were underdeveloped and he was bleeding in his brain. Doctors gave us a prognosis that was beyond grim. He might live, but his life would be painful and limited and full of doctors and surgery and therapy. My son—Mr. Miracle— started proving everyone wrong in that hospital, as his holes started closing up and his tests started coming back negative for one worst-case scenario after another.

He's now a sweet and wild eight-year-old boy living pretty much just like any other kid. There are a few challenges that we are handling with bravado, courage, and lots of humor. Don't get me started on how amazing my son is—I'll be here all day and never tell you any more about the diabetes that saved my life.

I tried to make things work with my then-husband, for my baby's sake. I really did. But I couldn't. Pregnant J-Lo didn't help. It was in the middle of all this insanity that I got the call from *The View*. I was first asked to come and sit in as a fill-in host while I was pregnant. Eventually, after Jeffrey was born, the call came that would change all of our lives: a permanent seat at the table, as a cohost alongside Whoopi, Joy, Elisabeth, and . . . oh yeah, the one and only Barbara Walters.

Once again, my career was taking off as my personal life was a mess. The first time was when my mom was dying and I was just starting in comedy. Now my marriage was crumbling and my baby was still in mortal danger, and into that mix came the job offer of a lifetime. Do I even have to say it? My eating spiraled out of control.

Ignoring Prediabetes and Heading Straight for the Big D: Diagnosis

When prediabetes knocked its way into *my* life, I was surrounded by so much chaos that I barely paid attention. It's a shame, because I could have taken steps to change the course of my health if I had only heeded those early warning signs. Instead, I was so overloaded with "Big Life Stuff" that the scare of diabetes was an afterthought. *Oh, you mean I might not live to see my son grow up or make it to my AARP-membership age with all my limbs intact? But I don't have it yet, right? No, okay, good, let's move on.*

It was now two years since my doctor had told me my glucose levels were high enough to make me prediabetic. At that time, I'm pretty sure I gave her a blank stare. I might have asked where the candy machines were. That's how much I DIDN'T GET IT. I was testing right at the line then. To be honest, to say I was only prediabetic was a technicality. And yet I changed nothing. Not one thing. Why? Because I didn't want to. Because my blood sugar and cravings were so out of control, I didn't think I could change the way I ate. And because I didn't realize that being prediabetic means you're going to get diabetes if you don't change.

I spent the next year trying to eat my way out of my pain—nothing new there—and trying to deny the signs that my health was getting worse, that I was quickly shedding that "pre" status that I took as license to keep bingeing. My toes tingled, and I blamed it on my shoes. My feet felt numb, and I blamed it on the cold. My vision felt blurry, and I blamed it on windshield glare or fluorescent lights or LA smog. My young-

est sister, Lori, had recently been diagnosed herself. Deep inside I knew what was happening to me. But I clung to the fool notion that I was different.

By this point, after my special little Jeffrey was a very small two-year-old, my marriage was falling apart, and the chaos of my life had reached an all-time high. It was in the midst of all of this that I was offered my dream job: a regular seat at the table on *The View*. Taking this job—which I'd worked toward all my life and never in my wildest dreams actually expected to get—was the hardest decision of my life. Did I have the guts to leave my son—even temporarily—and move to New York? This would be the second time my eating went off the charts.

After stuffing myself with a pancake breakfast or two, I knew I was facing an enormous decision. I could only accept this amazing career opportunity under two conditions: I had to take care of myself so I would be able to take care of my son, and I had to have the courage to leave him in the care of one of the best therapeutic centers in the world while I got my life in order. I also knew it was best for Jeffrey to continue his therapy with the doctors who knew him so well.

After Jeffrey was born and had to stay in the hospital for several months, his life in jeopardy, I thought I had reached the lowest time in my life—nothing compares to the fear and despondency over the possibility of losing one's child. My nerves were going through the roof.

All of these things, the good and the bad, caused me no small amount of stress. And stress, for me, at least for most of my life, meant it was time to eat. And I don't mean cute little pieces of crudités. I mean comfort food, the badder the better.

And what was I going to do at that table with all those smart

women? *Why did they pick me, anyway?* I couldn't imagine how I'd succeed. Just as important: how was I ever going to get through this without my best friend, food? All I wanted to do was curl up in a corner. With a ham sandwich, thank you very much.

With Jeffrey in intensive therapy treatments, I had to move across the country to start work on *The View*. By myself. Alone. It was too much for Jeffrey to travel, so he stayed with his father in Los Angeles, and I'd fly back on weekends to see him, and to further examine the wreckage of my ruined marriage.

I was lonely, forlorn, and out of control.

It was the pee that did it for me. When your blood sugar is too high, you feel extremely thirsty. You also feel like you have to pee all the time. I knew this had been a telltale sign for my sister Lori.

I mustered up the guts to go to the doctor, and she immediately set up a glucose test for me. To prepare for this, you're supposed to eat a normal meal and then not eat for four hours before having your blood drawn for testing. The whole thing stressed me out. But the part that stressed me out the most? Not eating for four hours. What would I do? What if I felt . . . *gulp* . . . hungry? How would I survive?

So I did what any food-addicted, sugar- and fat-craving madwoman would do. I made that last meal count. I treated it as though it were my last meal before a long sea voyage or an extended prison sentence rather than what it was: eat at eight a.m. and don't eat again before noon. I treated my-

self to the largest plate of pancakes I could find, doused with strawberry syrup, with an extra-large order of bacon. This might be my last guilt-free meal, I told myself. (As if any of my meals were guilt-free—far from it.) I might get some bad news, but at least I wouldn't be hungry while it was happening. Then I hauled myself to the doctor.

That's when I got THE DIAGNOSIS. It was in August 2007, days before I was to begin as a host on *The View*. My D-Day. Diagnosis Day. Diabetes Day. My not-so-hand-holding doctor delivered the news that I was no longer prediabetic. I had tested way above the threshold. I was full-fledged diabetic.

Now I had to pay attention.

But did I? Nope.

After my diagnosis I just kept on going: I went home and ate a big plate of pesto pasta, to the point that my head hung below my shoulders and I couldn't even lift it up. *Take that, diabetes.* I'd been given two prescriptions for diabetes medications that my doctor wanted me to start right away. I couldn't bring myself to fill it. I called my sister and she read me the riot act. *What are you thinking? You're somebody's mother now.*

I remember perfectly the moment everything changed. It was about a week or so after the Big D diagnosis.

What happened I can't explain, but I know God was behind it. I had a vision of my son as a little boy, crying and alone. He clung to a teddy bear and sobbed, wondering why his mommy was in heaven instead of with him. As clearly as you're looking at the words on this page, I saw this scene before my eyes. I knew, then, that there was no going back. I would not leave

my son motherless. I wouldn't make him watch me get sicker. I wouldn't ask him to stand over my hospital bed, struggling to decide whether to keep me alive on a machine or pull the plug. I cried that day, and I made a vow to myself: I would not leave my child while he was a child. My son wasn't going to have to make the choice to turn off the machines that kept me alive, at least not if I could help it.

People think my talent is comedy, and on a good day, I find my funny and I think I do all right. But I'm mostly convinced that my ultimate talent is making things as difficult as possible for myself. I'm also highly skilled in avoidance of the hard truth. That day, I accepted the truth about my health, my disease, and the changes I needed to make. That was the day diabetes saved my life. With more than a little help from God and my own tiny Miracle Man, Jeffrey.

From that day on, it was the threat of my diabetes that helped me hold things together in the big epic mess of my life. On my third day of work, I made one of the dumbest comments in TV history. And that's saying something, because there is no shortage of dumb on television. In a conversation at the *View* table, in front of a live audience of millions, I used approximately none of my brain cells and expressed my doubt about whether the Earth was really round. Yep, I did that, in the age of the Internet, no less, when anybody's dumb-ass comment can go viral. And you can bet mine did. That was tons of fun, as you can imagine.

I soon made the awful, inevitable decision that my marriage was over and pushed ahead with divorce. It was a brutal or-

deal, and eventually included a custody battle. Meanwhile, I was spending most of my time working, alone in a city where I didn't really know anybody, three thousand miles away from my baby.

Even just one of these challenging circumstances would have been cause for me to binge. Food instead of feelings, remember? But added all together, this situation was the recipe for a binge that would never stop. If it weren't for diabetes, I would have eaten my way through every one of these crises and come out the other side weighing about four hundred pounds. You think I am exaggerating? I am not—well, just a little: when I started on *The View*, I weighed 197 pounds.

The threat my diabetes posed had finally sunk in. The out-of-control eating habits I'd accumulated over my lifetime were going to put me in an early grave. In those difficult weeks and months, I clung to my diabetes—and my desire to rescue my health for my son's sake—like a life raft. I began to listen to what the doctors told me: stay away from sugar. Stay away from the fatty fried foods you love. Stay away from the starchy, gooey mac and cheese you adore. Stay away from everything sweet except your son.

For the first time in my life, I began to think about what I was putting in my mouth and made choices not to eat blindly to soothe my stress and avoid my feelings. I let myself even feel scared. Feel lonely. Feel sad.

Still, there was plenty I was avoiding. One thing? Needles. If you're diabetic, you've got to test your blood sugar, usually three to four times a day. For the first seven months after my diagnosis, I refused to test my blood sugar. Rather than pricking my finger with a dreaded needle, I tried to go by "feeling."

Will it shock you to hear that this did not exactly work out? I chose not to pay attention to the tingling in my arms, the waves of exhaustion that would come upon me after eating. I deliberately ignored how thirsty I felt all the time.

Finally, as soon as I won custody, Jeffrey came to live with me in New York. That shook me up. I looked at my baby and God put it right out for me: *Are you willing to risk it? Is avoiding a tiny pinprick worth risking this baby's well-being? Because nobody's gonna love him like you can.* I was still scared of that needle, but I started testing my blood sugar.

I used to avoid doctors like the plague. These days, I haunt my doctor's office. She's sick of me, I'm sure, but I'm not messing around anymore. If I'm not feeling right, I'm on the phone, checking my symptoms with my doc.

That day when I burst into tears at the thought of leaving my son without a mom, I started a new life path that led me here: to a place where I achieved a healthy weight and had a game plan for keeping it off and kicking diabetes to the curb. This plan, my Plan D, has also led me to a happy marriage, the second time around. I have been led to a job that surpasses my wildest dreams, every day. To a thriving little boy who makes me glow every time I look at him, play with him, and run around the park without breathing hard. This plan is also part of the promise I made to myself to see that boy grow into manhood. Whereupon I can harass him about his girlfriends, his wardrobe, his housekeeping habits, and whatever else gets into my elderly mind. Hey, I'll have earned it. *Kid, I wiped your butt, now it's your turn to put up with my %$#!*

That day also led me to this book and the opportunity to

share my story, with all my many ups and downs dealing with the Big D, so that all you folks in bed with diabetes can skip some of my missteps and get on with the business of getting healthy and being around to harass *your* children when they're all grown up!

Do It Scared

You'll hear me say this a lot. If I've got a mantra—other than *help me, Jesus*—it's "Do it scared." It means just what it sounds like: don't wait to get over being frightened about something before pushing forward to try it. Do it now. Do it scared—this goes back to my earliest days in comedy. I was completely desperate to get up on that stage and tell some funny stories. The idea of making people laugh was intoxicating to me. Some folks get drunk on liquor or high on drugs—for me, it's the sound of people laughing that transports me.

One night years ago, when I was first getting the bug to be a comedienne, my girls and I went to the Comedy Store in Hollywood. A comedian named Eddie Griffin opened that night, and after the show he gave me the advice about "doing it scared." When he shared the advice with me, I was just a girl who was funny at home, funny at her temp job, funny with her friends, and who desperately wanted to be funny up onstage. His show, he killed. Afterward, I worked up the nerve to ask him for advice about my own, at the time nonexistent, comedy career. If I recall correctly, Eddie also put the moves on me. What a mentor. I politely declined his offer, and instead he gave me this piece of wisdom I've never forgotten. *I really want to try this*, I told him. *So do it*, he said. (I think he fol-

lowed that up with an attempt to look down my shirt.) *What if I'm scared?* I asked. He replied: *If you're scared, do it scared.*

I do it scared every day. If you think my knees don't still wobble when I walk out onto that *View* stage, you're crazy. I do my job scared every single day. Every step and twist and dip I took on *Dancing with the Stars*? I did 'em all scared. Dancing onstage with millions watching, with the judges watching my every move, made me sick to my stomach. And did I mention what I discovered about myself while doing *DWTS*? Stage fright! Yes, I realized that I had a massive case of stage fright!!!

But I'm getting ahead of myself. Let me get back to truly understanding how diabetes was threatening my life: I was absolutely terrified of the changes I had to make to my life in order to deal with diabetes. I stayed terrified for a long time. But I also made changes, while I was still terrified. I made them one by one, day by day, week by week, and eventually the terror started to subside.

Giving up chicken-fried steak? Eating a portion-controlled diet? Frightening. Testing my blood sugar, with needles no less? Regular visits to the doctor? Scared me to death. Going to the gym, where I'd have to stand next to fit people who would surely see my flabby arms and my thighs that touch? Filled me with anxiety.

But this is the beauty of doing it scared. No matter how frightened you are, your fear doesn't have to stop you from moving forward, making changes, taking risks that will pay incredible rewards to your health and happiness, your

relationships, your *life*. Fear is a motivator, and in my case, a positive one. Use your own fears that way, too, and you'll eventually find that every scared little step leads you closer to a goal. I still live with fear every day, but I'm glad about that because it keeps me on my toes and making the right choices.

Today, I've lost more than forty pounds. I gave up fettuccine alfredo and piña coladas. I eat hard-boiled eggs and hummus; oatmeal and almonds. I sometimes go for some barbecue, but only in moderation. When I don't have time and need to stop at a fast-food joint, I've learned to make healthier choices. I have also learned to prepare quick, easy meals that fill me up and taste really good. Finally, after a long period of resistance, I gave up diet soda. I drink water instead. I feel better, I look younger, and I'm no longer plagued with headaches. Everywhere I go people comment on how soft and young my skin looks, how curvy-in-the-right-places my figure is, and how the smile never seems to leave my face. I have so much zest for life, so much energy, I can't believe I am the same person I was even a year ago!

Not long ago, I passed the age my mother was when she died. It was a bittersweet milestone. I still miss my mom. I wish she were here to bug me about my wardrobe and meddle in my relationship. I wish she could give me tips on being a mother, now that I am a mother, too. But I passed that milestone in better health than I ever could have imagined just a few years ago. I'm engaged with my body, my feelings, and my health. I'm not checked out anymore, and I'm no longer using food to soothe my feelings. After a lifetime of mindless eating,

of eating to avoid my feelings, I've finally figured out how to separate my feelings from my food. It's an ongoing process— and yeah, sometimes it's hard—but I wouldn't trade the way I feel now, and the healthy future I've invested in, for all the Big Macs in the world.

Diabetes could have put me in a wheelchair. Instead, it got me dancing. Ready to learn a few steps?

What You Need to Know about Diabetes: The Facts

I n my family, which was—and is—full of diabetics, we used to have our own special name for the condition. We called it "the sugar." This is an awfully cute nickname for a serious, potentially deadly disease, don't you think? This is like calling cancer "little c" or heart disease "funky heartbeat." This cutie-pie nickname for a disease that was slowly but surely picking off members of our family should give you some idea of how NOT prepared we were to deal with the reality of diabetes. . . . I mean, really: How much time are you going to spend being afraid of—or working to protect yourself against—something called "the sugar"?

When I was first diagnosed, I desperately wanted to keep sticking my head in the sand, to keep avoiding the basic truths of diabetes. I had lived for nearly forty years surrounded by diabetes and yet ignored it 99 percent of the time. I'd watched it take my mother's life when she was younger than I am now. And yet I knew nothing about this disease that had so deeply affected my family and inhabited my own body. It was all just too complicated and too scary.

I finally came to understand that running away from the reality of my disease would only make things worse. If I wanted to be around to mother my son into adulthood, I needed to deal directly and honestly with my health. That meant I needed to understand my disease so I could manage my diabetes, instead of diabetes having its awful way with me. The facts of diabetes don't change no matter how much effort we put in to avoid them, whether it's the disease you have or the one you're worried about developing.

You're here, reading this: that means you're ready to deal with the facts of diabetes in your life. You might be prediabetic. You might have insulin resistance. Or you may have gotten diagnosed with the Big D. Regardless, the information is out there. So let's get to it.

The bad news: diabetes can seriously limit your life.

Now the good news: your type 2 diabetes can be managed and sometimes reversed if you are very, very thoughtful. You can also prevent getting the diagnosis, even if you've already been told that you are prediabetic. Its underlying cause—the body's inability to use insulin effectively—can even be reversed. It's possible to become healthier than you've ever been—in fact, that's what you're going to need to do if you want to kick diabetes to the curb. By changing your diet, you can disrupt the blood sugar chemistry that is making you insulin resistant. By eating foods that don't trigger your body to release too much insulin and by adding in regular exercise, you will stabilize the way your body responds to sugar so it can stop producing too much insulin and re-enable its cells to use the insulin it does release. What does all this boil down to? I will show you not only a way to lose weight and redefine

your relationship with food, but a way to reduce most—if not all—of your diabetes symptoms.

. .

DIFFERENT TYPES OF DIABETES

When we talk about diabetes, we're actually talking about a spectrum of diseases that all share the same fundamental problem. Diabetic people have high, unhealthful levels of sugar trapped in their bloodstream. This is true for all three types of diabetes. Type 2 is the most common form of diabetes. That's what I have, and that's what 95 percent of the 26 million diabetics in the United States have. In this book, when I talk about diabetes, I'm talking about type 2. The other two types of diabetes are:

Type 1

A person develops type 1 diabetes when the pancreas loses its ability to produce insulin or makes too little for the body's needs. Without insulin, our bodies cannot metabolize glucose and other compounds of sugar and carbohydrates, which all of us rely on for proper body functioning. This type of diabetes usually occurs at an early age and is often detected by four classic symptoms: frequent and excessive urination, excessive thirst, ravenous hunger and excessive eating, and weight loss (because the body's cells can't utilize the glucose). Type 1 diabetics make up about 5 percent of all diabetics in the United States. Though some adults can develop type 1 diabetes, most often it is a genetic condition diagnosed in children and young adults. It can also be caused by acute injury to the beta cells, which in turn will trigger the body's immune system to attack itself. Though doctors and researchers have long said that there is no cure for type 1 diabetes, there is mounting evidence that if type 1 diabetes is detected in its earliest stages, progression of the disease might be prevented.

Gestational Diabetes

This type of diabetes occurs during pregnancy when a woman's changing hormones can interfere with how the insulin in her body does its job, resulting in high blood sugar. Most of the time, blood sugar will return to normal after childbirth. **Women who have had gestational diabetes are at higher risk for developing type 2 diabetes.**

. .

DIABETES ON THE RISE

In the United States and around the world, cases of diabetes are increasing at a truly alarming rate. We're talking millions, people. The rates of diabetes are expected to *triple* over the next forty years. By 2050, one in three adults could be diabetic. Today,

- 25 million adults and children in the United States have type 2 diabetes. That's roughly 8 percent of the entire population of the United States!

- an estimated 7 million of those diabetics have not been diagnosed. No diagnosis means no treatment.

- approximately 2 million new cases are diagnosed in the United States each year.

- more than 350 million people worldwide are diabetic.

Source: National Institutes of Health

. .

Diabetes in the Body

As I said earlier, diabetes is the presence of too much sugar trapped in the blood. But what causes high blood sugar? **The cause of high blood sugar—and the underlying cause of diabetes—is something called insulin resistance.**

Wait. Before you close this book, flip open a magazine, and decide this has nothing to do with you, give me a chance. If you want to beat diabetes—or avoid diabetes altogether—you've got to really understand the enemy you're facing. Let me break this down for you, piece by piece.

When I started learning about diabetes, one of the first things I heard was that diabetes is a disease of metabolism. I figured I knew what metabolism is. That's the thing I used to blame for my weight fluctuations. A slow metabolism. When my clothes wouldn't fit on a shoot or when I suddenly jumped a size (or three), I knew it was the slow metabolism at work. *Yep, it's that slow metabolism again. Please ignore the jumbo-size bag of Fritos in my hand.* I had no idea that it was actually those salty, fatty chips themselves that were affecting my metabolism and leading me slowly but surely toward diabetes.

Metabolism, for our purposes, simply refers to the process by which the food we consume is digested and then used for energy to power our every move and thought. Eating a diet that is made up primarily of starchy carbohydrates, sugar, or processed foods—all of which have little or no fiber—slows down your body's ability to absorb nutrition. At the same time, a diet made up of these "comfort foods" triggers your body to release too much insulin in a constant way. In a healthy, non-diabetic person, carbohydrates and sugars are digested and

converted into glucose, which is then sent as fuel throughout the body to be used as energy. When you become diabetic—or prediabetic—the constant high levels of insulin begin to disrupt this basic metabolic process and you get sick. Your cells can no longer respond to the insulin that is present in your blood, so they cry out for more sugar, which is why prediabetics and diabetics crave sugar and carbs (which both break down into glucose in the body).

Food to Fuel: Let's Back Up a Minute

The food we eat is made up of three major nutrients: carbohydrates, protein, and fat. Most of what we eat is broken down by our bodies during digestion, and either burned for energy or stored for later use, often as fat. These three types of food break down differently and at different speeds.

The starches and sugars in our food—found predominantly in carbohydrates such as rice, potatoes, and pasta—break down into a special type of sugar called glucose.

Glucose

Much of the food we eat is converted to glucose in our bodies. Glucose is our basic body fuel, our main power source for the energy we need to do everything from blink our eyes to run a 5K race. When we eat, the sugars and starches in our food break down into glucose. That glucose is then released into our bloodstream and moves throughout the body to bring its fuel to cells from our brains to our big toes and everywhere in between.

This is where we get the term *blood sugar*: it refers to glucose in the blood. Every time we eat, our blood sugar rises, as an effect of this process of digestion and glucose release.

Blood sugar lowers as the glucose in our blood is distributed to cells. It rises when we eat again. This cycle of rise and fall is normal, and it's the process we want to happen in our bodies. In a person who is developing diabetes, this cycle gets disrupted.

Different kinds of carbs

But there's more than one kind of carb—and different carbohydrates are digested, turned into glucose, and released into the bloodstream at different rates.

Simple carbohydrates are all those foods that we love to eat that tend to be white, fluffy, and delicious—potatoes, white rice, pasta, cereal, and delicious, wonderful bread. Simple carbohydrates are easy for the body to break down, so they hit the bloodstream with sugar (or glucose) fast.

Complex carbohydrates take a little longer to break down and therefore don't hit you with sugar right away. Why are they complex? Because they also include fiber—complex carbs are whole grains, vegetables, and fruit. Think of complex carbs as anything you have to chew—other than meat (which is a protein) and taffy (which is candy, for God's sake). The fiber and chewiness make complex carbs slower to release the sugar into the bloodstream. They fill you up more, and they are much better for you.

The glucose in our bodies is transported by our blood to cells everywhere in our system. But it doesn't just drop itself automatically into those cells. Actually getting glucose from the bloodstream into our cells requires another key player in the metabolic game: insulin.

Insulin

Think of insulin as the welcome wagon for glucose through-out your body. Insulin is like that unbelievably cheerful PTA mom who's on top of everything—you know the one—who's always running around making introductions, organizing car-pools, *making things happen.* Insulin makes a very important thing happen for us: it enables cells to accept glucose from the bloodstream and use it as fuel. Insulin functions like a key that opens the door to each of our cells, which allows glucose to enter and provide fuel to that cell.

That is, when insulin works effectively. When people de-velop prediabetes or diabetes itself, and they consume sug-ars and simple carbohydrates several times a day, they force the pancreas to produce excess insulin, which is needed to "escort" the sugars out of the bloodstream and into the cells. Over time, when insulin levels are driven up again and again several times a day (every time you eat a food high in sugar or a starchy carb that gets broken down into sugar), the pancreas becomes worn out and cells become resistant to taking in any more sugar. This is what we call insulin resistance: the cells of your body stop being able to *accept insulin as the key that lets in glucose.* The body continues to produce insulin, but the insulin doesn't do the work it is supposed to do anymore.

Insulin resistance doesn't happen overnight. It's not as though our cells just up and change their locks all at once. It's a process that takes place over time. First that insulin key becomes a little sticky in the lock. Then the key gets harder and harder to turn. Finally, the key doesn't turn in the lock at all. What happens next? The excess sugar that is constantly

floating around your body, unable to be absorbed by the cells, keeps your blood sugar abnormally high until the insulin begins to store it as fat, causing abdominal fat (that apple shape associated with prediabetes and diabetes), obesity, and high cholesterol. To make matters even worse, the excess blood sugar also attaches to proteins that may damage or thicken the arterial walls, directly increasing your risk of blood clots, heart attack, inflammation, cancer, and stroke.

Insulin resistance is a big, big problem. It is the thing that triggers your body to start storing fat, fat that fills your blood and lines your belly, your hips, your arms, and your heart. It slows you down. It takes away your energy. And it makes you feel terrible—moody, sluggish, irritable, and tired. Does this sound familiar? This is how I used to feel every day!

SCARY STATISTIC ON PREDIABETES

One-third of Americans qualify as having prediabetes, yet 90 percent do not know it.

Source: Centers for Disease Control and Prevention

GLUCOSE IN CELLS: WHAT HAPPENS NEXT?

One of three things happens when glucose enters cells.

1. Glucose is used right away by cells as energy to power the various functions of the body and brain.

2. Glucose enters cells but isn't needed immediately for energy. Cells have the ability to put glucose in short-term storage for use a little bit later. This is called glycogen.

3. Glucose enters cells, but there's no immediate use for energy and the short-term supply is also filled to capacity. In this case, cells put glucose in long-term storage. Can you guess what form this long-term storage of glucose takes? Yep, it's FAT.

And that, folks, is one way food becomes fat. We need fat on our bodies—it's a sign that we've got energy sources in reserve. We just don't want too much.

. .

How Do You Know? Tests for Prediabetes and Diabetes

Doctors can use a fasting plasma glucose test (FPG), an oral glucose tolerance test (OGTT), or an A1C test to detect prediabetes or diabetes.

FPG—Fasting Plasma Glucose Test

- This test is a simple, inexpensive one that is used to expose problems with insulin functioning. A noninvasive blood test, it requires that you fast overnight so that you can measure your blood glucose level first thing in the morning before eating.

- Normal FPG is below 100 mg/dl. A person with prediabetes has a fasting blood glucose level between 100 and 125 mg/dl. If the blood glucose level rises to 126 mg/dl or above, a person has diabetes.

OGTT—Oral Glucose Tolerance Test

- You also need to fast overnight for this oral test. However, your blood sugar is checked after fasting and again two hours after you drink a glucose-rich drink.

- Normal blood glucose is below 140 mg/dl two hours after the drink. In prediabetics, the two-hour blood glucose is 140 to 199 mg/dl. If the two-hour blood glucose rises to 200 mg/dl or above, a person has diabetes.

A1C (also referred to as glycated hemoglobin, glycolated hemoglobin, or hemoglobin A1C, or HbA1C tests)

- This is a blood test (done in a lab or at the doctor's office) that shows the average amount of glucose in the blood over the past two to three months. It measures what percentage of your hemoglobin (the protein in your blood cells that carries oxygen) is coated with sugar. The higher your A1C level, the more out of balance your blood sugar.

- An A1C of 5.6 percent or below is normal. In prediabetics, A1C levels range between 5.7 and 6.4 percent. If your A1C is 6.5 percent or above, you have diabetes.

The American Diabetes Association also offers a Diabetes Risk Test (www.diabetes.org/diabetes-basics/prevention/diabetes-risk-test/) to help you determine if you are at increased risk for diabetes or prediabetes. A high score may indicate that you have prediabetes or are at risk for prediabetes.

These tests are available through your doctor and in drugstores. As you begin to accept and then deal with your prediabetes condition or diabetes diagnosis, you will get to know these tests very well.

Sources: American Diabetes Association and the Mayo Clinic

Who Gets Diabetes and What Causes It?

Anyone can get diabetes. But some of us are at greater risk than others. There are several factors that contribute to your risk level for the Big D. Recognize yourself in any of these categories? I fit more than a couple, as you'll see. How about you?

Weight

If you're overweight, you're far more likely to develop diabetes than that fit friend of yours who sits next to you at work. The presence of fat cells interferes with the body's ability to use insulin. Excess fat stored in cells means excess free fatty acids are circulating in the blood. This causes the liver to make too much glucose and cells to become less sensitive to insulin. It's a circular relationship: being overweight dramatically increases the risk of insulin resistance, and insulin resistance seems to trigger the body into storing more fat and gaining weight. The debate continues as to which comes first!

It is no coincidence that the rate of diabetes is skyrocketing at the same time our nation faces an obesity epidemic. Fat and diabetes go together like . . . bad and worse.

If you've got a lot of weight to lose, don't freak out. I've been where you are. Don't get hung up on the big number. You don't have to lose fifty pounds, or one hundred pounds, or two hundred pounds. You have to lose one pound at a time. That's how we all do it, no matter how many total pounds we want or need to drop. The good news is that your risk of diabetes will start dropping as soon as you start to lose even a very moder-

ate amount of weight. For me, I probably was prediabetic all through my thirties, and possibly even in my late twenties. Remember, I didn't take my diagnosis seriously until I was in my early forties. I will thank God that I've done so well, but I also realize that I should have reacted sooner, given the fact that my mother died at forty-one.

Apples versus pears: Does shape matter?

You probably know all about the apple- and pear-shape thing. Apples are people who carry extra weight around their middles and upper bodies. Apples have bellies, flappy arms, big boobs. Apples, I am one of you. Pears are people whose weight settles in their lower bodies: think hips and butts. Pears may carry a lot of luggage behind them, but they have waists. Apples? We are the great waist-less masses, and we are typically those who are either prediabetic or diabetic.

In recent years, we've heard a lot about how where you store fat on your body matters. Torso fat is considered to be more dangerous than other types of fat and puts you at greater risk for a number of health problems, including diabetes. So what's the skinny on this fat situation? If you're concerned about how your weight is affecting your health, it's not actually your bottom that matters most . . . it's your belly. Another way to think about the weight issue is this: it's not just how much you weigh, but the shape of your waistline that matters. Belly fat is more detrimental to your health than fat carried in other places because fat in this area is metabolically more active. This makes this type of fat more easily broken down into free fatty acids that enter the bloodstream, interfere with insulin functioning, and raise blood sugar levels and triglyc-

erides. Together, these effects intensify insulin resistance and contribute to other negative impacts on your health, including high blood pressure and risk for heart attack.

Poor diet

You probably don't want to hear this again, but I need to tell you it again: A poor diet is closely linked to why your weight is triggering or causing your diabetes. Eating a high-sugar, high-fat, high-starch diet will put you at greater risk for diabetes because of how these foods set off the pancreas to produce more insulin more frequently, resulting in insulin insensitivity (insulin resistance) and too much excess insulin floating around in the blood, which causes storage of fat—the endless circle described before. There's no getting around it. A poor diet is also a recipe for obesity—especially when combined with low levels of physical activity.

I spent the first forty years of my life eating poorly, meaning I ate the wrong foods and I ate too much of everything. I will spend the next forty years of my life—*God willing*—eating in a way that makes me feel good, which means keeping my weight down and diabetes at bay. As you will soon see, eating in this healthy way tastes good, so don't be afraid that I'm about to take away all that you love in this world! No matter where you are on the diabetes spectrum—overweight, prediabetic, or a full-fledged diabetic—if you are consistently indulging in starchy carbs and fatty, sugary foods, you can radically improve your health and reduce your risk of diabetes by changing what you eat. And if you happen to be one of those people who can eat like Shrek and not gain weight? You're not off the hook, at least not when

it comes to diabetes. It's true that most people who are diagnosed with diabetes are overweight at the time of their diagnosis, but not all people are. Contrary to what some may believe, skinny diabetics are not mythological creatures. Adhering to a poor diet will increase your risk of diabetes even if you're not actually overweight: you may not have the fat around the middle, but a high-sugar, high-starch, low-fiber diet can cause chronic high blood sugar that can still lead to the precursors of cardiovascular disease, clots, inflammation, cancer, heart attack, stroke, and more.

Eating a high-fat diet can also set you up for prediabetes and diabetes. Fat hurts you in multiple ways. First, it damages the cells of the pancreas, so they have trouble getting the message to release insulin to start proper metabolism after you eat a meal. Second, fat reduces the ability of insulin to move glucose into the cells, worsening insulin resistance. Third, fat triggers the liver to let go of stored glucose into the blood, making blood sugar levels even higher. And finally, people who eat a constant diet of high-fat foods have chronically high levels of free fatty acids that not only interfere with blood sugar balance but also contribute to conditions such as heart disease.

Lack of exercise

Do you think walking instead of driving went out with the horse and carriage? Never laid eyes on a treadmill? Is your favorite workout the kickback—as in kicking back on the couch? I used to be you. I used to hate exercise. And guess what? My lack of physical activity contributed to my weight problem and eventually to my diabetes. Being sedentary takes away

the opportunity for your body to use the excess glucose; in other words, had I been exercising while I was eating so badly, I probably wouldn't have gotten so fat. My body would have been able to use the glucose through the exercise! Exercise enables glucose to enter the cells, especially those of muscles, and in this way acts like insulin. Exercise also makes the cells more sensitive to insulin—which means that exercise can help reverse insulin resistance. Now I'm using exercise to turn my diabetes around and reverse the insulin resistance that was created by years of not moving, except back and forth to the refrigerator.

Age

Yup—you guessed it: our risk of diabetes increases as we age. As our bodies get older, they naturally lose their ability to stay in metabolic balance. Our bodies are less efficient at using glucose and converting it into energy. Older adults also typically become less active, which, as I mentioned, means that there are fewer opportunities to convert the glucose into energy. What does this mean? We have to be even more careful of what we eat. I know, I know—what a pain in the butt. Rather than let go and treat yourself when you've earned the chance to relax, you actually need to become more mindful of what you put into your body and how much you move as you age. Here's another warning: a not-so-funny thing is happening today. The average age of diagnosis for diabetes is slipping . . . fast. As the number of diabetes cases rise, the age at which many people are starting to develop the disease is falling. The thirties and forties are prime time for prediabetes and diabetes, but if you're in your twenties you are not off the hook.

Bottom line: if you have any of the other risk factors for diabetes, your youthful age will not protect you against developing the disease.

High blood pressure and high cholesterol

These two conditions are just plain dangerous in their own right, as well as being signs you're at a higher risk for developing diabetes. When I was diagnosed, my cholesterol was a frightening number and my blood pressure was high enough that I was at risk for a stroke. Chronic high blood sugar triggers fat storage, fat that lines your blood vessels, which then increases your blood pressure and increases bad (LDL) cholesterol that clogs your vessels with plaque.

Both high blood pressure and high cholesterol are more common among people who are overweight, as well as among people who don't move much. The news gets worse: in addition to increasing your risk for developing diabetes, high cholesterol and high blood pressure can increase your risk of some of the very scary complications that go along with diabetes—heart disease, stroke, and cancer.

. .

METABOLIC SYNDROME, AKA "INSULIN RESISTANCE SYNDROME"

You've probably noticed that many risk factors for diabetes are also risk factors for other serious health problems. High blood pressure and high cholesterol put you at greater risk not only for diabetes but also for heart problems. So does being overweight and physically inactive.

Doctors have given this cluster of risk factors a name: metabolic syndrome. It's also known as insulin resistance syndrome. We don't need to fight about the names of these syndromes or why doctors keep making everything so confusing. All you need to remember is that there are two primary indicators for metabolic syndrome:

- Having extra weight around your middle—being an "apple"

- Showing signs of insulin resistance—determined through a blood glucose test, usually a blood glucose over 100 mg/dl

How is metabolic syndrome diagnosed?

- Glucose levels in the blood higher than 100 mg/dl
- A waist circumference of more than

 40 inches for men

 35 inches for women

- Reduced HDL (good cholesterol) of less than 40 mg/dl for men and less than 50 mg/dl for women

- Raised triglycerides (type of fat found in your blood) greater than 150 mg/dl

If you can say yes to two or three of these signs, you are considered to have metabolic syndrome. This is a way of saying you're at serious risk for diabetes, as well as heart disease and stroke.

. .

But the Good News Is . . .

Now I bet you are REALLY ready for some good news! All of these conditions (except aging) are reversible. You can lower

your blood pressure and your cholesterol by losing weight and exercising. What, did you think I was going to say fairy dust and wishing on stars? Sweat and vegetables, people, sweat and vegetables. Beans, whole grains, salmon, and cucumbers. And water, water, water. And more water. This is the recipe.

HEALTHY NUMBERS: HOW HIGH IS TOO HIGH?

It's important to know what levels we're shooting for when it comes to blood pressure and cholesterol. Maintaining blood pressure and cholesterol at these healthy levels can lower risk for diabetes and prediabetes, and help you keep your disease under control if you've already been diagnosed.

Healthy levels of cholesterol are:

LDL levels less than 100 mg/dl

HDL levels 60 mg/dl or higher

Triglycerides under 150 mg/dl

A healthy blood pressure reading is 130/80 or lower.

If your levels are higher than this, don't panic. Don't try to wish them away, or pretend they don't exist or don't matter. I've tried that route. I'm here to tell you it doesn't work.

Family Connection and Ethnicity

As was discussed earlier, there is a genetic component to diabetes. It's a disease that runs in families, which is why my

family tree is full of people who eventually wore only one shoe. Or worse. It's also a disease that is more prevalent among some ethnic and racial groups than others, which is why the mostly African American neighborhood where I grew up was like a hothouse for diabetes. African Americans are at nearly twice the risk for diabetes than non-Hispanic whites. More than 14 percent of African American adults in the United States are diabetic. African Americans aren't the only ethnic or racial group at higher risk. So are Hispanics, Native Americans, and Native Alaskans, as well as Southeast Asians, Indians, and Pacific Islanders. Although doctors, scientists, and researchers are not certain about the correlation between these ethnic groups and their propensity for prediabetes and diabetes, one researcher from the University of Michigan Medical School has proposed that all of these people and their cultures have an exaggerated response to insulin and a glucose-dense diet. Their ancestors may have had a "thrifty gene," which enabled them to go long periods of time on a limited diet and restricted calories. Jump ahead centuries, and these same genes may work against them in an environment with fatty, sugary foods so plentiful and available.

FAMILY MATTERS

Do you have a parent with diabetes? A brother or a sister? If someone in your immediate family has diabetes, you are at higher risk.

Prediabetes

I hope this is a no-brainer by now: a diagnosis of prediabetes is the single most important indicator that you're headed down the diabetes road.

What is prediabetes? It's a diagnosable condition that indicates the body is losing its ability to use insulin effectively and glucose levels in the body are higher than normal. If diabetes is the big show, then prediabetes is the band warming up. If you've been told you're prediabetic, learn from my mistakes. I used my "pre" time as a pretty desperate extension of my foolish, unhealthful life rather than using that time to make the changes to my diet and exercise habits while there was still time to avoid a full-on diabetes diagnosis. **If you've been diagnosed as prediabetic or if you're overweight, take this early warning and run with it . . .** straight to the gym and the produce aisle of your grocery store. I cannot stress this enough. Prediabetes is reversible. You have the power to change the course of your life and this disease. But you have to take action. Just knowing you're prediabetic isn't enough. Make the right changes to your habits now, and you can avoid membership in the diabetes club. Think of your prediabetes as a wake-up call: once you address your excess weight and start exercising, you can reverse your insulin resistance and get your blood sugar under control and in balance. By keeping your insulin resistance at bay you can eradicate your prediabetes condition, which may help you avoid diabetes altogether. Sound like a plan?

Okay, overweight people, you folks who splurge on dessert and skimp on exercise, who consider buttery mashed potatoes to be a proper vegetable serving and anything leafy and green

to be part of a sinister plot to destroy the world. Yeah, I'm looking at you.

You need to listen up *right now*.

Here's the tricky thing: prediabetes often doesn't come with symptoms. You can be prediabetic for years and not even know it. All the while, your body is becoming less able to use insulin, glucose is increasingly trapped in your bloodstream and in the fat cells of your body, and you're headed toward full-on diabetes. You're likely to be overweight if you're prediabetic. You probably experience fatigue pretty regularly, especially later in the day. It may feel as though you just run out of energy before your day is through.

This is why it's so important to deal with your risk factors: your weight, your diet, your activity level. This is also why you take a big risk by avoiding doctor visits. You're hearing this from a former master at putting off going to the doctor. Other than when I was trying to get pregnant and then was pregnant, I managed to avoid regular checkups for years. No more. These days, I practically stalk my doc. She's probably at home right now considering whether to change her phone number.

THE BASICS OF PREDIABETES

Type 2 diabetes doesn't occur in the body overnight. It's a disease that develops over time. Approximately 79 million people in the United States are prediabetic.

Prediabetes is defined as:

Fasting glucose between 100 and 125 mg/dl

Oral glucose tolerance between 140 and 199 mg/dl

A1C between 5.7 and 6.4 percent

Prediabetics will most likely go on to develop diabetes, if the underlying causes—namely the body's growing inability to use insulin—aren't addressed. This can typically take anywhere from one to ten years. It took me almost ten—talk about pushing the envelope.

WHAT MAKES A DIABETIC?

Diabetes is created by the body's inability to use insulin to move glucose—fuel—into our cells. The measurement of diabetes is done by measuring levels of glucose in the bloodstream. Remember, when insulin can't effectively unlock cells to allow glucose to enter, glucose gets trapped in our blood. This is what we mean when we talk about "high blood sugar." Once blood sugar rises to a certain level, we're considered diabetic.

To be diagnosed with diabetes, you must have:

Fasting glucose of 126 mg/dl or higher

A1C of 6.5 percent or higher

Overnight glucose of 200 mg/dl or higher

HOW HIGH IS YOUR RISK? A DIABETES RISK FACTOR QUIZ

Ask yourself the following questions; the more yes answers you give, the higher your risk of developing diabetes.

Are you overweight?

Do you have a parent or sibling with diabetes?

Does one or more of the following ethnic/ racial identities apply to you?

African American

Hispanic

Indian

Native Alaskan

Native American

Pacific Islander

Southeast Asian

Do you have blood pressure above 130/80?

Has your doctor told you that you are prediabetic?

Has your doctor diagnosed you with metabolic disorder (metabolic syndrome)?

Are you over forty years old?

Did you have gestational diabetes during your pregnancy?

Did you give birth to a baby who weighed more than nine pounds at birth?

Are you mostly sedentary and exercise rarely or not at all?

Source: National Institutes of Health

http://diabetes.niddk.nih.gov/dm/pubs/riskfortype2/

. .

Understanding Your Symptoms

After I was diagnosed as prediabetic, I did exactly what you should not do. I took it as a license to keep on keepin' on. Keep on stuffing myself with fatty, sugary foods, avoiding exercise,

and pretending that prediabetes didn't mean I was already getting sick. I was well on my way toward the Big D.

Then the symptoms started. That next year was full of signs that I was quickly on my way to dropping the "pre" from my status. My toes tingled. My fingers and feet felt numb sometimes. I felt tired. I found myself rubbing my eyes, trying to correct my suddenly blurry vision. All of these symptoms would come and go, which allowed me to continue to pretend I wasn't getting sick. A symptom would appear and I would panic, get on my knees in prayer, and beg God: *Please, Lord, please don't let me be getting sick!* The symptom would go away, eventually. (Not because God did anything about it. I know he was shaking his head at me this whole time.)

The symptom would go away because that's what diabetes symptoms do sometimes, especially at first. They come and go. Mine would come and I'd freak out. They'd go and I'd grab a bag of Cheetos to celebrate. I'm not kidding.

But they got worse. I started feeling thirsty—really thirsty, and a lot. I felt like I had to pee all the time. That was when I knew things weren't okay. As I mentioned, my sister Lori had already been diagnosed with diabetes at this point, and I knew these particular symptoms were her telltale sign. Pretending just wasn't going to cut it anymore. Trembling, I made the appointment with my doctor.

Tests confirmed what I already knew: I was diabetic.

Normal glucose is under 100 mg/dl. Mine was 294. I also had high cholesterol and high blood pressure.

I know how scary these symptoms can be. I remember what it felt like to dread the onset of tingling feet and blurry vision.

If you're experiencing any of these symptoms, call your doc-

tor. If you don't have a doctor, get a recommendation from a friend or a coworker, or head to a local clinic as a place to start. Action is the key. You can work through the fear, remember?

SYMPTOMS OF DIABETES

Blurry vision

Fatigue

Frequent urination

Infections of bladder, kidney, skin: frequent and slow to heal

Tingling in fingers and toes

If you have any of these symptoms, get to your doctor. Pronto. If you're overweight or obese, prediabetic, or otherwise at risk for diabetes, then you have a golden opportunity to change your habits to improve your health and avoid the dire consequences of diabetes. My point is, DO NOT WAIT until you have symptoms to address issues with your health and lifestyle that might be pushing you in diabetes' direction. If you take control now, you can spare yourself a lot of what I and millions of other diabetics go through.

I could have dealt with my impending diabetes while it was still just that—impending. Instead, I put on blinders until I ran right into the Big D. Make no mistake: there is no turning back once you've crossed the line from prediabetic to diabetic. You can do so much to manage your disease, and you can live a long and healthy life as a diabetic. But you can't make it go away altogether. Diabetes and I are together forever, now.

I hope to be married to my sweet hubby for the rest of my life. Trust me; I'm working my tail off every day to make that happen. But whether or not Sal and I are together for the next fifty years—during which time I will drive him nonstop crazy by never putting my clothes away in a dresser like a proper adult, and he will make me consistently nuts by talking during *Law & Order* reruns—I know I will be dealing with diabetes until the day I die. This is one relationship I don't have a choice but to stick with, for the duration. I am forever wedded to my diabetes, my son, and my darling Sal.

Living with Diabetes

So you're diabetic. I know firsthand how hard it is to hear those words. And overwhelming. It can send you into a real tailspin if you let it. It did to me, at least for a while. The very best thing you can do for yourself is decide to take charge. Don't worry about becoming an expert all at once. That's too much darn pressure. Take it from me: little changes can lead to big results. And the more you learn, the more you'll want to learn so that you can be well equipped to fight the good fight.

The good news is there is a world of information and support out there for you to take advantage of, and all you have to be is willing.

Testing, testing

Taking regular readings of your blood sugar is a fundamental part of managing your diabetes well. So of course I didn't do it at first! In my deeply foolish quest to avoid dealing with my diabetes like an adult, I put off testing my blood for several

months—seven, to be exact. I was freaked out. I convinced myself that I could manage my blood sugar levels "by feel." Who did I think I was, *David Blaine?* Of course it's important to pay attention to how your body is feeling and how different foods make you feel. But that doesn't give you a hall pass from regular testing. You have to track and manage your blood sugar. There's no magic that can do this for you, no sixth sense that will replace the value of getting that number.

I spent the first several months after my diabetes diagnosis living alone in New York City, working during the week on *The View*, and flying back to LA on weekends to see Jeffrey. When I was alone, it was somehow easier for me to kid myself about the foolishness of not testing my blood sugar. It was when Jeffrey moved to New York with me for good that the kidding stopped. I was the grown-up, the parent responsible for this little boy's well-being. I knew there could be no more messing around. I finally found the guts and good sense to start testing my blood sugar as my doctor had instructed me to do. Once again, my son gave me the motivation to push beyond my fear. Learn from my wayward ways! Test just as often as your doctor instructs you to.

After I began checking my levels, I'd do so twice a day—once in the morning and again in the evening. For about the last six months, I've been checking them once every couple of days—but I don't want to get complacent. It's always better to be safe rather than sorry. It's easy for diabetics to start feeling good because they are eating well and exercising, and then to start slacking off a bit. If you don't test yourself regularly, you may not know when your blood sugar levels start to creep up, and you'll have to hit reset right away. You will know what

I mean! When my blood sugar gets even the slightest bit too high I get real sleepy. If I don't pay attention and get it in check, then I get irritable and moody and can't sleep. Regular blood glucose tests are a great tool for helping us manage our blood sugar day to day, but if you're testing regularly you know that readings can fluctuate a lot. Food, exercise, stress, sleep—all sorts of factors can affect our blood sugar levels in a particular moment. That makes glucose meter readings great for daily, in-the-moment management of our diabetes— but not so great when we want to know the bigger picture.

Periodic testing with your doctor is another critical aspect of keeping your diabetes under control. The most common test is the A1C. This is a blood test your doctor will perform at your checkups. The A1C is a nifty test that actually measures the average of your blood glucose over an extended period of time. If your daily glucose meter readings are a snapshot of your blood sugar in the moment, then the A1C test is like a short documentary film that tells the story of your blood sugar over a period of several months.

How often you're tested will depend on your individual circumstances.

Keeping records

So here's one thing you probably didn't think about when you started thinking about the Big D in your life—that you'd have to start writing in a diary again. Yep. Just like when you were a teenager and you wrote about who you had a crush on. It is really important to buy yourself a journal and record your blood sugar, even if the glucose meter you use has a memory function. Having the readings written down gives you a visual

guide to how you are doing, and your journal is something you can show to your doctor.

I also make a point to record how certain foods I eat affect my blood sugar. That way, I'll think twice before I eat them again or eat them only on days when I know the rest of my diet has been on point.

I know this sounds like a lot to keep track of, and it is. I'm not going to lie. My brain is often like jelly. I consider myself lucky if I don't put my wig on backward. I could never keep track of all this information without writing it down. But taking a few minutes to jot down a few things is a small price to pay to Live Right, right?

HOW REGULAR TESTING HELPS

Self-testing with a glucose meter is a must-do for diabetics. It's safe, it's easy (I promise you!), and it gives you the most valuable, in-the-moment information about your blood glucose levels.

- Testing helps you learn how your body responds to different foods. This is especially helpful in the early days after diagnosis when you're just getting into the swing of eating to control your blood sugar. Over time, you'll become more familiar with how you react to different foods. Still, daily testing helps you keep your blood sugar in a healthy range and avoid complications down the road, such as problems with your eyes (blurry vision), kidney disease or deterioration, and damage to your nervous system, as well as all the other problems that we've talked about associated with chronic high blood sugar and insulin resistance.

- When you want to introduce a new food to your diet, you can test your blood sugar to see how your body

responds. Remember, we all react differently to food. It's not enough to know what a food generally does to blood sugar—you need to know how that food reacts in *your* body.

• You can test before exercise—especially if you're going to be working out hard. Testing before a workout lets you know whether your blood sugar is high enough, or if you need to eat something before you exercise to avoid your blood sugar dropping too low during or after your workout.

. .

It's not just about blood sugar

Keeping on top of your diabetes isn't just about monitoring your blood sugar. Sticking to a healthy routine of diet and exercise is probably the most important thing you can do on your own. We're going to be diving right into diet and exercise in the coming chapters, where I'll show you how I used them to lose weight and reverse my insulin resistance.

. .

OTHER IMPORTANT MARKERS OF YOUR HEALTH

These are tests and checks that should be performed regularly if you're diabetic:

High blood pressure

Cholesterol

Kidney function test (by analyzing creatinine in urine)

Eye exams

Foot check

. .

Medications

When you're diagnosed with diabetes, you may be put on medication. A lot of people are. I was. Of course I had to be dragged to the pharmacy to fill those prescriptions, but by now you already know I was the worst diabetes patient ever, until I made a choice to straighten up and fly right.

If you're on medication, follow your doctor's instructions. Together, you and your doctor will create a treatment plan that is right for you. Everyone is different. You need to do what's necessary to get your diabetes under control. This can mean something a little bit different for each of us.

Here's something that isn't different for everyone. Taking medication for diabetes is not a license to continue to eat poorly and avoid exercise. Even with medication, changing your diet and incorporating exercise are a critical part of getting diabetes under control, losing weight, and reversing your insulin resistance.

If you put the work in, eat well, and work up a little sweat every day, you may not need medication for your diabetes. How's that for some incentive? But this is a critical decision, and one that you must make with your doctor. That's exactly what happened to me.

Pill medication for type 2 diabetes

Many people who are newly diagnosed with diabetes are prescribed medication that is taken in pill form. There are three main types of pill medication for type 2 diabetes:

- Medication that helps the body create insulin (so the pancreas is not taxed to produce insulin, though this is not used for every patient suffering from type 2 diabetes—see below)

- Medication that makes insulin work better in the body
- Medications that lower blood glucose. These medications work in one of three ways, by:

 reducing the production of glucose.

 slowing or blocking the breakdown of foods that are high in sugars that create glucose.

 enhancing the body's own glucose-regulating ability.

These medications are sometimes prescribed in combination with one another, to target the body's insulin and glucose problem from multiple angles at once.

Insulin for type 2 diabetes

Sometimes type 2 diabetics require insulin to control their diabetes. If changes in their diets and the addition of an exercise program fail to lower their blood sugar levels, then these patients are usually started on one of the oral hypoglycemic medicines, which usually work. However, over time, most drugs begin to lose their effectiveness. When this happens, insulin therapy is recommended to improve insulin secretion and get blood sugar under control. This is not usually the case with newly diagnosed diabetics. These days, there are several methods for delivering insulin to the bloodstream, including syringes, insulin pills, and an insulin pump that delivers a steady dose of insulin constantly through a small catheter. Sometimes insulin and the pill medications discussed above are used together. It's nearly always the case these days that pill medications are the first option for controlling diabetes, and insulin might be used down the road if necessary to lower blood glucose.

It's Complicated: How Not Treating Your Diabetes Correctly Can Lead to Other Problems

My mom died from complications of her diabetes at the age of forty-one. That's younger than I am today. My mom was more than likely prediabetic for most of my childhood, but she wasn't diagnosed with full-blown diabetes and put on insulin until I was around twelve. I grew up looking at ketone sticks and needles. She died when I was only twenty-three.

My mom was always tired. She made more trips to the emergency room with dangerously low blood sugar, caused by misusing her insulin medication, than I could ever count. And eventually, her disease caught up to her. The complications of the diabetes that she'd carried for many years kicked in when she was in her late thirties. Her kidneys started to fail. She became seriously hypoglycemic. Her blood pressure sky-rocketed. She developed blurry vision. And she started to lose feeling in her feet. Her body was shutting down after years of soldiering on.

No one in the family really understood fully how much her eating behavior made her disease worse. When she fell into a coma and died, it wasn't until my sisters and I saw her death certificate that we realized how serious diabetes truly was. It read "death due to complications from diabetes."

She had never discussed her disease with us. She didn't even use the word *diabetes*; it was just "the sugar." Was my mom in denial about her disease? Probably. But I think a lot of

her mismanagement of diabetes was because she just wasn't informed about how eating certain foods and lack of exercise contributed to the disease.

Unfortunately, my mother never really had a handle on her disease or learned how to manage it. My mom didn't take care of herself as a diabetic; that much is clear. Oh, she did certain things: she checked her blood sugar and gave herself insulin shots. There were needles everywhere around the house when I was a kid. But she ate poorly. She was constantly snacking on sugary stuff. Her blood sugar was never under control. I think she just didn't know better.

I was twenty-three years old when my sisters and I gave the doctors permission to remove my mother from life support. I may have avoided the truth of my poor health and diabetes risk for many years afterward, but I never, ever forgot those last months and days of my mother's life. When I finally faced facts and accepted the serious reality of my disease, I had a very vivid picture of what lay ahead for me if I didn't turn things around. Complications wouldn't necessarily come right away. But if I didn't start taking my diabetes seriously and make the changes to my life that would help improve my health, those complications would come.

This is how diabetes works. The damage doesn't show up right away, or all at once. But without proper care—and that means both care from your doctors AND your own self-care every day—those complications WILL come.

When I'm tempted to skip a workout or binge on a plateful of cookies or even skip checking my blood sugar, I think about my mom. I think about how weak she was at the end, how much pain she endured. How hard it was for her to sleep and

get a break from that pain for even a few short hours. How frightened she was about what was happening to her. You know what else I think about? I think about myself at twenty-three years old. Playing at being an adult but still feeling like a kid inside. I needed my mom then, even if I would never have admitted it to her at the time. I think about myself at almost forty-six, now a mom, wishing my own mother were still around to talk mom stuff with me.

Then I think about my own son and how determined I am to spare him the pain of losing his mom before she's good and old.

Those cookies? They don't look so tempting anymore.

That early morning workout? Yeah, I can do that.

I don't want to face the painful, debilitating, life-threatening, and very real complications of diabetes. I don't want you to face them, either.

THE ALL-TOO-COMMON COMPLICATIONS FROM DIABETES

Left untreated or poorly managed, diabetes eventually leads to life-threatening complications. Research has shown that three out of five diabetics have at least one complication from their disease. This is why it's worth working hard to take care of yourself now and to keep up with it every day. Here are some of the most common complications from diabetes. Scary, right? I'm not gonna let these happen to me, and I don't want them to happen to you, either. Are you with me?

Eye Problems, Including Blindness
- Diabetes is the leading cause of blindness for adults ages twenty to seventy-four, due to high concentrations

of glucose that lead to cellular accumulation of
sorbitol, causing swelling and damage of tissues linked
to complications of eyes and nerves.

Kidney Problems
• Diabetes is also the leading cause of kidney failure,
due most often to glycosylation (or glycation), when
glucose damages proteins and interferes with kidney
functioning and may lead to eventual failure.

Nerve Damage
• As many as two-thirds of diabetics have some form
of nerve damage, caused by concentrations of both
sorbitol and glycosylation.

Poor Circulation
• Poor circulation is common among diabetics and can
lead eventually to amputations of toes, feet, and legs.
Elevated glucose increases production of free radicals,
associated with poor circulation and higher risk for
heart attack and stroke.

Just like every one of us has a unique response to the food
we eat, every diabetic is affected by the disease differently.
Educating myself about the facts and the basic science behind
diabetes was a critical step in taking control of my disease
and my overall health.

The most important thing I learned? That I had to take this
new knowledge and get to work applying it to my own body,
my own habits. Up next I'll show you how I did that, by de-
veloping a flexible, forgiving, reasonable plan for eating and
exercise that transformed my body, my outlook on food, and
my health.

• • •

You've got the facts. Now it's time to start using what you know to change your habits and your health.

Get out your dancing shoes. It's time to start working on some steps.

three

The Three Keys to Plan D

have a long history of failure when it comes to sticking to a
diet and exercise plan. From the time I was a teenager, I've
set out to eat like a movie starlet (newsflash: they don't eat
much) while *actually* eating like a longshoreman. Make that
two longshoremen. Make that two longshoremen who've been
held captive without food for days.

You get my drift? I am an eater. I really like food.

I've abandoned more diets than any sane person has even
started. Over the years, I've tried every weight-loss strategy
you can imagine, and they've all crashed and burned. Remem-
ber that liquid diet I told you about? Yes, a liquid diet is exactly
what it sounds like—all fluids, no solid foods. Oh, I dropped
weight. I dropped five dress sizes in a few short months. I
thought I had conquered my weight problem for good. There
was just one little, itty-bitty problem. I had lost that weight
without actually eating any real food. A liquid diet doesn't ex-
actly have a maintenance phase, you get me? At some point you
kind of have to start eating again, which I did. And when you
start eating again you gain that weight right back. Which I did,
too. Goodbye, size 2 jeans; hello, elastic waistband.

Another time I was on one of those packaged meal plan diets. You know the ones, where you can buy your breakfasts, lunches, dinners, treats, and snacks all reasonably portioned ready to go? Great idea—unless you're like I was and decide to eat a week's worth of desserts for dinner. Gee, I wonder why that diet failed.

And exercise? I was really good at gearing up for exercise. I was highly skilled at buying cute workout clothes. I could sign up for a spin class or a Pilates session or a new gym membership, no problem. *Show me where to sign! I'm great at this part!* Taking a big old marking pen to my calendar and blocking out time for a workout? I could schedule exercise like a pro. What I was really bad at was actually doing the exercising.

When it came time to work out, there was always something else that needed to happen first. I needed to fold that laundry. I needed to go over my script for my next shoot. I needed to kick back and watch *Oprah*. Oh yeah, and I most certainly needed to do *that* with a nice big bag of potato chips.

Coming to terms with my diabetes diagnosis meant I had to find a way to change my eating habits and incorporate exercise into my daily life. I did not, however, step instantly and gracefully into this new life. Heck, I'm still working out the kinks in my own routine. I don't binge like I used to, but I still have plenty of ups and downs with my eating. And I still manage to find ways to avoid exercise every now and then. But then I developed—for the first time in my life—a rock-solid foundation for healthy living. I developed this through a lot of trial and a lot of error. But now I have a framework for what I call Living Right, and I love it. I know how to live at a

healthy weight, to live with my diabetes under control, and to live with me controlling my food choices, instead of food cravings controlling me.

My plan is flexible. You don't have to take any food off your list entirely. You don't have to sign up for a pricey gym membership or log hours a day on a treadmill. You know that saying "Slow and steady wins the race"? That's how I approached these changes in my life.

And it works.

My plan works wherever you are on the spectrum: whether you need to lose weight or are in the danger zone of prediabetes and looking to turn things around. And, of course, it's a plan that works if, like me, you're a full-fledged, no-fooling diabetic. These are the three keys that I use to manage my weight, my diabetes, and my overall health.

No matter what your specific weight-loss goals may be, you'll use the same three keys. On my plan you will:

- Eat a low-glycemic diet full of nonstarchy vegetables, grains, fruits, lean protein, and healthy fats . . . with a few indulgences along the way!

- Make exercise a part of your daily life . . . and like it!

- Remake your relationship with food . . . and enjoy eating guilt-free!

The Three Keys to Plan D: How the Plan Works

This diet may not seem all that special or different. In some ways, it's not. One doctor I talked with told me, "Any diet can work . . . if you let it." That's the key. You've got to make the best choices *most* of the time. In Chapter 4, you'll get all the

details on the eating plan that has helped me lose weight and reverse my insulin resistance. This is a flexible way of approaching food, a realistic way of eating that keeps my blood sugar in balance.

The Plan D is a combination of three key ideas.

Key #1: Change the way you eat in *simple ways.*

This does not mean saying goodbye to all your favorite foods; it means eating much, much less of them, and learning to combine the good foods with your favorite foods in the right ways. When you pay attention to food in these two ways, you can balance your blood sugar, reset your body's ability to respond to insulin so it can actually process the glucose, and lose the fat that is making you so sick. One of the worst things you can do is let yourself get too hungry . . . or crazy! (As you'll soon see, *forgiveness* is a huge part of my plan, too!)

This first step to changing the way you eat means clearing out your fridge and cupboards and starting from scratch. No more fried food (*sniff—I'll miss you, fried chicken*), no more soda (*Pepsi, you had me at hello . . . and now it's goodbye*), and sayonara to super-sweet desserts (*chocolate cake—I thought we'd have more time together!*).

This new lifestyle has taught me many things. What they say about beans is true: they taste good, fill you up, and take things out of the body in ways that leave you feeling light and balanced. I've also learned that our taste buds can change. Before I began this journey, I'd have told you that my taste buds were permanently attracted to ribs and pizza. That love for cinnamon buns was genetically coded onto my tongue. I would have been wrong.

After eating my new, healthful foods for a while, I've actually developed a taste for vegetables and whole grains. I love to sit down to a meal that has vegetables as the star attraction with a small side of grilled chicken in a minor role. I can't tell you I'm dreaming about quinoa just yet, but stay tuned!

Temptation for bad-for-you foods truly does diminish when you just don't eat them regularly. On the other hand, you will develop tastes for new foods that actually nourish your body and keep you healthy.

. .

A QUICK OVERVIEW OF HOW TO EAT ON PLAN D

1. **Watch the white sugar.**

 White or refined sugar is in everything—from soda to sweets to packaged TV dinners to ketchup to breakfast cereals to candy, cookies, and cakes. Do you crave sweets? That's likely because you're used to getting a slow drip of it in foods you may not even realize contain sugar. Craving sweets is also a classic characteristic for those of us with type 2 diabetes; one of the key things you're going to do on Plan D is get rid of these cravings when you balance your blood sugar. Wouldn't it be nice not to sit around obsessing about sugar?

2. **Watch the starchy carbs.**

 This means any carbohydrate that does not contain much fiber—potatoes, bread, pasta, baked goods, more bread, and did I mention the bread? Yeah—you really have to watch the bread! Carbs without fiber are just as bad for your blood sugar as white sugar.

3. **Eat lots of veggies!**

 These green, yellow, and red lovelies will make your body happy and help you manage your insulin and

your blood sugar (more on how all that works in a bit!).

4. **Add whole grains.**

 Don't go for the white bread, crackers, rolls, or bagels. When you want a sandwich or some cereal, discover some of the new grains that are so tasty and good for you and your blood sugar—millet, amaranth, or quinoa. One of my new breakfast favorites is a slice of toasted Ezekiel bread!

5. **Eat moderate amounts of lean protein.**

 That means chicken, pork chops, fish, shellfish, beans, and other legumes (that's a French word you're going to get to know real well). You can occasionally have red meat, but because it's loaded with fat and fat worsens the insulin resistance behind your type 2 diabetes (among other problems), you need to eat red meat in very limited amounts.

6. **Eat moderate amounts of fruit.**

 Yes, fruit is good for you and it's not candy—it's nutritious and contains fiber. But it does have sugar, so we diabetics need to watch the kinds of fruit we eat.

. .

Key #2: Make daily exercise your goal.

I can practically hear you sighing.

I get you. I was right there where you are now.

I'm being honest when I say that before the Big D, exercise was a word and a concept I didn't even understand, except for maybe the occasional run through the shoe department to grab a pair of slingbacks on sale. My diabetes diagnosis changed that. For the first time in my life, I *had* to move.

In the beginning, the only thing I could do was go to the gym. I mean literally, it was all I could do to just make an

appearance in the lobby. You think I'm kidding? I'm not. I would haul my big body over to the gym and march through those glossy doors. Then I'd just about bolt right back out those doors, except for a quick stop to get a pick-me-up drink. Gradually, once I committed to changing the way I lived, it took me about two weeks to move past the juice bar and onto the treadmill (it took me about three days of trying) . . . where I would walk for fifteen minutes. If my trainer asked me to do sixteen, I'd say *no way*. Fifteen. That's it. I was not, shall we say, a cooperative client.

But do you have to get a trainer or join a gym in order to lose weight and get your diabetes under control? *No, you do not!*

Exercise is not rocket science. It doesn't have to happen in any one particular place and sure doesn't require a room full of folks telling you what to do and how to do it perfectly. It's all about doing *something*. This can be an organized something, like going to the gym. But it doesn't have to be.

I'm a working mom with a busy job. I get to the gym when I can, but I don't have time to be one of those "gym people." Now, I have figured out a way to work out at home, in a hotel, or at my gym. I fit in walking on a treadmill, doing the elliptical, or walking around the park with small arm exercises for strength training and some sit-ups for core strengthening. When I travel, I bring a jump rope with me. And when I do go to the gym, I now actually go to the workout room, not just the place where they sell food.

The bottom line is that you've got to move. You don't have to move a lot at first. You can start with fifteen minutes of cardio—any kind—three times a week. Then bump it up to twenty minutes. Add a day. Work your way to thirty minutes, three times a week, then four. If the treadmill and the elliptical trainer at the

gym don't work for you, get outside. Walk to the park and back. Walk around your neighborhood. Borrow your neighbor's dog and walk that puppy till he's ready for a nap!

And don't forget to make it fun: wrestling with your kids, dancing with your husband, getting down and dirty in your garden, even walking around a big mall or superstore—these activities count. The goal behind this part of my plan is to be physically active, in some way, every day. Spreading out exercise in this way is the healthiest option: studies show that moderate and even small amounts of daily exercise are an important key to long-term health. Doing a bit of exercising every day also means you don't have to spend hours at the gym to make up for a week's worth of lounging around. Doing that is also not all that effective. You get a great workout that day, but you tire yourself out so much that most likely that will be the only exercise you do for days. Kind of counterproductive, isn't it? There are so many options for small amounts of moderate exercise—most of which don't involve a gym or equipment— that you can develop a workout routine that fits your life (you will find great suggestions that work for you—whether you are single, have a partner, or prefer group activities—in Chapter 5). Variety and commitment are key to sticking with it.

Regular exercise will not only help manage your diabetes or beat your prediabetes, it will also improve your memory, your mood, and your energy level. You will feel more clear-headed and cheery, and have less appetite for your old trigger foods that bring you down. Exercise is a win-win!

Key # 3: Renovate your relationship to food.

The way I live my life with the Big D isn't totally perfect. I'm not a saint, and you shouldn't try to be. Sometimes carby

goodness calls my name. Sometimes there's a birthday party and the homemade cake just beckons. I can't say no all the time; no one can. My plan does not require *anyone* to be perfect. Perfect and I don't share the same universe. This program focuses on hitting your marks *most of the time* and understanding *why* you're deviating from the plan when you make that choice.

How do I do this in my life? I use a system I've created for myself called the **Sherri Steps**. This process is what I came up with when I finally faced the reality of my diabetes diagnosis head-on. I knew that something about the way I thought and felt about food had to change if I was really going to stick to eating right, not just dieting to lose weight. These steps are my way of walking myself through the pros and cons of what I'm about to eat. I'll talk you through how I use these steps to help me, and I'll help you make them your own. And, sure, you can keep calling them the Sherri Steps—but as far as I'm concerned, heck, name them after your cat or your kid, call them after Santa Claus or Derek Jeter. Whatever works for you. This flexibility and freedom are very important to renovating your relationship with food.

What is important is for you to identify the steps *you* need to take control of your eating choices. That way, *in the moment* you can make reasonable, healthful choices about what to eat . . . and what you should try to avoid eating. In Chapter 6, I'll share with you how I came to understand the importance of my relationship to food and how you can create your own steps to help you manage your emotional reactions to food and temptation. For now, here's a quick preview of how the Sherri Steps work:

When you find yourself craving a food that you know won't

help you in your goal of losing weight or managing your blood sugar, ask yourself the following:

How will it feel to eat this?

Why do I want to eat this?

How will this food make me feel *after* I've eaten it?

What will this food enable me to do?

What will this food *prevent* me from doing?

Can my body handle this food today, *right now*?

Taking the time to think about what I am putting into my mouth allows me to slow down and make a decision. It is okay if the decision is, sometimes, to eat that cake. Like I said, no one is perfect. But if I do take the time to talk myself through these questions, then I own my decision, I know I'll have to tone it down the rest of the day, and I'll enjoy that little bit of something guilt-free. The best part is that, most of the time, slowing down and thinking about what I'm eating makes me choose to eat LESS. Fancy that.

These three keys—a healthy, low-glycemic diet; regular exercise; and a new relationship to food—are the fundamental building blocks of my daily health regimen now. These keys are what help me live with the Big D. These keys are the building blocks of Plan D. They are the reason that I felt fit, healthy, and confident enough to wiggle into a slinky ballroom-dancing costume and shake my maracas for the world to see on national television. They are the reason at forty-five I look and feel better than I ever imagined I could, diabetes or no diabetes.

Making the Commitment to Change

When I think about the things in my life that mean the most to me, I realize they are all built on deep commitments. My relationship to God. My marriage and my family. My career. I can now add my health to that list, which feels really good.

No matter where you are on the path toward diabetes—whether you're overweight and worried about what's to come, or prediabetic and hoping to stop the march toward the big D, or you've arrived, like I did, at a diagnosis of diabetes—the whole process of change begins with a decision, a decision to commit to reclaiming your health. Like a lot of your other most meaningful commitments, this is one that will last your lifetime.

Think about the things in your life that matter to you and the commitments you've made to nurture them. Maybe it's your relationships with your children or your partner, your parents or your friends. Maybe it's your job, or the volunteer work you do to help others in your community. Maybe it's your pets, those furry creatures that you love like family. Make a list of these commitments. Look hard at that list and think about what these commitments mean to you—what kind of effort you put into them and what rewards you receive in return.

Now ask yourself: Does my health have a place on this list? Is my long-term survival important enough to commit myself to it? I don't know you personally, but I'm telling you this friend to friend: the answer is yes.

Remember, when you commit to Plan D you're not committing to doing everything right all the time. Making a commit-

ment to your health is not a commitment to being flawless or executing this plan perfectly. You're not committing to never feeling scared or lost or worried that you don't have what it takes. I feel those things every day.

You're committing to sticking with it. You're committing to waking up every day and doing your best to follow these three keys, and to being gentle with yourself when you stray from them. You're also committing to keep going even when it doesn't feel easy or convenient.

Stand up and say it: this is important. Shout it to the rooftops. Climb a mountain—or the nearest set of stairs—and yell it to the sky: I will take care of myself. I do value my life enough to change my habits.

Down to Business: Getting Focused

Making the mental and emotional commitment to change is a huge step. But it's just the first step. Making changes to your eating and exercise habits and having those changes really take root in your life takes focus.

I've been known to have the attention span of a gnat. And I may be being unfair to the insect community with this comparison. But you know what? When I've made a commitment to something, my ability to focus really snaps to it, in ways I haven't always given myself enough credit for. Since my very first, nervous days as a novice actor, I've always showed up on set with my lines learned cold. I would never even consider stepping out onto the *View* stage without preparing for my interviews with that day's guests or without reading up on the news for our "Hot Topics" discussion. I never forget a friend's birthday. I remember the stories my husband tells me about

issues he's having at his work—and I remember to ask him about them. I pray every day. Even if the f-word—and by that I mean "flighty"—is one that's been attached to your name at some point, I'll bet, like me, you're a lot better at hunkering down and paying consistent attention than you think.

We focus on what matters to us. These changes must matter to you. It's time to elevate your health to the level of importance where it deserves—and gets—your focus. Here are a few of the strategies that helped me get there.

Accept that this is a project that is going to take time.

Especially in the beginning, when these changes are new and feel unfamiliar, working on the three keys is going to require your energy and your attention. Waiting for a convenient time to pay attention to your diet and exercise isn't going to cut it. Be prepared to carve out time every day for exercise, for shopping for food and preparing meals. It's also important to make time to reflect on how you're feeling, whether that means writing in a journal or making a mental review of your day. Is taking on this plan going to shake up your status quo? You bet. Is it worth it? Oh yes.

Simplify your schedule.

Let's face it, unless you're curing cancer in your spare time or using your lunch break to split the atom, you've probably got some pockets of time that could be put to use. Look for opportunities to declutter your daily routine and how you can use that time toward making progress with your Plan D. When I first began implementing my Plan D keys, I changed

my morning routine by not turning on the television as soon as I got out of bed. The peace and quiet gave me time to focus on preparing my meals for the day and also to reflect on the other healthy choices I wanted to make for myself.

I love technology and social media, and I used to pop on and off my computer all day long. Too many times I'd make plans to go to the gym and wind up hunched over texting or talking on the phone instead. So I made an adjustment to my schedule. Rather than checking my Twitter feed and Facebook page ninety times a day, I set aside time in the morning, midday, and evening to get my Internet fix. This helped me free up time to follow through with my exercise plans.

Do something first thing in the morning.

I wake up every morning and set my attention to my commitment to living healthfully. On some mornings, that means heading to the gym right away. Other mornings, I write in my journal or take a few moments while I'm making breakfast to visualize the day ahead. Beginning the day by putting your focus on one or more of your three keys can set the tone for the rest of your day.

Tackle one big thing at a time.

We're all starting in different places when we begin. Maybe you're someone who's already eating pretty healthfully and just needs to make some adjustments to things like portion control or cutting back on sweets. Maybe you're exercising a couple of times a week, and you're looking to build on that to improve your fitness. If that's the case, you may be able to concentrate on adjustments to your eating and exercise hab-

its at the same time, right from the start. But if you're like I was and you're starting basically from scratch with all this healthy living stuff? Well, in that case, you may want to start by focusing on one key at a time. Spend your first couple of weeks focused on food and don't worry about exercise. Give yourself time to concentrate on the new fundamentals of your diet, and make progress in identifying some of your issues and triggers related to food. After you've lived with your new eating routine for a few weeks, you can add exercise to the mix.

Remember, we're in this for the long haul. Changing all your habits overnight isn't the goal. The goal is to work these healthy changes into your life and make them stick.

Practice Makes Me Healthy

You know the saying "Practice makes perfect." Only here, perfect isn't our goal. Perfection is a lovely idea, but it's not realistic. Practice, though, is still an invaluable tool in your kit. Practice is what will take all of my suggestions and make them real for you, on your terms. Daily practice of these new habits is what will make your commitment and focus worth it.

The changes that you're making to your eating and your exercise routine, and to your relationship to food itself, aren't ones that you can think your way into—any more than you can think your way out of bad habits that you've lived with for so long. Time for reflection is critical, but thinking about making these changes is not the same as actually making them.

Here's something I know firsthand, having made these changes in my own life: sometimes, especially at first, they can feel . . . odd. Choosing to eat oatmeal instead of pancakes felt wrong and even kind of scary, to be truthful. Putting on

workout clothes instead of lingering in my pajamas made me nervous. We hang on to habits for any number of reasons, but one is that the familiar is reassuring. Changing habits as essential as the food we eat and the way we use our bodies? You're bound to experience discomfort—and I'm not just talking about sore glutes and tight hamstrings. I'm talking about feeling awkward, unsure, and afraid.

The simple truth is that the more we practice new behaviors, the more they feel familiar. And when we think about what we eat and make healthy food choices and exercise every day, day after day, the discomfort will disappear. Athletes talk about a concept called muscle memory. The idea is that the more you repeat a physical task, the easier it becomes. In a sense, the concept of muscle memory applies not just to physical activity but to any new habit you're trying to adopt. Just as your muscles will adjust and "remember" the routine of walking or running or cycling, your body and your mind will adapt to new foods, new choices, and new ways of thinking about your diet and your health.

When you start your day, don't think of it in terms of a day to succeed or fail. Think of the day ahead as an opportunity to practice these new habits, to practice making healthy choices, one choice at a time.

You Gotta Laugh

Remember those themes of my life—food, faith, and funny? After all of my ups and downs, they are still with me. Faith grounds me, lifts me up, and gives meaning and shape to my world. Food? Food used to be a crutch I leaned on, but today my relationship to food has changed fundamentally. I am proud to say that food nourishes me. Food sustains me, but it

no longer holds me captive. And funny? Funny is not just my livelihood—it's my lifeline in the trenches of daily life. Humor is never more useful than when you're dealing with really serious stuff. Every time I take on a new challenge, humor helps me through. *The View. Dancing with the Stars.* Motherhood, for goodness' sake. And yes, transforming my eating habits, my body, and my health. Learning to manage my diabetes— that's serious business. I couldn't have done it without laughter. And neither should you.

As you start working with the three keys, be sure to let yourself laugh. Find your own funny. When things get tough, that's when to look hardest for the humor in your situation, because that's when laughter can have its most transformative effect. It's awfully hard to hang on to tension or stress or anger once you've found something to laugh about.

Sharing humor helps, too. What's funny becomes funnier when you can tell a friend. I text my girlfriends stories of my daily foibles, and they laugh right along with me. At night when we're snuggled in bed, Sal and I share stories from our day, and we almost always end up giggling as we drift off to sleep.

· ·

FINDING YOUR SMILE

Here's a trick for when you're really stuck and you're having a hard time finding anything funny about your situation: just find something to smile about. It doesn't have to be something knee-slappingly hilarious. In truth, it doesn't have to be funny at all. It can be touching or sweet or plain old nice. The simple act of smiling can help you relax and breathe. It's a really effective way of hitting the reset button on your mood.

· ·

Implementing the Three Keys

It's all well and good to have a plan. But how do you stick to it? How do you put it into practice every day? This was always my biggest problem. I'd start big . . . and then I'd STOP big. This time around, I wanted to do things differently. No. I *needed* to do things differently. I had created my three basic components—my three keys—which helped me break down my goals into manageable steps. But even manageable steps can be abandoned, and I really didn't want to give up this time.

In Chapters 7 and 8, I'll talk in depth about two of the most important things that keep me going: motivation and forgiveness. Staying motivated over the long term and giving yourself a break for not being perfect: these used to be just concepts to me, and now they are part of my daily life.

four

Eating for Balance and Weight Loss: An Easy Plan

As you know by now, I'm a Chicago girl who grew up on the city's South Side, where we like our comfort food battered, fried, and piled high. Fried chicken, cheesy grits, thick and tangy coleslaw? This was a typical Sunday dinner. Sweet, sticky barbecue? It's in my blood. In my family, we loved food with a passion. A little too much passion. We ate sweet and spicy pork and beans cooked in lard, corn bread and butter, and sweet potato pie stacked high.

Those gatherings—whether it was a regular Sunday supper or a birthday party or a Fourth of July cookout—were about fun, celebration, and togetherness. I was with my people. I felt safe and loved. From my earliest childhood, I associated (mistakenly, I now know) those feelings with *food*. Food became my constant. My best friend. My steadfast companion. Whether I wanted to cry or to laugh, I turned to food.

And then a not-so-funny-thing happened. One by one, we got sick. First it was grandparents and great-aunties and -uncles, next our older cousins who lived around the block.

Diabetes was a way of life, a rite of passage, in my family and my community. Clearly something was catching in our neighborhood. When people got to a certain age, their eyes got fuzzy and sometimes they lost a limb. That was what happened when you got old, right? Then it was my mother who got sick. As I've told you, diabetes took her life at forty-one. Eventually, diabetes came for me and my two sisters, and all three of us have diabetes. And that food we loved, those meals that felt so celebratory and loving? Turns out *that way of eating* was killing us.

If you're anything like me, you may have spent a lot of years not thinking much about what you ate. Well, if you're really like me, you spent a lot of time daydreaming about what you wanted to be eating. I'd barely be done with breakfast before I was fantasizing about lunch. But I stubbornly refused to think about *what the food I was eating was doing to my body*.

Those days are over. These days, I think about everything I eat. That may sound dull and oppressive. Actually, it's just the opposite. Diabetes forced me to renovate the way I eat: I had to gut my kitchen, my taste buds, and the inside of my belly. Diabetes made me look at food for what it really is: *nourishment* for my body. Through lots of trial and error, I have finally found a way to be mindful about my eating *without* constantly obsessing, or weighing and measuring every bite. I eat less than I used to, and I eat very differently. But I enjoy food a whole heck of a lot more than I did back when I would plow through a plate of fried chicken and macaroni and cheese without a second thought. Doesn't that sound good?

You'll start this process by clearing out some of the worst offenders from your diet: starchy simple carbs, heavily pro-

cessed, sugar-laden snacks, turbo-sized meals full of fat, and soft drinks and not-so-soft drinks that are loaded with sugar. These are the foods that are making you sick, the foods that are slowing you down—*literally weighing you down*. I used to love 'em, you love 'em, but we're gonna have to get rid of those baddies and replace them with such good food that your cravings for everything sweet will disappear.

Next, you'll start introducing new foods to your daily eating. Fresh, fiber-rich fruits and vegetables, hearty whole grains, healthy fats and lean protein. Using these healthful ingredients and a handful of basic strategies will allow you to combine your foods well and at the right times, which will even out your blood sugar and help your body begin to use insulin effectively again.

This diet is not about deprivation! Whether you're here because you want to lose weight or because you're prediabetic or diabetic, you can't make real and lasting changes to your health if you're simply denying yourself. On Plan D, you're going to eat well, and you're going to taste and appreciate food in new ways. You're going to break the cycle of overeating and eating the wrong foods—the cycle that sends your blood sugar surging and crashing, that leaves you feeling constantly hungry. Most important, you're going to lose weight and learn how to manage your diabetes for the very long lifetime that awaits you.

Getting Started: One Step at a Time

Getting a diagnosis of diabetes is just frightening, there's no two ways about it. It can also be overwhelming. When I first got my diagnosis, I did not pay attention. I kept right on eating

the high-starch, loads-of-fat, sugar-laden diet I had always eaten. I didn't think about change. I was terrified of change. Change happened slowly, but I did get there.

Since you're reading this book, you've already started to change: you've taken a huge first step by becoming educated, one that took me years to take. What have you done? You've decided to confront your diabetes rather than avoid it. You've decided to learn about your disease rather than hide from it. You've decided to consider making changes to your diet and your life rather than doing the same thing and hoping for a different result. You are already light-years ahead of where I was.

Good for you.

Glycemic Index and Glycemic Load

Before we get into meals and exercise, we need to take a closer look at the glycemic scale. If you want to eat like me, you've got to understand how to use the glycemic values of different foods to create your own version of a daily eating plan that will protect and stabilize your blood sugar, help your body start to use insulin effectively again, and allow you to lose weight.

Measuring foods based on their glycemic values involves using a couple of different numbers: the glycemic index (GI) and the glycemic load (GL). The goal of the glycemic index and glycemic load is simple: to provide us a way to evaluate how a particular food will affect blood sugar and insulin. Together, they accomplish this by providing us with different types of information about the type and amount of carbohydrate in the foods we eat.

Glycemic index: What is it and how does it work?

The glycemic index is a measurement of how quickly a food will break down into glucose in the body, based on the type of carbohydrate that food contains. (Very low and no-carbohydrate foods, including meats, nuts, cheeses, and non-starchy vegetables like greens and spinach, aren't measured on the glycemic index.)

The faster the food moves through the digestion process and into the bloodstream as glucose, the higher its number on the glycemic index. Starchy and sugary foods that often are made from simple carbohydrates will break down quickly and deliver a rush of glucose to the blood. These are known as high-glycemic foods. Some of the foods at the high end of the glycemic scale are white bread, candy, and sugary drinks.

Low-glycemic foods, on the other hand, are typically made of more complex carbohydrates, are generally higher in fiber, and therefore are harder for the body to digest. Slower digestion means a more gradual release of glucose into the bloodstream. Low-glycemic foods keep our blood sugar steady-as-she-goes.

But wait. Some foods we know to be nutritious have higher GI levels than some decidedly not-good-for-you foods. Is it possible that a Snickers bar (GI=55) is actually better for you than a slice of watermelon (GI=74)? Nope.

And here's where the glycemic load comes into play. That and some of that good old-fashioned common sense.

Glycemic load

The glycemic index gives us some important information, but it doesn't tell us everything we need to know about how a particular food will affect our blood sugar. The glycemic *load* measures how much of the carbohydrate is actually consumed in a given serving of food. If the glycemic index measures the *quality* of carbohydrate in food (simple or complex, or somewhere in between), then glycemic load combines that information with a measurement of the *quantity* of carbohydrate in a serving of that same food.

So, a high GI food like watermelon is made up, in part, of a very fast-digesting carbohydrate, which earns it a value of 74 on the GI scale. But the amount of carbohydrate in a slice of watermelon is actually very low—watermelon is mostly water and also contains a significant amount of dietary fiber, as well as vitamins and minerals. The low overall presence of carbohydrate in watermelon means it has a GL value of only 4. Which means that you can enjoy watermelon in moderation. You can't eat it all day long, but it is part of a balanced diet.

That Snickers bar, on the other hand? Sure, it has a lower GI than watermelon. But take a look at its GL. It's 11, nearly three times as high as that slice of watermelon. That Snickers bar has a far greater concentration of carbohydrate per serving than the mostly-made-of-water watermelon. What's more, the Snickers bar is packed with fat, which doesn't register on the glycemic index. Remember, the glycemic index is only a ranking of how quickly carbohydrate-based foods break down in the body. It tells us nothing about fats and proteins.

Together, the GI and GL tell us *what kind of carb* we're eat-

ing (fast- or slow-digesting, or somewhere in the middle) and also *how much* of that carbohydrate we're getting in a serving (how carbohydrate-dense that particular food is). Together, the glycemic index and glycemic load give us a much more complete and accurate picture of how a food will likely affect our blood sugar.

Why use the glycemic index and glycemic load?

The glycemic scale is not the only way to create a diabetic and weight-loss-friendly diet. I considered several options when I was first putting together my own diet and exercise plan, talking with doctors and nutritionists to figure out what would work best for me and my body. I chose the glycemic scale because I can look up any food and find out its level—it's a fast, reliable way to get to know more about the foods I am eating.

The glycemic index and glycemic load aren't the only tools I use for my diet, far from it. I practice portion control, and I stay aware of the caloric value of the foods on my plate. I do my best to use good, old-fashioned common sense when it comes to what and how much I'm eating. What the glycemic scale offers me is a framework to make my food choices. It means I don't have to count individual carbs in an exchange program. I don't have to measure and weigh every food. I do measure some foods to make sure I'm not going overboard with my portions. By concentrating my eating on foods at the low end of the glycemic index and foods with a low to moderate glycemic load, I don't have to overthink.

Remember, we all respond to foods differently. The carbohydrate foods that work best for me may not work as well for

you. And you may be able to eat some foods that I just can't. By using the glycemic index and glycemic load as a starting point for selecting foods, and by testing your blood glucose regularly and on the schedule your doctor recommends, you'll be able to determine exactly what foods work for you—and which ones you need to avoid or limit.

. .

HOW TO USE THE GI AND GL

Scale is 1 to 100.

100 is glucose.

Low-glycemic foods are 55 or less.

Middle-glycemic foods are 56–69.

High-glycemic foods are 70 and higher.

Choose mostly low and mid-range GI and GL foods.

When you do eat a high GI food, add low GI foods to the meal. The combined effect will be to lower the overall glycemic impact of the meal you're eating.

. .

Factors that affect the glycemic index and glycemic load

Fat

The presence of fat in a cooked or processed food will affect that food's GI value, and also its GL. Fat in food lowers its glycemic values—but that doesn't mean it's more nutritious. So make sure you check any food's saturated fat content!

Fiber

Fiber also lowers the glycemic values of a food. But in this case, it's a good thing! Fiber slows digestion, and therefore

causes blood sugar and insulin levels to rise more slowly as well. Foods such as beans and whole grains, which are in the mid-range of the glycemic index and often have higher glycemic loads, are also full of slow-digesting fiber, as well as protein and other nutrients.

Age, or ripeness

The longer a fruit or vegetable sits on the counter or in the fridge, the riper it becomes—and the higher its glycemic index value. That spotty brown banana that cuts like butter into your cereal has a higher GI and GL than the firm, yellow-skinned one you brought home from the store at the beginning of the week.

Cooking times

Grains and pastas have GI and GL values that rise the longer they are cooked. A firm, al dente pasta or a chewy brown rice will register significantly lower glycemic values than a long-cooked batch of noodles or a pot of rice that's cooked practically to mush.

Processing and preparation

The more processed a food is away from its original state, the higher the glycemic values. Nobody's asking you to adopt a totally raw food diet—I don't eat that way, far from it. But fresh and raw foods do have their place on my plate, and it's an important one. Make sure you include plenty of raw and minimally processed foods in your daily diet. When you do this, you give yourself the license to also include smaller and less frequent servings of more heavily processed foods that you like—even a serving of those mashed potatoes now and then!

QUICK REVIEW: GLUCOSE IN THE BODY

During digestion, food turns to glucose in the body. Different foods break down at different speeds. The speed at which foods convert to glucose directly affects how much glucose enters the bloodstream and how quickly. Choosing foods that break down slowly—and avoiding foods that deliver a quick rush of glucose into our bloodstream—is critical to managing blood sugar levels and reversing the insulin resistance that is the cause of our diabetes. If you're prediabetic or overweight, switching to a low-glycemic diet can help you avoid the fat that is created when there's too much glucose and insulin in your system. This will help you lose weight and hopefully avoid diabetes altogether!

WHAT YOU CAN'T DO WITH THE GI AND GL

The glycemic index and glycemic load are great tools for managing your diet when you're working on lowering your blood sugar, improving your body's use of insulin, and losing weight. But the GI and GL can't do it all. You still need to think about your food choices. Here are some big stroke tips.

Choosing fat and proteins

The GI and GL are measurements of carbohydrates only. Carbohydrates are a big and critical part of our dietary picture—they have an immediate and direct effect on blood glucose. And they make up the majority of our daily diet, or close to it. But you need to keep in mind the basics of protein and fat—choose lean and low-fat options, keep

portions controlled and moderate—in order to create a fully balanced diet.

Evaluating restaurant, store-bought, and processed foods

Every food that is included on a list of glycemic values has been tested and ranked for its impact on blood sugar. GI and GL values can vary widely, even among simple, whole foods. This is even more the case with processed foods. One kind of potato chip is not exactly the same as another. A slice of pizza from a place at one end of the block will have a different GI than a slice from the pizza joint at the other end of the block. GI and GL values will differ by brand, by ingredients, and by preparation.

Measuring calories

The glycemic scale tells us nothing about the calories in our food. Low glycemic does not mean low calorie. While it's true that some of the very lowest glycemic foods are also very low in calories—think leafy greens and nonstarchy vegetables like spinach, broccoli, and cabbage—once you move up the scale a bit things change. Take apples and peanuts, for an example, which are both low-glycemic foods. Both have nutritional value and a place in a diabetic or weight-loss eating plan. Which one has a lower glycemic value? Peanuts (GI=14) have less than half the GI value of apples (GI=38). If you went by GI and GL values alone, you might think it was better to eat lots of peanuts and watch your apple intake. The truth is peanuts and peanut butter are nutritious high-protein foods that are very high in calories. Apples, on the other hand, are a high-fiber food that contains natural sugars and are low in calories. If you just used the GI scale, you might think it was okay to eat lots more peanut butter than apples. And you'd sink your diet, quick.

A Glycemic Ranking of Many Common Foods

BREADS, FLATBREADS, TORTILLAS	GLYCEMIC INDEX	GLYCEMIC LOAD
Corn bread, 1 slice	110	31
Baguette, 1 slice	95	15
Kaiser roll	73	12
White bread, 1 slice	73	10
Bagel	72	33
Wheat bread, 1 slice	70	8
Pita bread, white	57	10
Pita bread, wheat	56	8
Corn tortilla	52	12
Wheat tortilla	30	8

CEREALS	GLYCEMIC INDEX	GLYCEMIC LOAD
Corn Chex	83	21
Rice Krispies	82	22
Corn Flakes	81	21
Corn Pops	80	21
Cheerios	74	13
Raisin Bran	74	12
Special K	69	14
Instant oatmeal	65	17
Cooked oatmeal	58	6
All-Bran	42	4

CRACKERS	GLYCEMIC INDEX	GLYCEMIC LOAD
Rice crackers	78	17
Graham crackers	74	13
Soda crackers	74	12
Melba toasts	70	16
Wheat crackers	67	9
RyKrisp crackers	65	11

BAKED GOODS AND PASTRIES	GLYCEMIC INDEX	GLYCEMIC LOAD
Donut, glazed	76	24
Angel food cake	67	19
Croissant	67	17
Pancakes	66	17
Banana muffin	60	16
Bran muffin	60	14
Oatmeal cookie	54	9

Chocolate chip muffin	52	17
Blueberry muffin	50	15
Vanilla cake from box mix, frosted	42	24
Chocolate cake from box mix, frosted	38	20
Pound cake	38	9

GRAINS	GLYCEMIC INDEX	GLYCEMIC LOAD
Couscous	65	23
White rice	64	23
Brown rice	55	18
Quinoa	53	13
Bulgur	48	12
Barley	25	11

LEGUMES	GLYCEMIC INDEX	GLYCEMIC LOAD
Baked beans	48	7
Chickpeas, canned	42	9
Pinto beans	39	12
Lima beans	31	7
Black Beans	30	7
Lentils	29	5
Chickpeas	28	8
Kidney beans	27	7
Soy beans	18	1

PASTA AND NOODLES	GLYCEMIC INDEX	GLYCEMIC LOAD
Spaghetti, cooked 20 min.	64	27
Buckwheat noodles	59	25
Spaghetti, cooked 5 min.	38	18

VEGETABLES	GLYCEMIC INDEX	GLYCEMIC LOAD
Parsnip	97	12
Potato, baked	85	26
Beets, canned	64	10
Sweet potato	61	17
Corn on the cob	60	20
Potato, boiled	59	14
Peas	48	3
Carrot	47	3
Tomato	38	1

Off the Charts!

This list of vegetables looks pretty incomplete, doesn't it? I imagine you're wondering, where are all those colorful veggies that Sherri keeps blabbing on about? Good news: those veggies are so healthy and low in glucose-producing carbohydrates that they aren't even included on this list. Many of the most nutritious vegetables are so low in carbohydrates, they aren't included. These vegetables have very little impact on blood sugar and insulin levels, which makes them extremely valuable to us, eaten on their own and in combination with other, higher-carb foods and also proteins and fat.

These superstar veggies include:

Bell peppers

Broccoli

Cabbage

Cauliflower

Dark greens like kale, collards, and bok choy

Green beans

Leafy greens for salad

Mushrooms

Onions

Spinach

These low-carb, super-low-glycemic veggies are the superstars in my diet. I eat them daily and combine them with starchier, higher-glycemic vegetables as well as whole grains, beans, lean proteins, and healthy fats.

There are more fruits that are naturally higher in sugar—and therefore carbohydrates—so you'll see many more of your everyday fruits make the list.

FRUITS	GLYCEMIC INDEX	GLYCEMIC LOAD
Watermelon	72	4
Pineapple	66	12
Cantaloupe	65	8
Banana	51	13
Mango	51	13
Orange	45	5
Grapes	43	7
Strawberries	40	4
Apple	38	6
Prune	29	4
Peach	28	2
Pear	28	4
Plum	24	2
Cherries	22	4

CANNED FRUITS	GLYCEMIC INDEX	GLYCEMIC LOAD
Peaches in syrup	59	29
Fruit cocktail	55	20
Pears in juice	44	12

DRIED FRUITS	GLYCEMIC INDEX	GLYCEMIC LOAD
Dates	103	42
Raisins	64	28
Apricots	32	23

DAIRY	GLYCEMIC INDEX	GLYCEMIC LOAD
Whole milk	41	5
Yogurt, full-fat	36	6
Skim milk	32	4
Yogurt, low-fat w/fruit	27	7

SO, WHERE'S THE BEEF?

I was first introduced to the glycemic index by a nutritionist several years ago, not long after my diagnosis. I pretended to listen to her talk about the difference in glycemic values for barley and brown rice. I nodded my head earnestly as I scanned the pages, looking for my favorite foods. Snacky stuff. Eek, not good. Rich pastries. Erg. More bad news. I flipped pages one after the next, looking for meat. I wanted to know exactly how much pork I could eat on this new diet. Page after page, but no meat? What gives?

The glycemic index measures carbohydrates only. It's not a list for all foods, only foods that have enough carbohydrates to be measured and assigned a value. High-protein foods like meats, eggs, some dairy (including cheese), and many (but not all) nuts don't have enough carbohydrates to be included on the glycemic scale.

These foods play an important part in your diet. Lean proteins will make up between 20 and 30 percent of your daily consumption. And you'll combine proteins with food from the glycemic lists in order to create balanced meals and snacks. It's especially important to include protein when you are eating from the high end of the glycemic scale. Combining starchy, high-carbohydrate foods with protein lowers the overall carbohydrate load of your meal—which means slower digestion and slower release of glucose into your bloodstream. Good for your blood sugar and good for your waistline, too!

CANDY AND SWEET TREATS	GLYCEMIC INDEX	GLYCEMIC LOAD
Jelly beans	78	22
Snickers bar	68	23
Ice cream	62	7
Milky Way bar	62	26
Pudding	44	9
Peanut M&Ms	33	6

SWEETENERS	GLYCEMIC INDEX	GLYCEMIC LOAD
Honey, 2 tablespoons	69	15
Table sugar, 2 teaspoons	68	7
Jam	44	12

SNACK FOODS	GLYCEMIC INDEX	GLYCEMIC LOAD
Pretzels	83	16
Microwave popcorn	72	8
Corn chips	63	17
Potato chips	54	11

BEVERAGES	GLYCEMIC INDEX	GLYCEMIC LOAD
Cranberry juice cocktail	68	24
Cola	63	16
Orange juice	57	14
Grapefruit juice	48	11
Pineapple juice	46	15
Apple juice	41	12
Tomato juice	38	4

DIABETES 411:
THE GLYCEMIC INDEX

As part of changing your diet, you're getting acquainted with something called the glycemic index and how it relates to the blood sugar you are trying to manage. A few years ago, if you'd told me I'd be writing about the glycemic index, I'd have said you needed to put down the bottle. Then again, I never thought I'd be talking about the president's reelection chances with Barbara Walters

or debating the merits of the Patriot Act with Whoopi Goldberg. Life is nothing if not an endless surprise.

The glycemic index and glycemic load are tools we have that can help us know exactly what the food we're eating will do to our blood sugar once that food is in our system.

Everybody is different. My body is super-sensitive to pasta— even looking at it seems to make my blood sugar spike. But you may be less sensitive: you might be able to indulge in a small plate of penne now and then without triggering cravings. The best way to understand your body's sensitivity to high-glycemic foods is to look at the list, choose foods with a low or medium index, and pay attention to how you feel. If you do indulge in a high-glycemic food, make sure you note how that food makes you feel. For instance, some people who are prediabetic can eat sweet potatoes and yams without triggering a reaction; me—no way. My body is too sensitive to the natural sugar in sweet potatoes, despite its high fiber content.

Using the glycemic index and the glycemic load gives us a road map, a starting place from which we can evaluate how particular foods influence our individual systems.

Glycemic Index

The glycemic index is a ranking system for how quickly food breaks down in the body and converts to glucose (or blood sugar). High-glycemic foods are made of simple carbohydrates that break down quickly, flooding the bloodstream with glucose and causing blood sugar to rise quickly.

Low-glycemic foods, on the other hand, are typically made of more complex carbohydrates, are generally higher in fiber, and therefore are harder for the body to digest. Slower digestion means a more gradual release of glucose into the bloodstream. Low-glycemic foods keep our blood sugar steady-as-she-goes.

Glycemic Load

The glycemic index gives us some important information, but it doesn't tell us everything we need to know about how a particular food will affect our blood sugar. The glycemic *load* measures how much of the carbohydrate is actually consumed in a given serving of food. If the glycemic index measures the *quality* of carbohydrate in food (simple or complex, or somewhere in between), then glycemic load measures the *quantity* of carbohydrate in a serving of that same food. Together, they give us a much more complete and accurate picture of how a food will affect our blood sugar.

What does this mean for you? Try to:

- Eat heartily from the low-glycemic end of the food scale—paying attention to *both* glycemic index and glycemic load.

- Eat carefully from the middle range of the glycemic index and foods with a mid-range glycemic load.

- Eat sparingly from the list of foods that are high on the glycemic index and have a high glycemic load.

Foods You Will Be Avoiding
The crafty culprits: sugar, fat, and empty carbs

You don't have to remove these foods entirely from your diet, but you do need to shift your diet away from them. Rather than eating these foods every day, or even every week, make them an occasional indulgence, a small part of an otherwise high-fiber, low-fat, low-glycemic eating routine.

In my experience, it is darn near impossible to keep these

foods around and just eat less of them—at least at first. This is why I suggest cleaning out your cupboards and spending a couple of weeks without eating any of these foods. This will help you stop the cycle of cravings that keeps you going back to the cookie jar or the lasagna pan or the potato chip bag for serving after serving. It will also give your body time to adjust, since you'll be replacing these foods with lots of new ones, rich in fiber and nutrients. Think of it as hitting the reset button. Once you've reset your overall eating patterns, you can carefully reintroduce these foods in the small quantities and occasional servings that your body can handle, while keeping your blood sugar steady and losing weight.

Type 2 diabetes and prediabetes are both conditions that have food right at the bull's-eye. Those of us with diabetes, and those of you with prediabetes, cannot digest and process food in the way our bodies need. Rather than delivering the energy of food into our cells as fuel, the blood of a diabetic remains overwhelmed by glucose, or blood sugar. Excess glucose also gets stored as fat. Insulin is the human hormone that is supposed to manage the level of glucose in our bodies, by moving it from our blood to our cells, where it will be used as fuel. As diabetics, our bodies have lost the ability to use insulin effectively to move that glucose from our blood to our cells, where we can burn it for fuel. Our blood sugar levels rise, or "spike," and cause symptoms that range from uncomfortable—like sleepiness or excessive thirst—to life threatening—like a diabetic coma. Without foods that spike blood sugar, there is no type 2 diabetes.

The first step is to say goodbye to the foods that helped make you sick. Think of these foods as the two-faced mean girls you went to high school with. You thought they were your

friends—they kept you company when you were lonely, they comforted you when your boyfriend dumped you, they took your mind off things when you were stressed. Turns out, they were working against you, behind your back, the whole time.

I'm not going to tell you that you'll never eat these foods again. You will. But they will go from being a frequent part of your diet to a very occasional visitor. And at first, in order to break their hold on you, you're not going to eat them at all.

After you've stopped the cycle of cravings, you'll slowly re-introduce some of these foods into your eating routine. They'll no longer be center stage. Think of them as bit players. That's right; you're sending those mean-girl foods to the back of the pack.

What are these two-faced foods? They're foods laden with sugar, starchy carbohydrates, and saturated fat. They're heavily processed foods, like those in the junk food aisle at the supermarket—where your heart maybe skips a beat—and in those fast-food places where you've memorized the menu. Back in the day, I could have recited more than a few fast-food menus by heart!

You're probably going to see some favorites on this list. I'm here to tell you I get it. I loved these foods too—some of 'em, I still love. (T-bone steak with a side of au gratin potatoes, anyone?) I gave them up because they were hurting me and threatening my life. And I am here to testify that life can be just as good—even better—without these foods.

Fats—the bad ones

Foods high in saturated fat are dangerous for diabetics, and they make it difficult to keep your weight in a healthy range. Foods can be naturally high in saturated fat, like bacon. Oth-

erwise healthy foods also can be cooked in a high-fat environment, which can make them unhealthful. Take fish, for example. Fish is a lean protein that also contains fat—but the fat in fish is good for you! It's loaded with omega-3 fatty acids that support our brain and body functioning. But when you fry that piece of healthful white fish in a wide pool of butter or deep pot of oil, what was once a healthy meal becomes a no-no.

Processed foods can also be high in saturated fat—peanut butter, canola oil, donuts, tortillas, chips, nondairy dessert toppings, and any cream sauce slathered on your pasta. These scream: fat! So here's your no-good fat list.

Meats

Bacon

Beef, especially high-fat cuts like ribs, brisket, and, yes, hamburger

Lamb

Pork, high-fat cuts (lean pork is a great choice)

Sausage

Skin-on poultry

Dairy

Cream (heavy, light, whipped, all of it. I don't care if it's whipped on the wings of angels. Get rid of it!)

Full-fat cheese

Full-fat cottage cheese

Full-fat sour cream

Full-fat yogurt

Half-and-half

Ice cream

Whole milk

Fried foods

Deep-fried anything—including good-for-you
stuff like tofu and veggies

French fries (I know, this one is tough!)

Fried fish

Fried meat

High-fat snack foods (aka junk food!)

Chips: potato chips, tortilla chips

High-fat dip

Popcorn

Snack mixes

*(Just look at the label of anything in a package; if you see fat on
the list of ingredients, you can be sure it's a bad fat!)*

Fats for cooking

Butter

Canola oil

Crisco

Palm oil

Peanut oil

Fats in processed foods

Coconut oil

Hydrogenated vegetable oil

Palm kernel oil

Partially hydrogenated vegetable oil

(You'll find these unhealthful oils in straight-up junk food, like chips and fried goodies, err . . . baddies. But stay alert, because you will also find these oils in places you might not expect: supermarket baked goods, crackers, snack foods, and even cereals.)

. .

DIABETES 411

Trans fats. You might have heard a lot about these in the news lately. They're bad for everyone, diabetic or not. This type of fat, which is always a processed fat that does not occur in nature, is either a monounsaturated fat or a polyunsaturated fat. Because of their makeup, trans fats raise LDL (bad cholesterol) and lower HDL (good cholesterol) and are linked to heart disease. How do you spot a trans fat? Look for partially hydrogenated vegetable oil on the label of the packaged food you're considering. This is why it's so important to read labels—so you know exactly what you're eating and can avoid the foods that undermine your health, your weight loss, and your diabetes management. Want to know the easiest way to avoid these fats? Stop buying processed snacks and start making your own from simple, whole foods. In Chapters 9 and 10, I'll give you lots of suggestions for healthy and homemade snacks that can replace the junky and heavily processed foods that carry around these bad-for-you fats.

. .

Sugars

Sugar is *everywhere*, people, not just in the obvious places. Sugar is a major ingredient in so many of the sweet treats we love, of course. But once you start looking, you'll find sugar tucked into lots of places you might not expect: things like salad dressing, crackers, and canned foods. You don't have to stop eating sugar altogether. But you do need to limit your

sugar intake. And the best way to accomplish that is to know exactly when and how much you are consuming. My sugar mantra? Make it count! That means I avoid sugar most of the time, and I stay away from unnecessary sugars in foods that don't need them. (Salad dressing? Ketchup?) That way, I can indulge in a little bit of good, old-fashioned, down-home sweet stuff every now and then!

Drinks

Alcohol (a little red wine once in a while is okay, but if you are going to have a mixed drink, skip the sugary juices usually used)

Coffee drinks

Energy drinks

Fruit juice with added sugar

Fruit punch

Hi-C and other fruit-substitute drinks

Soda (even diet soda—yes, this has no "real sugar," but it's still going on the list of foods to avoid. I had a love affair with diet soda that finally ended and I've never felt better.)

"Fruity" Foods

Canned fruit in syrup

Fruit rolls/fruit leather

Jam, jelly preserves

Sweetened applesauce

Sweets

Cakes

Candy: hard candy, chocolate, candy bars

Coffee drinks

Cookies

Donuts and pastries

Ice cream

Pies

Sweet breads: think banana bread, zucchini bread

Syrup

Starchy carbohydrates: aka "The White Stuff"
Baked goods made with white flour

Bagels

Bread

Cakes

Cookies

Crackers

Muffins

Pie crusts

Rice—white or brown

White flour tortillas

Starchy vegetables

These starchy vegetables do have real nutrient value. You don't need to forsake them altogether. You just need to eat them in limited quantities and in combination with other, lower-glycemic veggies. Also, different types of these vegetables have different effects on your body. In the end, tune in

to how your body feels after having a small serving and see if you feel like you've triggered a rise in blood sugar.

Beets—beets are loaded with vitamins but are high in sugar; especially don't top them with marshmallow!

Carrots—carrots range in their glycemic index, depending a lot on how they are prepared. They do contain a lot of nutritional value, but when cooked or candied, they will spike your blood sugar!

Parsnips

Peas—the fresher and less cooked, the better.

Potatoes—new are better than Idaho, your classic baked potato.

Squash, including yellow squash, zucchini, acorn, and spaghetti squash

Sweet potatoes and yams—as I mentioned before, some diabetics can eat from this family, some of us cannot!

New Foods to Love: What You Will Be Eating

I may have changed my diet, but I haven't stopped loving food. Far from it. I used to eat so desperately and compulsively that I didn't really remember much about how that food tasted. Now the experience of eating for me is all about taste and texture, savoring and enjoying foods that nourish me, experimenting with new ingredients and flavors.

Healthy carbohydrates

I'm here to tell you that carbs are not all bad for you. Far from it. Certain carbs in large quantities—heavily processed, starchy carbs like breads, cakes, and cookies—are not good for you. They will perpetuate your weight problem and your diabetes.

But carbohydrates themselves are essential to our health. They're also enjoyable—and you can enjoy them without guilt or worry once you know to pick the right kind of carbohydrates. These "smart carbs" are rich in fiber, which slows digestion and ensures that blood sugar rises gradually. Crisp fresh fruits and vegetables, hearty whole grains, savory legumes—these healthy carbohydrates are also packed with nutrients. And remember, the longer it takes for food to break down in the body, the more gradually glucose is released into the bloodstream. These healthy carbohydrates do just that. Carbohydrates will make up 40 to 60 percent of your diet— they'll just need to be the right carbs.

Your friend *fiber*

What's the big deal with fiber? A lot, actually. Fiber is a diabetic's best friend.

High-fiber foods slow the digestion process, allowing carbohydrates to break down more slowly—that means a slower rise in blood sugar. Eating fiber-rich foods has been shown to reduce levels of "bad" LDL cholesterol because the fiber literally takes the fat out of the body. Over the long term, a high-fiber diet helps stabilize blood sugar levels by slowing down the release of insulin and aiding the absorption of nutrients the body needs. Fiber fills you up: you eat less, and what you eat gets used by the body more efficiently.

Healthy carbohydrates

*Fruit**

Berries

Blackberries

Blueberries

Raspberries

Strawberries

Citrus

Clementines

Grapefruits

Oranges

Tangerines

Other

100 percent fruit juice (in small quantities)

Apples

Kiwi

Low-sugar jams or preserves (in small quantities)

No-sugar-added applesauce

Pears

Note: Some fruits have more sugar than others and therefore may trigger your blood sugar more, including pineapple, bananas, papaya, mangoes, and other tropical fruits. When you enjoy these, try to pair the fruit with some protein to cut the sugar effect.

Beans

Black beans

Black-eyed peas

Kidney beans

Lentils

Soybeans

Split peas

Whole grains*

Amaranth

Barley

Bran

Bulgur wheat

Oats

Quinoa

Whole grain bread made from oats, rye, spelt, and whole wheat flours

> *All rice has a high glycemic index, even though long-grain brown rice is lowest in the category—so only eat moderate amounts of rice on the D Plan.*

Vegetables

Leafy greens

Chard

Collard greens

Kale

Lettuces

Spinach

Other

Avocado (high-fat, but good for you; keep portions small)

Bell peppers

Broccoli

Cauliflower

Celery

Cucumber

Mushrooms

Onions

Tomatoes

Lean protein

Protein converts slowly in the body to blood sugar. This means that it is easier for diabetics and prediabetics to transfer that glucose from our blood to our cells. Eating some protein with every meal is another way you'll keep your blood sugar in check while also losing weight. Protein-rich foods will make you feel full quickly, and so they are a great weight-loss tool. Plus, they keep you satisfied for a longer period of time, so you don't get hungry as quickly. As with carbs, the trick is to choose the right proteins. Because proteins are calorie-dense—and even lean protein has fat—it's also important to keep protein portions moderate. The good news is that there's a long list of lean, healthy proteins that you can make a part of your everyday eating. Lean protein will make up 20 to 30 percent of your diet.

Dairy

1 percent and skim milk (some people react sensitively to cow's milk on account of the sugar; you may also want to try lactose-free milk or almond milk, which tend to have less sugar)

Low-fat cottage cheese

Low-fat yogurt (no sugar added)

Nonfat half-and-half

Meat and animal proteins

Eggs

Fish

Pork, lean

Poultry (without the skin)

PROTEINS TO LIMIT OR AVOID

Full-fat dairy products

Heavily processed meats, including bacon, sausage, and corned beef

High-fat cuts of beef and pork

FATS TO LIMIT OR AVOID

Butter

Canola oil

Palm oil

Partially hydrogenated oils found in processed meals and snacks

Shortening

Good-for-you fats

Yes, fat is good for you! A fatty double cheeseburger is not good for you, but there's a whole world of healthy fats that are an important part of a balanced eating plan. These fats, like protein, help to balance the sugar effect of carbohydrates, as

well as support your immune system, brain functioning, and emotional balance (and we all need a little bit of that!).

Whereas saturated fat can raise cholesterol levels and inhibit the body's ability to use insulin to carry glucose from blood to cells, unsaturated fats actually help control blood sugar. Fat, like protein, helps to slow the digestion process, so carbohydrates break down more gradually and blood sugar rises slowly after eating. There *are* important reasons to limit the amount of fat in your diet—even these healthy fats. Fats pack a lot of calories, which can undermine your weight loss. And too much fat can actually slow the digestion process too much, leaving your blood sugar elevated for an extended period of time. To make the most of these healthy fats without overdoing it, try to include a small serving with every meal. For example, you can have a half avocado with your green salad, drizzle olive oil over some grilled vegetables, or create your own to-go nut-and-seed mix—these are all easy ways to make sure you include these essential fatty acids in your diet. Though it's best to eat your nutrition, you can take an omega-3 supplement, but make sure it is highly refined and of good quality; also, these tend to be expensive!

Healthy fats

Light salad dressing (watch out for added sugar in these if you're buying ready-made dressing)

Olive oil

Nuts and seeds

Almonds

Natural peanut butter—no sugar added

Pecans

Seeds, including pumpkin and sunflower

Walnuts

Vegetable oils

Coconut oil

Grapeseed oil

Safflower oil

Sesame oil

· ·

COCONUT OIL

In the past, this oil was thought of as bad for us, but new research has been shown that it's easily digested and can boost metabolism and energy. It also contains a fortifying ingredient (lauric acid) that seems to protect against viruses, lowers cholesterol, and increases our absorption of important vitamins such as A, D, E, and K. So add it to your list—and I think you'll like the way it tastes!

· ·

What do these foods have in common? Nearly all of them are on the low to moderate end of the glycemic scale. Low and moderate glycemic foods are made of complex carbohydrates, and are higher in fiber and lower in sugar than their counterparts at the high end of the glycemic scale. When you eat with the glycemic index in mind, you're concentrating most of your eating on foods that are nutrient dense, high in fiber, and low in sugar. These are foods that will fill you up and give you energy. What they won't do is spike your blood sugar and leave you feeling hungry and on the hunt for your next meal before your plate is even cleared.

For the first two weeks, you'll concentrate your eating on the low end of the glycemic scale and on eating lean protein with every meal. During this time, you'll avoid starches and sugars entirely. This is NOT how you'll have to eat for the rest of your life. I promise! But in order to jump-start your weight loss, even out your blood sugar, and break the hold that these foods have on you, you need to spend a couple of weeks without them. I'll talk more about how to manage these two weeks in Chapter 9.

Once you've broken your cycle of sugar-fueled cravings and constant hunger, you will begin to reintroduce a wider range of carbohydrates and starches into your diet. You'll do this gradually, starting with a single serving a day. After a week, you'll move to two servings per day and, finally, to three. All the while you'll be eating lots of the veggies, beans, and whole grains that are now the healthy, low-glycemic basis of your diet, along with lean protein and healthy fat. By slipping the starches into your diet slowly and gradually, in combination with plenty of low-glycemic, nutrient-rich foods, you give your body a chance to accept these foods as one small part of a broad, varied, and healthful diet—without spiking your blood sugar.

The Strategy

My diet is based on healthy food and a few simple strategies. Believe me, I've tried diets full of weights and measurements, complicated meal preparation, and expensive ingredient lists. In finally creating a diet I could really live with, day in and day out, I ultimately fell back on some basic, common-sense principles. Much of what I'm about to share with you may sound

a lot like your grandmother's advice about eating. It's true! These are tried-and-tested principles of balance and moderation that have survived the test of time. They've outlived fad diets and so-called "health" crazes. I've tried just about every one of those fad diets, and they all failed.

In crafting my own eating plan, I found that these common-sense, grandma-wisdom principles are also the ones promoted by physicians and experts who treat diabetes. These simple guidelines work in combination with the most up-to-date scientific knowledge about how diet can help manage diabetes if you have been diagnosed and even eliminate the shadow of diabetes if you are prediabetic or insulin resistant. I'm pretty sure your grandma didn't have a list of the glycemic index of foods on her refrigerator, next to that picture of you in a tutu. I know mine didn't! But I have one on my fridge, and you should, too. The glycemic index, that is, not the tutu picture!

Sherri Strategy #1: Practice portion control.

You knew this one was coming: one of the keys to managing your weight and your diabetes is to moderate the amount you eat. Keeping portions in check keeps your overall calorie intake under control. I can hear you saying, *Duh, Sherri, tell me something I don't know.* Well, did you know that overeating can also send your blood sugar through the roof? It's not just what you eat, but how *much* you eat that contributes to the amount of glucose in the bloodstream. Yep, that big pile of food on your plate translates into a higher concentration of glucose entering your blood after a meal.

Remember, even healthy, low-glycemic foods convert to glucose eventually. They just break down and enter the blood-

stream more gradually. That's why eating healthfully is not a license to eat unlimited amounts. Eating moderate portions of the right kinds of food is a key part of keeping your blood sugar steady, avoiding cravings, and losing weight.

What is a healthy portion? In the old days, I thought a portion was whatever it took to make me feel full and satisfied. Turns out, that was a whole lot more food than I needed. When I was learning how to eat my way back to health, I had to learn, for the first time, what a reasonable, healthful portion looked like. What an eye-opener that was!

I manage my portion control using what experts call the "plate method." This really works for me, since I'm usually trying to pull a healthy meal together for myself while attempting to complete nine other tasks. Measuring and weighing my food—another option for managing portion control—just isn't a practical option for me. The plate method lets me eyeball my meal portions.

Here's how it works: I fill one half of my plate with low-starch, low-glycemic vegetables. Green salads, healthy veggie slaws, sautéed peppers and onions—these are a few of my favorites.

I fill one of the remaining quarters of my plate with whole grains, beans, or moderately starchy vegetables. Fresh peas, savory black beans cooked with fresh herbs, hummus, and brown rice are some of my standbys.

The last quarter of my plate gets filled with lean protein. Grilled salmon, sautéed chicken breast, spicy tofu. Love 'em! There's also room on this yummy plate for a healthy fat serving, which could be some tasty vinaigrette for the salad, a small pat of butter for those fresh peas, or a dollop of low-fat sour cream for my black beans.

Add a piece of fruit and a tall glass of water and I'm good to go!

MANAGING PORTION CONTROL ON THE GO

Eating right for your diabetes doesn't mean you can't go out to eat or enjoy your favorite restaurants. But eating out is a time when temptation can easily strike. Those all-you-can-eat pasta places? If places like these had halls of fame, my picture would be on the wall. And it wouldn't be because I'm on TV. Oversize plates, food bathed in fat and oil—restaurants can be scary places for those of us who are trying to eat right for our health and don't have the willpower of a superhero. Here are a few tips for navigating your favorite restaurant menu, allowing you to have fun, enjoy your meal, and stay on course.

- Choose an appetizer as your entrée.
 In the mood for something a little indulgent? I know the feeling!
 Just make it a little something, not a lot. Pair an appetizer of your
 favorite dumplings with a side salad.

- Share a main course.
 Splitting an entrée with your honey or your friend is a great way
 to keep your portion in check while enjoying a special meal out.

- Ask for a half plate.
 More and more restaurants are offering small-plate dinners, but if
 you don't see this option on the menu, don't be shy about asking.

Sherri Strategy #2: Eat frequent, regular meals.

Portion control takes effort, especially if you're like me and you're used to approaching mealtime as if you're constantly at an all-you-can-eat buffet. So here's some good news: on my plan, you're going to eat often. Eating frequent and regular meals is another way we can keep our blood sugar steady and in check, while *also* losing weight.

Before my diagnosis, during all those years when I was overeating—eating too much of all the wrong foods—I'd regularly indulge in big meals. And after a big meal, or a day of overindulgent consumption, I would try to make up for it by NOT eating at all. I'd spend an afternoon, or maybe a whole day, denying myself any food at all. At some point, though, my hunger would come roaring back, and I would crumble. In a flash, I'd be back in the drive-thru line, stocking up on enough to feed a small nation. Does any of this sound familiar? I later learned that denying your body food is one of the WORST things you can do if you're trying to lose weight.

On my plan, you won't go more than three to four hours between meals or snacks. No, that doesn't mean you should be sliding out of bed for a midnight snack and then do it again at three a.m. But it does mean you'll start with a blood-sugar-balancing breakfast and follow it up with a midmorning protein-rich snack. After lunch you'll have another snack to tide you over until dinner.

Why? Eating regular meals and snacks will help keep your blood sugar even throughout the day, without spiking highs and crashing lows. Our blood sugar continues to drop the lon-

ger we go between meals. When blood sugar gets too low, the message sent out from our body is urgent and clear: FEED ME! Eating often enough to keep blood sugar steady helps avoid this desperately hungry feeling, which we all know can lead us to bad decisions—as in goodbye, spinach salad; *hellooo, Twinkies!*

Eating every three hours also helps mightily with portion control. When you're eating this often, you simply don't need to eat as much at any single time. But eating this often can take some getting used to. Before I changed my eating ways, I used to approach every meal as if it were the last one I'd ever have. It was all *grab* and *gimme* and *more, please.* Letting go of that impulse takes work. (We'll dig deeper into this in Chapter 6, where we talk a lot more about changing your basic relationship to food.) You will adjust, quicker than you may think—and the knowledge that your next meal or snack is just a few hours away will make a big difference.

WHAT I DO: BREAKFAST AT NIGHT

Nooo, I'm not talking about pancakes for dinner. *Don't I wish.*

What I am talking about is prepping your breakfast the night before. In my house, mornings are a mad rush. Getting breakfast right can make a real difference in how the day goes. Eating well for my body in the morning helps me "get with the program" for the rest of the day. So I have made a practice of doing some breakfast prep before I go to bed. I set a place at the kitchen table with my bowl, spoon, and coffee mug. I wash and cut my fruit. If I'm having oatmeal, I cook up a batch of steel-cut oats in the evening and then reheat a portion in the microwave the

next morning, topped with some of that already prepared fresh fruit and a few nuts for protein and fat. It's a thirty-second breakfast that fills me up, keeps my blood sugar nice and steady, and helps me start my day the right way.

. .

Sherri Strategy #3: Combine foods to balance blood sugar and reverse insulin resistance.

Once you've broken the cycle of cravings and constant hunger that comes from eating high-glycemic and high-fat foods, you can actually take control of what you're eating rather than having your cravings for food control YOU. You become the boss of food, and as the healthy eater in charge, you can use food to help you get thinner and healthier, and if you are prediabetic, you won't cross over to the D. Food becomes a powerful tool for health in your capable hands.

As a diabetic or prediabetic—or as someone who wants to lose weight—one of the most effective ways you can use food as a tool is by eating the right combinations of things. For this, we turn to our handy, dandy glycemic index/load. Remember, foods at various points on the glycemic index will digest at different rates, depending on the type of carbohydrate they contain. When you combine low-glycemic foods with healthy proteins and good-for-you fats, or with smaller portions of food from the higher end of the glycemic scale, you slow the overall rate of digestion and release of glucose into the bloodstream.

The most important rule of combining food is to NOT eat simple carbohydrates by themselves. If you're going to indulge in simple carbohydrates—those starchy, sugary foods that

break down lightning-fast into our bloodstream—you need to combine them with protein and high-fiber, low-glycemic foods; this combination strategy will help blunt the impact of the starchy carb on your blood sugar.

For example, if you are dying for a bowl of pasta, make it an appetizer size and accompany it with a palm-size grilled chicken breast and some leafy greens. The protein of the chicken will keep your blood sugar from spiking from the pasta. Of course, choosing whole wheat pasta would be best, but there are going to be days when you're just dying for the delicious white version!

Meal combining with the glycemic index and glycemic load is pretty simple. Use these basic strategies for a short while and before you know it, combining foods will feel familiar and natural.

> Anchor your meal with low-glycemic foods.
>
> Use middle-range glycemic foods, as well as lean protein, in moderate amounts.
>
> Use high-fat and high-glycemic foods in small amounts.

Eating a wide variety of foods is a great way to achieve balance without having to overthink things. Looking back, I can't believe how narrow my food choices used to be. In my old, starch-and-fat-heavy diet, practically everything I ate was white or brown! My plate looked either like a puffy cloud of fluffy food or something drowning in a gooey sauce. Now when I think about food, I think about colors—if my plate is colorful, I know I'm on the right track. To make it easy for me to include veggies with every meal and snack, I keep tons of

fresh vegetables clean and cut in my refrigerator: sliced bell peppers, celery, and cucumbers—I love to munch on these raw! I also pay attention in the grocery store or market to the vegetables that are in season and make sure I have these on hand to steam or water sauté—cauliflower, green beans, broccoli, spinach, and cabbage are some of my favorites.

Combining foods this way allows us much greater variety in our diets. It also gives us room to be less than perfect! When we combine foods correctly, no food becomes completely off limits!

WHAT I DO: KICK THE BOTTLES

My fridge used to be full of bottled dressings and sauces and jars of salsa and dips. These products may be convenient, but they're not always healthy. Those squeeze bottles of salad dressing and marinades, those colorful jars of dips and salsas can be full of sugars and loaded with fats. I discovered that I don't have to give up on tasty dressings, dips, and sauces—I just need to make my own.

Salad dressings

I use olive oil and other healthy oils like walnut and grapeseed in combination with different vinegars to make tangy salad dressings. My favorite is a garlic-herb vinaigrette that I make in the blender. I peel and crush a clove of garlic, and pull a generous handful of fresh herbs from my stash in the fridge. I use whatever is handy: parsley, basil, oregano. Into the blender they go, along with equal parts vinegar (I like red wine vinegar or apple cider vinegar) and olive oil, about a quarter to a third of a cup of each. A dash of salt and pepper followed by a quick zap of the blender, and I've got a tangy, garlicky, super-healthy salad dressing.

Salsas

I make my own super-quick salsa with fresh (or canned) tomatoes, chopped onion, a sprinkle of cilantro, and a squeeze of lime. No cooking required—fresh salsa is great over fish and chicken, or as a snack with baked tortilla chips. I amp up the flavor and spice by adding chopped garlic and jalapeños or other hot peppers.

Dips

I make a delicious and decadent dip for veggies by mixing low-fat or nonfat Greek yogurt with fresh herbs, salt and pepper, and a little chopped garlic. Sometimes I take a few spoonfuls of my garlic-herb salad dressing and swirl it right in the yogurt for a delicious dip to eat with raw veggies or to spread over cooked fish, chicken, or pork.

BBQ

I've even learned how to make my own barbecue sauce! I simmer a can of crushed tomatoes with a generous splash of apple cider vinegar, seasoned with chopped garlic, smoky dried paprika, a spoonful of honey, and a dash of salt and pepper. It's flavorful and fast and perfect on skinless chicken breasts. It's got that familiar barbecue flavor I crave, but unlike those bottled sauces, with my own version I get to control the sugar and fat.

WHAT I DO: PLAN—AND PACK— MY SNACKS

Snacks can make or break my eating plan. Planning my snacks, I've found, is as important as planning my meals. Without a plan for snacking, I'm much more likely to find myself standing in front of the vending machine at work, lustily surveying the dangerous array of candy bars and potato chips, or veering into a bakery for a softball-sized

muffin on my way to a meeting. My keep-on-track strategy
for snacking involves making healthy, tasty, portable
between-meal treats at home. Here are a few of my
favorites.

Popcorn

I used to keep boxes of microwave popcorn in my pantry,
thinking that this was a healthy alternative to potato chips
or cheesy puffs. Popcorn is a great snack option—it's
high in fiber and low in calories—but most processed
microwave popcorn products are loaded with salt and fat.
I got rid of my stash of store-bought microwave popcorn
when I cleaned my pantry of dangerous-to-me foods. But
I still eat popcorn, and I still make it in the microwave. Did
you know that you can microwave popcorn at home from
scratch? My version keeps all the good-for-me goodness of
popcorn and skips the added fat and salt. All you need is
a glass bowl and a microwave-safe plate to act as a cover.
Add popcorn kernels to the bowl, cover with the plate,
and microwave on high for three to five minutes, until the
popping starts to slow. The bowl itself will be hot, and
steam will release when you remove the plate, so use a
dish towel or pot holders. Poof! Just like that, you've got a
popcorn snack—with no oil or butter. One-quarter cup of
kernels will make four to five cups of popcorn. I store my
popped corn in an airtight container, so it's fresh whenever
I want to pack a snack. This is also a great treat to have
on hand to handle nighttime snack cravings. I add flavor
to my popcorn with a sprinkle of fresh Parmesan cheese,
a pinch of salt, and some fresh ground pepper, or even a
dash of chili powder.

Fruit-and-nut mix

Trail mix is another one of those store-bought products
that can deceive you. Trail mix—sounds healthy, right?
Sounded to me like the sort of snack a skinny person

would eat while on a fifty-mile bike ride or in between
sets of one-handed push-ups. Like popcorn, store-bought
"trail mixes" often take healthful basic ingredients—in this
case fruit and nuts—and load them up with fat, sugar, and
salt. My solution? I make my own. It's simple to do, and
the result is a delicious, filling snack that keeps well and
is entirely portable. I buy an assortment of raw, unsalted
nuts—I like almonds, walnuts, pistachios, and sunflower
seeds—and toast them in the oven. Be sure to stay nearby
while you're toasting nuts—by the time you can smell them,
they're burned. I mix my nut medley with unsweetened
dried fruits, at about a 3:1 ratio of nuts to fruit as a way
to keep the sugar levels of this snack in check. My favorite
dried fruits are apricots, figs, dates, raisins, and cherries,
and I use one or two of these in a batch. Dried fruits
generally fall in the mid-range of the glycemic index, and
they usually have a high glycemic load. Eating dried fruits
in combination with protein-rich nuts lowers the overall
glycemic impact of the snack mix. It's also important to
keep portions moderate: a serving of about a third of a
cup is plenty. This is a filling, calorie-dense snack where a
little bit goes a long way.

Hummus and carrots or whole grain crackers
I keep hummus on hand and pack a snack-sized
serving—a few tablespoons—into a small to-go container.
I always have a bag of baby carrots in the fridge—they're
already washed and peeled—and a handful goes right in
that snack container. Sometimes I eat hummus with a few
whole grain crackers instead of carrots—but only now and
then, and only after I've read the label to make sure I'm
eating crackers that *aren't* full of sugary additives.

WHAT I DO: THE BOTTOMLESS SALAD BOWL

The bottomless salad bowl is just what it sounds like: a never-ending supply of salad. This is a simple strategy that has made a huge difference in my ability to eat healthfully on a daily basis. I keep a big bowl of my favorite chopped green salad in my fridge, ready to pull out to serve with dinner or pack a lunch for myself on days when I'm brown-bagging it. Here's the trick: I never let this bowl become completely empty. When the salad supply starts to run low, I set aside a few minutes, do some chopping and dicing, and replenish my supply. I also keep a ready batch of my favorite homemade salad dressing. With a little planning— keeping my fridge stocked with the right ingredients, making time for salad prep a few times a week—I've always got a good-for-me meal or side dish on hand.

I can't count how many times having this ready-to-eat salad has kept my daily eating on track. No matter how busy I am at the moment, I've always got a healthy option for lunch, dinner, or even an in-between-meals snack. There are a few keys to making the bottomless salad bowl work.

1. **You've got to like eating it.**

 Trust me, if I didn't actually enjoy this salad, it would wilt away in my refrigerator. My standard salad includes crispy romaine lettuce, shredded cabbage, chopped carrots and cucumbers, thinly sliced scallions, and juicy chunks of apple. I also like to toss in beans and reduced-fat feta cheese for protein. Tossed with a healthy, flavorful dressing, this is a fresh, crunchy, fun-for-my-taste-buds salad that I look forward to eating on a regular basis.

2. **Mix things up.**

 I make sure to switch up ingredients in my salad bowl so I don't get bored with the same old, same old.

I use different kinds of greens. I'll add chickpeas one day, and black beans another. I rotate other crunchy veggies like bell peppers, celery—even little broccoli florets.

3. **Know what ingredients work.**

One challenge of making salad in advance? If you use the wrong ingredients, things can get awfully soggy. I've learned a few tricks along the way to help extend the life of my salad, and they mostly have to do with controlling moisture. I stick to crunchy, firm veggies like carrots and cabbage, and crisp or firm greens like romaine and spinach. Tomatoes are wonderful in salads—and they're a vitamin-rich, low-glycemic food—but they are full of liquid. If I have a hankering for tomato, I'll chop one and add it to my serving of salad when I'm ready to eat. I love cucumbers, but they also have a high moisture content. I scoop out the gel and seeds in the center of the cucumber, leaving crunchy, firm flesh to chop into chunks.

THE TAKEAWAY: THE BASICS OF HEALTHY EATING ON PLAN D

✔ Clear your cupboards and fridge of starchy, high-fat, high-sugar, and processed foods.

✔ For two weeks, refrain from eating simple carbohydrates, which are high-fat and high-sugar in any amounts.

✔ Replace your starchy diet with a mix of healthy carbohydrates, lean protein, and unsaturated fats.

✔ Practice portion control.

✔ Eat frequently: three meals, two snacks. Don't go more than four hours without eating.

✔ Combine foods to create a balanced, healthy meal that is also *satisfying*.

Get Moving: Exercise Reverses Insulin Resistance

Exercise can mean the difference between reversing your prediabetes or managing your diabetes on your own and having to do it with medication, including insulin injections. How's that for some straight talk? Changing your diet is critical. But exercise plays a unique role in resetting our bodies' ability to use insulin.

You want to reverse your insulin resistance? Lose weight? You've got to get moving.

When I was diagnosed with diabetes, exercise and I were not exactly well acquainted with each other. In fact, I'd say we were near strangers. I could no more imagine myself on an elliptical machine or learning to tap dance than I could suddenly grow four inches in height! Here's where, once again, diabetes stepped in to give me a great gift. Without that threat to my health and my life, I'd probably still be on my couch, in my stretchy pants, snacking away, watching *Dancing with the Stars* on television. Instead, I wound up actually *Dancing*.

With. The. Stars. I have my diabetes diagnosis to thank for that amazing, terrifying, and transformative experience.

By the time I was a contestant on the show, I had reached a pretty good weight for me. And I thought I was in pretty good shape. But nothing, and I mean nothing, worked my booty harder than dancing five to six days a week, five to six hours a day. Dancing is an art, a competitive sport, and a mind-body experience wrapped into one.

Now I'm not about to challenge you all to a dance contest; far from it. What I do want to share with you is a new way to think about exercise so that you actually enjoy it, don't avoid it, and come to relish it as part of your daily routine.

The exercise plan I'm about to share with you is the reason I was able to hoof it through all those grueling rehearsals with my *DWTS* partner, Val Chmerkovskiy. Without the years of gradually working my body into shape, I could never have withstood the physical demands of *DWTS*. My time on *Dancing* was shorter than I wanted it to be but was truly one of the most incredible experiences of my life. I did it scared, for sure, but I can't imagine NOT having done it. If I hadn't been exercising, I wouldn't have been ABLE to do it.

No matter where you are today in terms of exercise, trust me: you can change. You can move more. You can even like it. I am living proof that you can transform your habits and your attitude toward working out. Big changes in little steps, remember? That's how I did it. I went from couch-potato princess to rumba queen. I'm never going back.

These days, I can't imagine my life without my exercise routine. That doesn't mean I always jump out of bed singing a happy tune when the alarm goes off two hours early so I can get to the gym before work. *Please.* I grumble and shuffle and look

back at my hubby, who is snoring and smiling away in dream-
land, and sometimes I think, *What the %&$* am I doing?*

But I get up and I do it. I used to find every reason in the
world why I couldn't exercise. I was too busy at work. My boobs
were just too darn big to handle all that jumping around.
Something very important was on television. Well you know
what? Work is always gonna be there. Sports bras can wrestle
even my chest into place. And there's this thing called DVR.

No more excuses.

What changed for me? A lot. First of all, I understand why
I'm making exercise a priority. And no, it's not to wear an itty-
bitty bikini. (Though I did look pretty great in that bathing
suit I wore on *The View*, didn't I?) Regular exercise is a neces-
sity for me: to control my weight, manage my diabetes, and
protect the long life I want to lead. It's that simple.

My exercise routine also fits my life, which is why I'm able
to keep up with it. I make a decision every day to spend time
doing something physically active—but as I've said, I'm hardly
a "gym person." I'm a busy working mom with way too few
hours in the day. I don't have the time or the luxury to spend
hours at the gym every day. When I made the commitment to
incorporate exercise into my schedule, I knew it had to be on
my terms. Exercise would have to happen within the crazy
jumble of my life.

Turns out, really integrating exercise into your daily life
is the key to sticking with it. It can also be the key to making
it fun! I make daily exercise my goal, which means I actually
work out almost every day. But I don't do the same kind of
exercise each time. That's partly because my busy schedule
and my priorities (those would be my son and my hubby) don't
allow me to wander leisurely to the gym for a couple of hours

every day. But I also vary my exercise because it keeps things interesting and keeps my body and my mind guessing.

Over time, I have worked my way into an exercise plan that combines cardio, strength training, and interval training. I get to the gym when I can, but I don't have time to be one of those people who is always there. Most of my exercise—the activities that I most look forward to, the stuff that brings me the most joy—is all the playing around I do. Play counts, people! As long as you're moving, you're exercising. I chase my son around the park. I salsa-dance with my husband, Sal. I used to dance with Jeffrey in my arms, but he's nearly too big for that now . . . *sigh*. So we dance together on the living-room rug. You can build an exercise regimen around activities you love, with the people you love. I did it, and I'll show you how. I've definitely added dancing to my regular routine. Yes, *DWTS* was one of the most challenging experiences of my life—but one of its many gifts was the discovery of how much I love to dance! Dancing works every part of your body. Every single muscle you have is going to get stretched, toned, and strengthened—never mind the allover shaping and kick-in-the-butt cardio. So try it! It is fun, even if you don't have any rhythm.

DIABETES 411: HOW EXERCISE REDUCES INSULIN RESISTANCE

When we become insulin resistant, our bodies can no longer use insulin correctly, to deliver glucose from our blood to our cells. The good news is insulin resistance can be reversed—and exercise can make it happen. How does exercise renew the body's ability to use insulin?

Exercise creates an immediate demand for energy.

When we exercise, we burn fuel, and this causes our cells to call out for a resupply. This call-to-action helps our cells become more responsive to insulin to suck in glucose from our bloodstream, which regulates our blood sugar level.

Exercise pushes blood flow to the cells.

Strength training in particular sends a rush of blood to the muscles that are active, increasing blood flow to those particular cells. Part of reversing insulin resistance is improving the flow of blood to your cells.

Exercise reduces body fat.

If you're working out regularly and eating well, your body will have to rely on the energy stored in your fat cells. That means you're getting rid of excess body fat—and the sugar stored in those fat cells.

Exercise boosts metabolism.

Exercise is a great metabolism booster. This means we'll burn the calories we consume more efficiently, both during workouts and throughout the rest of the day. Because exercise is helping you build lean muscle mass, you are also able to use the excess glucose floating in your blood, and use it for energy. You will increase weight loss and balance your blood sugar all at once!

. .

Getting Started: One Step at a Time

Before my diabetes diagnosis, I did my best to *avoid* moving. Take the stairs? *Please.* I never met an escalator I didn't love. *Why walk when you can drive?* This was my general mantra. I made it a point to move as little as possible.

Of course, my diabetes diagnosis changed that. For the first

time in my life, I *had* to move. My first step was a pretty basic one. I joined a gym. Sensible, right? They smiled at me, those fit folks at the gym, and they handed me a membership card and said, "See ya soon!" All I could think was, *Now, what the %&$! am I supposed to do?* I spent a week just looking at the card, then putting it back in my wallet and going on about my day. I finally decided to push myself. The next morning, I packed my bag with some brand-new workout clothes, laced up my sneakers, and . . . hailed a cab to take me right to the gym's front door. (It hadn't occurred to me yet that walking to the gym was even *possible.*) I took a deep breath and walked into the bright, sunny lobby. I gazed around as though I'd just landed in a foreign country. Suddenly, I spotted a familiar sight. The juice bar! This I could do. I marched right up, bought myself a big ol' smoothie, and walked right back out the door.

This became my gym routine at first. Pack the bag, hitch a ride to the gym, buy a smoothie, and head home to the safety of the couch. Then a week or so later, I took the step. Fifteen minutes' worth of steps, as a matter of fact. I slunk my way into the workout room and climbed up on a treadmill. I'd signed up to work with a trainer, and she put it out there for me: *Sherri, give me fifteen minutes. That's it.* So I did it. After that first day, getting onto the treadmill and walking for fifteen minutes became my routine. Heaven forbid my trainer asked me to add a minute, or five, or ten. *No way, lady. Fifteen is what I'm in for and that's it.* Along the way, something interesting happened. My body started to like the activity. I started to notice how my mood changed after a session at the gym. I could feel the muscles in my legs getting stronger. I was less tired, less cranky. Plus, there was less of me, all around.

My early progress made me want to work harder, to see what more I could do. I'll never forget the look on my trainer's face the day I said, "How 'bout I do twenty today?"

If you're already exercising, keep it up! You are way ahead of where I was when I first started. If you're like me and you have historically treated exercise as the source of a communicable disease, then you're going to start slow and easy. You're going to start by moving for fifteen minutes a day, just like I did.

. .

FIFTEEN IN FIFTEEN: WORKOUTS TO GET YOU STARTED

Too easy? Make these twenty-minute workouts, or thirty. Do one in the morning and one in the afternoon or evening.

- Walk around the block—once, twice, whatever it takes to fill those fifteen.

- Dance to an old-school favorite: mine is MJ's *Thriller*, your favorite R & B, or Madonna!

- Jog or march in place while watching fifteen minutes of the news or your favorite TV show.

- Vacuum your living room and bedroom.

- Clean out your closets.

- Do fifteen minutes of beginner yoga with a DVD.

- Walk or jog on the treadmill.

- Spend fifteen minutes of your lunch break moving— walk outside, walk up and down the stairs at your office.

- Take a five-minute walk before or after every meal (and that's three meals a day!).

- Rake leaves in your backyard.

- Start a garden and commit to working on it for just fifteen minutes every day.

- Hit up your local mall and walk its perimeter twice.

- Spend fifteen minutes playing with your kids at the park.

- Go to the park and take a walk with another mom—a workout buddy does wonders!

- Get on a stationary bike, or a real one, and take a fifteen-minute ride.

You get the idea! By adding just fifteen minutes each day, you'll be adding almost two hours of exercise a week!

. .

The Basics

My exercise plan includes three basic types of exercise. There are many ways to get these types of exercise. You may want to go to the gym. If so, great! But you don't have to belong to a gym or have a trainer to incorporate these types of exercise into your life and turn your health around. My most rewarding exercise—the activities I look forward to most—happen a long way from the gym. They involve playing around and being silly with my kid and my husband. It's true: you can make goofy fun a health-enhancing, legitimate exercise pursuit.

But first, let's go over the basic types of exercise we all need to be doing on a regular basis: what they are, why they matter, and our target goals for how often we should be doing them.

Moving the heart: aerobic exercise
What it is

Proper exercise types call this "cardio"—I call this "movin' your butt." Aerobic exercise is the foundation of my exercise plan.

Why it matters

Aerobic exercise burns through calories, and therefore it's critical for weight loss. It also improves your cardiovascular health and fitness, and can help you lower your blood sugar by using up the glucose directly—bypassing even the need for insulin. Cardio workouts are a great mood booster, thanks to the endorphins released during aerobic workouts. Your cardio session will also give you more energy and help you shed that fatigue that so many of us diabetics struggle with.

Ways to get cardio workouts

Climbing your stairs a few times

Dancing—in a class, in your living room, wherever you can make it happen

Hiking

Jogging

Mowing the lawn

Sweeping out your garage at a quick pace

Swimming

Vacuuming your house

Walking on the treadmill, around your neighborhood, or with your dog

The goal

You should strive for moving at least thirty minutes, five times a week. (Don't worry if this seems way out of reach—you'll work toward this goal at a pace that suits you, starting with those fifteen minutes you just read about.)

Makin' yourself strong: strength training

What it is

Exercises that strengthen your core muscles (abs and back), arms, and legs.

Why it matters

Strength training builds lean muscle mass. Muscle in the body burns more calories than fat in the body. Strength training also delivers a rush of blood to the cells of the muscles you're working. For diabetics, improved blood flow to cells helps to balance blood sugar and reverse insulin resistance. As muscles get stronger and more efficient, they also increase your weight loss.

Ways to strength train

DVD workout with free weights

Hauling groceries

Lifting your kids

Pilates

Weight circuit at the gym (most gyms will have machines set up with various arm-core-leg routines; ask a trainer for suggestions to alternate body areas)

Yoga

The goal

Three times a week for twenty minutes.

Stop and start: interval training

What it is

Sounds complicated, right? It's not. Interval training simply means combining strength training with cardio and alternating the order and individual movements and the pace of the movements.

Why it matters

Think of interval training as a supercharge button for your exercise session. This powerful combination of strengthening and cardio maximizes blood sugar balance, calorie burning, and weight loss.

Ways to interval train

If you're dancing, turn up the volume and shake it *fast* for one minute. Repeat this every few minutes.

On a brisk walk, jog for short periods of time. Start with fifteen seconds, or thirty, and work up from there.

Speed up your walking pace for thirty to sixty seconds at a time, several times during a walk.

The goal

Try interval training at least once or twice a week.

Any of these strength-training approaches will help you build lean muscle, balance blood sugar, and maximize your weight

loss as you get your prediabetes or diabetes under control. When you combine strengthening with cardio and eating right, then you are on your way to feelin' so good, so strong, and so clear, you will never want to stop. Your body will crave the exercise just like it used to crave a bowl of popcorn!

Cardio-Strength Training at Home: My Workout Routine

This is the cardio-strength workout that I do at home when I can't get to the gym—or I just don't feel like leaving my house to exercise. I pop in some fun music, move a couple of chairs off the carpet in the living room, and start moving. This workout hits both upper- and lower-body muscles as well as your abs, and combines cardio and strength training by switching off between the two types of exercise. After a quick warm-up, I rotate between two-minute bursts of cardio and a couple of strength-training exercises. I make sure to begin and end my workout with my cardio cycle.

My at-home cardio strength workout requires nothing but comfortable clothing, hand weights or your at-home version of these weights, and no-skid shoes—your everyday sneakers will do the trick. This workout is easy to customize. You can increase or decrease the length of the cardio cycle. You can add or subtract sets and repetitions to the strength-training exercises. When you're ready, you can repeat the entire workout cycle more than once. Having this flexibility means you can continue to challenge yourself, even as your fitness improves. It also means that even when you're short on time, you can still work up a sweat and burn some calories.

Cardio: two-minute cycle

Here is my basic two-minute cardio cycle. If this feels too rigorous for you, you can adjust the time you spend in the more vigorous exercises. Start with fifteen seconds of jump rope* or jumping jacks, and spend an extra fifteen seconds marching in place. To increase the difficulty, just add time—or plug in some additional types of cardio, like stair stepping or running in place.

Each two-minute cardio cycle contains:

Thirty seconds of marching in place

Thirty seconds of jumping jacks

Thirty seconds of marching in place

Thirty seconds of jumping rope

You don't need an actual jump rope for this—you can pantomime this and work out just as hard.

Strength-training exercises

For each strength-training exercise, try starting with one set of ten to twelve repetitions. Don't worry about the number of repetitions as you're getting started—if you need to do fewer than ten, that's fine. You can increase the number of repetitions to keep this workout challenging as your fitness improves. You can use regular hand weights—a two- or three-pound size is a good place to start—or you can get creative and find weights right in your own house. Try canned goods or bottled water from your pantry, pins from your kids' bowling set, or whatever you have handy. Just make sure whatever you choose can fit comfortably in your hands while you're moving.

Here we go!

Warm-up

Walk in place for three minutes.

Two-minute cardio cycle

Strength training
Push-ups

Relax, I'm not asking you to jump on the floor and give me ten perfect military-style push-ups. There are different versions of this strength move, and they all build muscle and strength. Start with the one that feels right to you.

Wall push-ups

Stand arm's length away from a wall. Put your palms on the wall, just wider than your shoulders. Bend your elbows and allow your upper body to move toward the wall. Keep your spine straight and your abdominal muscles engaged. Straighten your arms and raise your body back from the wall.

Modified floor push-ups

Get on your hands and knees on the floor, with your hands slightly wider than your shoulders. Slide your knees backward, away from your torso, until your back straightens and your bottom drops. Think of your body as creating a straight line from the top of your head, down to your spine and your bum. Bend your elbows—they'll stick out to the sides—and lower your upper body toward the floor. Engage your abdominal muscles and concentrate on keeping that straight line along the back of your body—you don't want your bottom sticking up in the air. Push back up and straighten your arms to finish the motion.

If you find that you fall somewhere in between the modi-
fied push-up and the wall push-up, here's an adjustment that
may work for you: instead of putting your hands on the floor
along with your knees, elevate your upper body by pushing
against a firm and stationary surface—a sturdy coffee table
could work, or a stack of firm sofa cushions.

Regular push-ups

If or when you're ready to move to a regular push-up, you'll
set up on the floor just like for modified push-ups. Instead
of staying on your knees, extend your legs back behind your
body, resting your weight on your toes, with heels pointed
to the ceiling. You want to feel a straight line along the back
of your body, this time extending all the way from the top
of your head to your heels. Engage your abdominal muscles
and lower your upper body, elbows falling out to your sides.

Two-minute cardio cycle

Strength training
Squats

Stand with feet hip width apart. Stretch your arms in front of
you at shoulder level. Send your bottom backward like you're
sitting down in a chair. Keep your spine straight and engage
your abdominal muscles. As your bum heads back, your knees
will bend. As they bend, be sure to keep your knees over your
ankles—you don't want your knees to extend over your toes.
Go as far as you can into the squat while keeping your form.
Don't worry about how far this is—any movement is good and
muscle building, and you'll make progress as you repeat this
workout. Push back to standing.

Bicep curls

Stand with feet hip width apart. Holding one weight in each hand, let your arms fall to your sides, with your palms facing your body. Lift weights toward your shoulders, keeping your elbows still and aligned with the sides of your body. Lower the weights and return your arms to their original position.

Two-minute cardio cycle

Strength training
Lunges

Stand with one foot forward and the other foot back, as if you're just starting to move into a split. Bend both knees into a lunge. Watch your front knee: as with squats, you don't want that knee to extend over your toes. Keep your spine straight and your abdominal muscles engaged. For extra balance, do your lunges next to a wall, and place a hand on the wall for support.

Tricep curls

Stand with your feet hip width apart. Hold one of your weights with both hands, one hand at each end. Take the weight up above your head until your arms are nearly straight. You want to keep a very slight bend in your elbow. Gently lower the weight behind your head, bending your uplifted arms at the elbow. Raise the weight and straighten your arms to complete the move.

Two-minute cardio cycle

Strength training
Lateral arm lifts

Stand with legs hip width apart, with one weight in each hand. Let your arms relax at your sides, with your elbows just slightly bent. Lift both arms to shoulder level, then lower.

Bicycle abs

Lie on a mat or a comfortable surface. Tuck your hands behind your head. Pull your knees up and toward your chest, at about a 45-degree angle. Lift your shoulders off the floor—take care and do this gently, you don't need to come up far. Most important, you don't want to strain your neck. Keep your neck muscles relaxed and let your abdominal muscles do the work. Bring your right elbow and your left knee toward each other, then release them. Repeat this move with your left elbow and your right knee. Once you get going, this will feel like a pedaling motion. You might feel tempted to fling yourself through this move, but don't. There's nothing to be gained by speed here: concentrate on completing the movements with good technique. Keep your breathing steady and relaxed throughout the exercise. Try starting with one minute of bicycle abs.

Two-minute cardio cycle

Cool down

Walk in place—or around the room—for three minutes.

WHAT I DO: PUT REMINDERS IN YOUR PATH

It's always a challenge not to put off exercise. We're all busy, whether with kids, jobs, families, or all of the above. One way to guarantee that your exercise program *won't* give you the results you want is to put off your workouts in favor of other tasks. To help keep myself committed, I give myself visible, hard-to-ignore reminders. I leave my gym bag next to the front door, packed and ready to go, where I can see it. (And of course where Sal can trip over it, but hey, we all have to make sacrifices.)

Planning a walking session? I put out my sneakers in plain view the night before. Every week, I post my exercise goals on the fridge. When I've completed one of those goals, I get the giddy satisfaction of crossing it off the list. That never seems to get old! Reminders like this can keep you on track with your exercise, even when you're being pulled in a hundred directions.

Put these reminders anywhere you are likely to run into them: in your Living Right journal, on the refrigerator, on the mirror in the bathroom, or even on the back of the front door, so you see them as you try to leave the house! The point is helping yourself by reminding yourself.

Beyond the Gym: Workouts for Real Folks

If my exercise were wholly dependent on getting to the gym every day, I wouldn't be able to hack it. If you're anything like me, getting to the gym every day is just not a realistic goal. Work, kids, hubby time, the regular business of being an upstanding citizen: they all compete for time with working out. One of the reasons this exercise program has worked for me where others have failed is because I finally built a routine based on what my life is actually like, rather than the smooth and seamless wave of daily perfection I used to envision for myself.

I've come a long way since the days when I couldn't get past the juice bar in the gym lobby. I get to the gym whenever I can, but I still need to rely on workouts closer to home to meet my exercise goals. These real-life workouts also provide variety, keeping me from getting bored, and I can do them with

my husband, my son, and my friends. Real-life workouts are what you can do without equipment, at home or on the go, with friends or family, or on your own. Did I mention that I've taken up tap dancing?

Real-life workouts for nowhere near the gym

Go for a bike ride with your partner or your kids . . . or both!

Take your family to the beach and go for a swim or a walk/jog in the sand.

Pick an activity to learn with your mate. Join a couples yoga class, or . . .

Join a recreational sports league: anything from softball to bowling.

Find a hike . . . and take it!

Take a dance class.

Play tag or hide-and-seek with your kids.

Do chores around the house such as vacuuming, sweeping, washing windows.

If you have a dog, take him on a walk around the block.

If you don't have a pet, take yourself for a walk around the block.

Climb stairs instead of taking the elevator or escalator.

If you have a Wii, try one of the easy exercise games—by yourself or with a friend.

Try swimming or water aerobics at the Y!

Take a Zumba class—these are inexpensive and popular.

By moving your butt up and off the counter stool or sofa, you will give your body a chance to get the blood moving and the glucose burning! Even a slight increase in physical activity has many other benefits besides assisting you in turning back your diabetes symptoms: you will feel more balanced in your moods (through the release of endorphins); you will think more clearly (exercise boosts memory and problem-solving skills); and you will have more energy (as you burn calories, your body gives you more energy!).

DRINK UP: STAYING HYDRATED

I drink eighty ounces of water a day. Really. I drink water with lemon. Water on the rocks. Fizzy water. Still water. Water, water, water. And I have never felt better. Water is your miracle cure for both weight loss and exercise efficiency. It's also mandatory for diabetics and prediabetics to keep our systems really well hydrated. One rule of thumb is to drink about half your body weight in ounces: if you weigh 150 pounds, drink about 75 ounces of water a day. If you weigh about 200 pounds, you should be consuming about 100 ounces of water a day. Invest in a couple of good water bottles, and fill them up and leave them in the fridge so you can grab one on your way out the door. One brand has a built-in filter so you can refill your water from any spout during your travels throughout the day. Water is plentiful, so make sure you are getting enough.

Thinking Big, Starting Small: Strategies for Sticking with It

Before diabetes made me a truly healthier person, I spent years trying to lose weight and get "healthy." Of course, "health" to me in those days was measured by whether I could squeeze into a size 4 miniskirt, or how many vaguely felonious-looking guys gave me a second glance. Let's just say my old self wouldn't exactly have been a candidate for the President's Medal for Physical Fitness.

One thing that all my failed attempts had in common? I tried to do too much, too fast. I took on the BIG goals—*Dropping thirty pounds! Wearing skinny jeans meant for a teenager! Getting flat abs for bikini season!*—without ever having any idea of how to turn a big goal into a whole lot of small steps. It wasn't until I learned to chop up my lofty goals into simple, manageable, achievable pieces that I found success in an exercise routine. That's why my first, and most important, strategy for sticking with your exercise is to:

Set specific, manageable goals

Depending on where you're starting, sticking to a daily exercise regimen that combines aerobic exercise with strength training and intervals may feel overwhelming. I know it felt that way to me. But here's the thing: you don't have to worry about that when you're just starting out. Like I said, all you have to do is fifteen minutes a day of moving your tail. That can be walking on the treadmill. That can be walking to the grocery store and back. That can be dancing around your living room in your skivvies.

Once you start, how do you progress? Slow and steady.

Doubling your workout time from one week to the next is not a reasonable goal. It's an invitation to feel bad about yourself and throw in the towel. Believe me, I've been there. A reasonable goal is to add five minutes a week to your workout time. The next week, add another five. Five minutes starting to feel not quite challenging enough? Time to think about bumping that number to ten. Or adding another day to your routine.

Remember, push yourself, but be kind. We all slip up. This is not an exercise plan that demands perfection—far from it. Part of setting reasonable goals means allowing yourself room to miss a workout without beating yourself up or giving up altogether. Get up the next day and start again.

· ·

WHAT I DO: GET MOVING IN THE MORNING

Time has a way of slipping away from us as the day goes on. You can plan a perfectly synchronized day, full of saintly and virtuous activities, and then *bam!* Real life hits. Your kid comes home sick from school. You get an unexpected visit from your mother-in-law. Your boss gives you a new project, with a due date of *right now!* This is why I try to get in some exercise first thing in the morning. It's my way of guaranteeing myself some of my planned physical activity before the day gets away from me. You don't have to do all your workouts in the early morning. But planning to exercise early in the day can help guarantee that you get in your workout. Early exercise also gets your metabolism revved up, helping you burn calories for the rest of the day! Although my favorite time of day to work out is first thing in the morning or just after I get

Jeffrey off to school, sometimes that just doesn't work with work. So I fit in my exercise after I get off work or on a lunch break. But believe you me, I plan it out as much as I can ahead of time so I know I will get it done. It makes me crazy in the head if I don't get my exercise in!

. .

Use what you've got

We've all got busy schedules, and lives that feel so full it's hard to imagine squeezing another to-do into your daily list. The fact that you're here reading means you've made a commitment to turn your health around. So let's talk about *how* to make that happen. For me, it happened when I looked honestly and realistically at my life, with its hectic schedules and demands. I stopped trying to adhere to a workout schedule suited for idle socialites, one that ignored my laundry list of daily responsibilities—a list that actually includes laundry, and lots of it. I started looking for ways to plug physical activity into my life, rather than waiting for an extra hour or two of time to magically appear in my day. Suddenly my excuses— *I'm busy with my kid! I've got to work all day! The house is a mess!*—started to look like opportunities.

Got kids?

Think you have no time to work out? Welcome to my world. Kids are the great time suckers of the universe, aren't they? I used to think I was busy before I had a child. Ha! I didn't know busy until after my son arrived. Here's the thing that works in your favor: Kids? They. Never. Stop. Moving. So move with them! Get on the floor and play. Take your exercise routine to the park. Walk your kid to school. Or try my favorite and

throw a dance party on your living room rug. If you make a commitment to keep pace with your kids for fifteen minutes every day, you're gonna move.

Got a dog?

Dogs are natural exercise partners. If you've got a dog, you've got a dog that needs to be walked. Rather than trying to find time to walk the dog *and* work out, do both at the same time. If you're pet-less and looking for some extra motivation, offer to walk your neighbor's dog. You'll make a couple of fast friends (the dog and your neighbor).

Got a job?

Take my old mantra and flip it on its head. *Why drive when you can walk?* Leave your car keys at home a couple of days a week and take a brisk walk to work. Use your lunch break for a quick workout at the gym or a brisk walk around the neighborhood. There's probably someone else at work who would love to join you.

Got chores?

I used to use this excuse all the time. *I can't work out, my house is a mess. I've got to stay home and clean.* Of course, staying home to clean usually turned into staying on the couch to catch up on my Lifetime movies. With a bag of Reese's Peanut Butter Cups. People, cleaning your house burns calories! So get to it! Give yourself a boost by turning on some music, and you can turn vacuuming or sweeping or dusting into a cardio session.

Instead of driving, why not walk to the grocery store? Use those grocery bags to do some strength training on the way home, and you'll get two workouts in one!

Make every minute count

Thirty minutes of aerobic exercise doesn't mean you have to do your thirty all at once. Can't find the time for a half-hour walk? No problem. Look for three ten-minute mini-windows throughout your day. Heck, I probably spend ten minutes a day scanning for chin hair. Get yourself out the door for three ten-minute walks, and you've met your goal. Want to make it really easy? Plan to walk for ten minutes after each meal. Daily exercise becomes a whole lot more manageable when we let go of the idea that a sixty-minute nonstop workout is the only thing worth doing. Every minute counts, so start grabbing them when you can.

WHAT I DO: TAKE A WALK AFTER DINNER

I'm always looking for ways to incorporate physical activity with family time. I've mentioned the dance parties that Jeffrey, Sal, and I have in the living room—this is probably my single favorite way to get moving. Another family exercise activity I've grown to love? A walk after dinner. A fifteen- or twenty-minute walk after dinner is a great way to squeeze some extra exercise into your routine. It's also a really effective way to signal to your body that eating for the day is done. I used to think that settling in on the couch with a bag of potato chips was the highest form of relaxation, the best reward for a long, hard day. I was wrong. Turns out it's a twilight walk with my husband and my boy.

HOW TO DANCE LIKE A *STAR*: PRO TIPS FOR EXERCISE

I learned so much from my time on *DWTS.* I learned that sequins really do make you shimmy better. I learned I have muscles in places I don't even let my husband touch. Most important, I learned about how true athletes train and care for their bodies. It was such an eye-opening experience. It was also a knee-buckling, ankle-swelling, *Lord help me, I'm gonna fall over* experience!

My everyday, catch-as-you-can workouts have changed forever as a result of my all-too-brief moonlighting gig as a dancer. I'm back to wearing my schlumpy workout clothes, and I've traded heels for sneakers, but my workouts will never be the same. You don't need a sequins-and-feathers getup—though if that floats your boat and gets you moving, well then costume up!

You also don't need a pro dance partner—but if you can find one as cute as mine, you ought to snap him up. You don't need cameras following your every step—or in my case, misstep! In addition to calluses in places I never imagined possible, some seriously twisted-up toes, and a whole new appreciation for structured undergarments, I took home from *DWTS* a whole new set of skills and strategies for working out. Here are my best tips for exercising like a dancer, straight from the pros.

Work your whole body.

There's nothing like dancing for a whole-body workout. When I was doing *Dancing with the Stars*, I was introduced for the first time to muscles that I've apparently carried around in my body for forty-plus years and never knew about. My back, my legs, and my butt hurt like I had been mashed by a steamroller! But the biggest discovery

of all was my core—who knew that I had muscles under that belly and chest! There's a reason that those dancers you see cha-cha-ing around in sleek outfits look so good from head to toe: their demanding training regimen works their entire bodies.

You can create an at-home version of this head-to-toe workout. The combination of cardio and strength training can give you a whole-body workout—if you let it. Don't ignore a part of your body because it feels weak, or because you don't like a particular exercise. Make some adjustments to make the workout right for you. Frustrated because you can't complete a set of bicep curls? Pick up a lighter hand weight and work gradually toward your goal. The very thought of lunges makes your knees wobble and ache? Try squats or leg lifts instead.

Swimming, yoga, and Pilates are all great activities for working out your whole body all at once. My favorite? Dancing, of course!

Stretch—before, during, and after

Stretching is kind of like flossing your teeth: you know you're supposed to do it, that it's good for you, but a lot of times it's a step that you just skip. Okay, confession: I'm actually a proud and diligent flosser. I figure that I talk so much, I'd better keep my pearly whites looking good. But I have always been a lousy stretcher. After *Dancing with the Stars*, I decided to be as good to my muscles as I am to my choppers. Dancers stretch, big muscles and small ones, from their neck and shoulders to their toes. Stretching can help improve flexibility and widen your range of motion, which in turn can reduce your risk of injury from exercise. Stretching also improves blood flow to muscles throughout the body. Improving circulation is important for us diabetics and prediabetics.

Stretching tips

Don't bounce. Keep your stretch steady, and use even and slow movements to move into and out of your stretch.

Don't force it. You should feel a pull, but you should never feel pain.

Don't stretch cold. It's not a good idea to stretch before a workout, before you've had a chance to warm up your muscles. Save the stretching for after your workout. But don't skip it!

Here are some good general stretches that will open your joints and big muscle groups:

Sit in a butterfly stretch, with feet together, and gently let your knees fall to the sides.

Lie on your back and lay one leg over the opposite hip or knee to open your back; alternate sides.

Lie on your back and, using a yoga strap or stretchy band at the bottom of your foot, gently pull in your leg to stretch the hamstring; alternate.

To stretch your quads, stand next to a railing or wall for support; raise the outer leg, and bend it back at the knee. Don't force it; only stretch as much as you can feel the quad stretching.

Technique matters

Flinging yourself through a workout routine may feel like the only way to make the most of it, but you're missing out if you do. Dancers are all about technique. They think about every part of their body when they're learning a routine. They stand up straight, they follow through on every movement, they practice control. Paying attention to technique can help you make more of your workout.

I remember the first time my trainer, Kira, taught me to do proper squats. You don't just stick out your butt and hope it goes down: you can really hurt your knees and back if you don't pull in your core. My technique? I pretend I am using a public toilet.

When I first started using a treadmill? I almost fell off, I felt so clumsy! The point is, learning good technique means paying attention.

Technique will put emphasis on muscles that might otherwise get ignored. Technique can help prevent injury. This can be as simple as thinking about your posture when you are taking a walk, squaring your hips and flexing your feet during a cardio dance class, or flattening your back during push-ups. Chances are if an exercise feels too easy, you're probably not using great technique. If you are a member of a gym, seek out a trainer to ask about proper technique. Another good way to learn proper technique for exercising and stretching is by taking a yoga or Pilates class, where you learn specific ways to position your body and maintain its alignment before, during, and after exercise.

Work out with a buddy.

Man, did I get lucky. I had the most dedicated, talented, and supportive dance partner on *DWTS*—and he was Russian. And let me tell you, keeping me upright on that dance floor took some serious supporting! I made a bunch of friends for life on *DWTS*, but nobody more so than my awesome partner, Val. Spending hours together every day in rehearsal, having all manner of body parts right up close in each other's space . . . you bond. Now I'm not saying you need to get *this close* to your workout buddy. But there's nothing like having a pal to work out with, to train together, egg each other on, keep each other focused, and make each other laugh.

Now that *DWTS* is over, I have other workout buddies—Jeffrey, Sal, and sometimes a trainer. Maybe your workout partner is a friend, a neighbor, your husband, your sister: whoever you choose, recruiting someone to work out alongside you will make your workouts more fun. And fun workouts are the kind you want to do again and again.

THE TAKEAWAY: SHAPE UP TO SLIM DOWN AND REVERSE YOUR INSULIN RESISTANCE

✔ Start moving: just fifteen minutes a day. Work your way up from there.

✔ Make your workouts a combination of cardio, strength training, and interval training.

✔ Your goals:

Cardio: thirty minutes a day, five days a week.

Strength: three times a week for twenty minutes.

Intervals: include them in two workouts per week.

✔ Find ways to work out away from the gym.

✔ Set manageable goals.

✔ Turn your excuses into opportunities.

✔ Don't wait for a magic hour to appear: make every spare minute count!

✔ Work it like a *star*!

The Sherri Steps: Changing Your Relationship with Food

've got a confession to make: I've spent most of my life having a torrid, completely self-destructive, totally dead-end affair. It ended only recently, and for good. My partner in this illicit, decades-long escapade? Food.

Food and I have had a deep, serious, dysfunctional relationship. For a long time, I had a deeper love affair with food than I had with any man. More messed up, too—and that's saying a lot, considering that dating would-be felons was once a regular pastime of mine. Food was like the lover I couldn't get enough of, but who always left me feeling bad about myself. I went to food for comfort, for solace, for company. Food was my constant, the presence that was always there for me.

I spent many years using food (and sex, but that's another book) to try to fill an emptiness that never left me. And when things got tough, I headed straight for the refrigerator or the nearest fast-food joint. Even after I found God again, I still went to food to fill me up emotionally.

Changing my diet and adding regular exercise to my life have been critical steps in getting my diabetes under control, losing weight, and becoming the healthiest I've ever been. But I'd tried diet and exercise before, and I always failed. What was different this time? This time, with my life on the line, I took a step I had avoided my entire life: I changed my relationship with food. I realized that unless I did this, no diet was ever going to really work, no exercise plan would ever keep me on track. My life changed completely—finally, and for the better—when I changed my relationship to food. But it took my diabetes diagnosis—and the grim prospect of leaving my cherished young son without a mother—to make me do it. I'm sorry I waited so long, but I'm glad I did finally tackle that beast.

The Food-Feelings Connection

When I say I changed my relationship with food, I don't mean I put a lock on the refrigerator door. Heck, I'd have picked through one of those for a late-night snack, no problem. Instead, I started to pay attention not just to what I was eating, but also to how the food I ate made me feel. It sounds so simple, but when was the last time you really paid attention to how what you eat makes you feel, not just physically but also emotionally?

I looked at the choices I was accustomed to making with my diet and I knew they were unhealthful. I knew I ate the wrong kinds of food. I also knew I ate way more than I needed to. My connection to food clearly wasn't just about sustenance. So what was it about? In order to find that out, I tuned in to that inner place where I—and I believe many of us—make deci-

sions about food. And I discovered some startling things as a result.

Starchy = sleepy and snappish

Right out of the gate, I discovered that starchy food made me sleepy and irritable. Now mind you, I lived on starchy foods for many years. Potatoes, bread, pasta—these were my primary food groups, and I loved each one to death. I couldn't get enough. I'd finish a big plate of pasta with pesto for lunch and not an hour would go by before I'd be thinking ahead to dinner and plotting my next carb-laden feast. It just so happened that I spent these same years feeling sluggish, cranky, and exhausted. I never made the connection. Not before diabetes forced me to, anyway.

I blamed my constant exhaustion on my hectic schedule. When I first started in entertainment, I was working a full-time day job at a law firm and working nights in comedy clubs around Los Angeles. Of course I was tired—I was on the move, in overdrive, eighteen hours a day! Eventually I was able to leave my office job and support myself with acting and comedy gigs. I stayed busy, but it was a different kind of busy. My schedule changed, but my tiredness didn't. And what about my quick temper? I was always irritable, which is not a charming characteristic for someone who made her living being funny.

Once I started paying close attention, the connection was as clear as could be: Those mashed potatoes I loved so much, the French fries I craved? They tasted great going down, but thirty minutes later I was snapping at someone. The deep-dish pizza I used to devour before a stand-up gig? All that

starch made me need a nap just when I needed my energy to be soaring. When I cut these things out of my diet, I didn't have the swings—high or low.

Making the connection between my constant tiredness and moodiness and my never-ending consumption of starchy carbohydrates was a watershed moment for me.

Sugar shame

Sugary foods did something else to me. These foods made me feel wired, guilty, and ashamed. For years I used sugar and sweet treats as both comfort and reward. I congratulated myself for a successful audition with a pint of ice cream. I soothed myself after a long day at work with a donut—or three. I comforted myself after a fight with my boyfriend with a dozen trips to the fridge for a "single serving" of chocolate pudding.

It's amazing to realize that all that time I was using sugar to feel better, it was actually hurting my body and causing me to feel lousy about myself. Sure, that stuff would taste great going down—at least the first few bites, anyway. By the fourth pudding cup or partway through the second donut, the regret would start to creep in. By the time I'd finished that pint of ice cream or polished off enough cake for three people, I felt like a loser.

Once I started paying attention to how sweet stuff actually made me feel, it became a lot easier to say no to a bowl of ice cream or a sticky pastry. I was still tempted by sweet things—I am to this day—but I no longer kidded myself that they were "helping" me in any way. I realize that the outcome of eating sweets is just the opposite. That king-size chocolate bar I used to gobble up late at night—my misguided reward

to myself for working a long day, or skipping dinner—left me feeling jittery and down on myself as I tried to go to sleep.

As I began to make changes to my diet, I knew I couldn't spend the rest of my life wrestling with temptation and cravings in the way that I had for the first half of my life. My new eating plan was helping to break the physical cravings I had for sugar and fat, for the salty, fried foods that used to be the mainstays of my diet. But those cravings were never going to go away entirely. Temptation is always just around the corner. Especially if that corner has a deli or a bakery on it! I knew I had to have a real plan in place to separate myself from using food as the crutch it had been for so long.

I shifted my attention from what I was going to eat to *how eating made me feel.*

I developed a series of questions—yup, those Sherri Steps I mentioned earlier—to sort out my feelings before I take a bite (or ten bites) of something that may not be good for me. Because let's face it: we may learn to like it, but we're never going to have to resist the temptation of broccoli. When I finally committed to changing my relationship with food, I began with digging deep inside of myself. I began to think about food, the way I ate, what I ate, and why I ate. I began to make connections between what I ate and how I felt after eating certain foods. And when I began to connect those dots, I had to stare at some pretty scary feelings: I was scared. I was nervous. I was angry. I was lonely. I was tired. I was distressed and uncomfortable. Those feelings were my starting place. But as I took away certain foods and figured out other ways to have the difficult feelings, I began to feel better. It wasn't as if all of the difficult feelings disappeared—but a

lot of them did. Balanced blood sugar makes you feel more positive, optimistic, clearheaded, and, well, balanced. So a lot of those negative feelings became history!

Your relationship to food won't look the same as mine. Nobody's does. We all have our individual tics and crutches and weak spots when it comes to foods that are bad for us. I will tell you this: when you start to examine your relationship to food, you will discover that the foods you crave, the foods that make you feel as though you're out of control, those foods mean something. You use them for some purpose, a purpose other than nourishment. Maybe it's loneliness, maybe it's boredom, maybe it's being ticked at your boss or having a crush on that cute guy you see on the bus on your way to work.

I remember what it felt like to start this process. At first, the steps felt a little awkward and uncomfortable to me. Now they are more like second nature. Don't get me wrong: I'm still tempted by foods I've loved my whole life, foods that I know are deadly for me. I still long for sweet desserts, white bread, delicious deep-fried chicken. The difference now is that I know how these foods can take over my body, hijack its chemistry, and send me spiraling down. And I have a plan in place to resist these foods when temptation strikes. It's also a plan that lets me indulge in a treat now and then.

The result is that my indulgences these days are nothing like they used to be. First, they are the exception and not the rule. Second, they are a choice, not a compulsion. Third, and perhaps most important, my indulgences stay in the moment, where they belong. I no longer carry guilt around from one meal to the next.

Getting Started: Ask Yourself Some Tough Questions

Just like you can't overhaul your diet in a matter of days, or go from a couch potato to a long-distance runner overnight, changing your relationship to food won't happen immediately. You can make steady progress if you begin to tune in to how you think and feel about food. Ask yourself these questions.

What does food feel like to you?

Your relationship to food, and your body's chemistry, are different from mine. We all react to food differently. We all have our particular cravings, those foods that make us weak in the knees. I can't provide you with the answers for what will work for you. What I can do is show you the questions that led to the answers that worked for me.

What foods do you crave?

We've all got 'em. Those foods that we feel powerless to refuse. Those foods that once we start, we inevitably eat way too much of. For me it was fast food—burgers and fries, fried chicken, pizza. I knew the employees at my local drive-thru restaurants better than I knew my neighbors.

And then there was Pinkberry. Oh, Pinkberry. Nobody warned me about Pinkberry. For those of you who don't know, Pinkberry is a frozen yogurt chain with stores all over Los Angeles and New York City, and those cities are my two main stomping grounds. My very twisted relationship with Pinkberry started out as a casual thing. I'd stop by a few times a week for a frozen yogurt when I was still working in Los

Angeles. I indulged in a cup of mango or sometimes just plain.

Things didn't really get serious between Pinkberry and me until I was in New York for *The View*. I was alone. Jeffrey was in Los Angeles with his father, and I was seeing him only on the weekends, when I'd fly back to the West Coast to spend a couple of days with my baby before leaving him again on Sunday night. I was stressed about work. I felt at any moment those good folks who'd hired me would discover their mistake and I'd be unmasked as a fraud: not funny, not interesting, not worth a seat at the table. I was freaked out by New York City, a place I'd visited but never lived, a place where I had a whole lot of acquaintances and colleagues but almost no friends.

Into this tangle of stress, loneliness, and sadness stepped Pinkberry. My pink knight—or so it felt at the time. Pinkberry was familiar! It reminded me of my LA home. And Pinkberry was a minor indulgence! It wasn't ice cream, after all, it was fro-yo! Never mind that it had more sugar and carbohydrates in a single serving than I was supposed to eat in an entire day. Skinny girls ate Pinkberry. I saw them every time I went in. This quickly grew to be OFTEN. From once a day to twice, and then *three times a day*, I'd make the trek to that deliciously pink awning.

Of course, I was ordering a large serving every time. But pretty soon a large just wasn't . . . large enough. So I upped my regular order to an extra large. That worked for a while, but before long I'd start to get nervous about only ordering that one, extra-large cup of frozen goodness. I mean, it was a long way back to the apartment. I'd probably finish my extra-large cup before I even got home. It would be such a bummer to get

there and be stuck wishing I had a little more Pinkberry to relax with on the couch.

So I did what any sugar-addicted fiend worried about her next fix would do. I started to order TWO servings at once. An extra large for right away, and a medium to take home for later.

Yes, that's right. I used to order Pinkberry with a side of Pinkberry. If the second one melted before I managed to eat it? No problem. I drank it like a milkshake. Remember, I had been diagnosed diabetic at this point. I just hadn't yet fully accepted it or the changes that would have to be made in my life if I wanted to live past middle age. I knew that I was out of control and that what I was doing was dangerous for my health. I just couldn't stop. I even talked about my Pinkberry obsession on *The View* one day. On air, with millions of people watching, I announced that my Pinkberry consumption was out of control and that I needed to stop.

So, what did I do after we finished taping that very day? You guessed it. I headed straight for the big P. That's when a force even more powerful than Pinkberry intervened. There's only one . . . and he sounds a lot like Morgan Freeman. *No. More,* God told me. Now, I've described to you my relationship to God. It's a pretty chatty one. He loves me and builds me up. He's also very free with his advice and opinions about what I should be doing and how I should be doing it. (I suppose that is not surprising, him being *God* and all. . . .) The God I know even gets a little cheeky from time to time. My God definitely has a sense of humor.

But not on this day. And not about Pinkberry. The God who spoke to me that day didn't sound like Morgan Freeman. He

didn't sound cheeky or funny or even loving. He sounded angry. He meant business. I heard that voice in my head and I knew I'd crossed a line. I turned around and made haste for home. I needed to put as much distance between myself and that pink awning as I possibly could—as fast as I could. I haven't had a taste of the P-stuff since that day.

I hope you don't have a food that grips you as much as Pinkberry did me. If you do, know that you are not alone. I know we've all got foods that challenge our willpower and feel impossible to resist. Knowing what your weaknesses are when it comes to food can help you prepare to resist temptation. These are the foods that make you vulnerable, that are most likely to throw you off course.

I'm going to be straight with you: These are also the foods that may not have any place in your new diet. There are plenty of naughty foods that we can learn to eat once in a blue moon, and in small quantities. But we all have a few foods that seem to always get the best of us, where no amount of willpower is ever enough. If you can't manage to make these foods a very small, very rare part of your diet, it is easier—and healthier for you—to eliminate them altogether.

STEP THIS WAY

Make a list of the foods, or types of foods, that you crave the most. Are you a sugar freak? Do you love starchy stuff? Be honest with yourself. Ask yourself: What are the foods I'm most afraid to give up? Those are the first foods to remove from your house.

Learn What Hungry Feels Like

Think about it. Do you know what hungry is? I thought I did. Before my diagnosis, I thought I was well acquainted with hunger—because I felt "hungry" all the time. Turns out, I was wrong. Unstable blood sugar, mindless eating, my emotional reliance on food, and those unstoppable cravings driven by high-carb, high-fat foods made me feel a constant need for food that had nothing to do with actual hunger. I continue to be amazed at how little food it takes for me to feel full. Not stuffed like a meatball grinder, just simply *full*.

But untangling actual hunger from all the other feelings wrapped up in reaching out for food didn't come easy for me. It helped that my diet was changing from starchy, sugary, fatty foods to new foods at the other end of the glycemic scale. Low-glycemic foods, remember, will digest and enter the bloodstream as glucose more slowly. Unlike high-glycemic foods, they won't leave you feeling hungry soon after eating.

It also helped to ask myself these questions:

Why this food?

Knowing what you do about the foods that make you most vulnerable, this question can shed a lot of light on eating beyond hunger. If chocolate is your great weakness, and you're staring down a humungous piece of chocolate cake, then hunger might not be the impulse that's driving you to eat.

Why now?

If you're searching out a snack an hour after lunch, chances are you're eating for a reason other than actual hunger. Bored?

Need a break? There are lots of ways to add a little variety to your daily routine that don't include a trip to the refrigerator. Play your favorite song and take a quick walk. Go have a visit with your friend who works down the hall. Don't just eat because you're looking for something to do.

Am I hungry, or am I stressed?

Stress was, and is, a huge eating trigger for me and many others. Before you dive into that bag of chips, take a deep breath. Now examine your mood—are you feeling anxious or bothered? Are you reaching for food to quell uncomfortable feelings? Be honest, and then be gentle with yourself. You're not crazy, and you're not alone. You can reach out to me and my community at www.sherrishepherd.com. You can find me on Twitter. You can also trust that as you balance your blood sugar, a lot, and I mean a lot, of these negative feelings are going to disappear. You will just not go there as often, or not at all.

Am I looking for fuel to get me through my busy afternoon, or do I want a snack to comfort me?

Sometimes we really are just hungry! Hunger can creep up on us, especially during the afternoon hours. If you find yourself reaching for a snack in the middle of a busy afternoon, asking yourself this question can help you identify what your mid-afternoon hunger feels like. It can help you choose a snack that won't send your blood sugar sky-high. Also, it might mean that you need a more substantial lunch, or more protein at lunch. And remember, until your blood sugar is under control, you may still misread thirst for hunger cues. Having water should always be the first step.

WHAT I DO: CELEBRATE YOUR MILESTONES . . . JUST NOT WITH FOOD!

Celebrating my progress on the road to Living Right is one way I've found to stay positive, energized, and committed to the changes I'm making in my life. I used to reward myself with food. Nailed an audition? That calls for some Burger King. Big check came in the mail? Bring on the barbecue. Learning how to reward myself with something other than food was such an important step in changing my diet. Now I celebrate my accomplishments AWAY from the refrigerator or the bakery. I'm quick to reward myself for even small accomplishments related to my health. A strong week at the gym? I've earned myself a bubble bath or a pedicure. I made Barbara Walters giggle at the *View* table? How about an afternoon walk through Bergdorf?

A WORD ABOUT STRESS

We all feel stress. We all have to manage it. There is no magic trick for making it disappear in our lives. I know that no matter what, each week I am going to have the stress of juggling a big ol' job, my son's needs, the relationship I want to nurture, and taking care of myself— by that, I mean time for exercise, praying, and staying connected to all of you. Stress doesn't stop for anyone. But I'm better at managing it.

For one thing, being in balanced blood sugar makes me much calmer. Eating right and exercising are what help the most in this department. In fact, if I begin to feel nervous or anxious, that usually means that I took more than one

bite of a birthday cake on the set. Or I had too big a serving of those red new potatoes. Or that I didn't get my workout done because I had to fly from Vegas to New York and go right to the studio for *The View*.

The better you take care of yourself, the better you will be able to manage your stress. But here are some other things I do to take the edge off.

I pray.

I talk to my girlfriends.

I walk.

I think of all that I have to be grateful for.

I hear meditation and yoga help in this department, too—maybe we can try them together!

Know Your Own Body

By now you've heard me say this more than a few times. Everyone reacts to food differently. This is also true emotionally. I'm a stress eater, and I'm tempted to eat when I'm short on sleep. Maybe you are most tempted to eat when you're feeling overwhelmed or sad. Our individual reactions to food are also true physiologically. My blood sugar spikes at just the sight of a baguette. You may be able to eat a bit of bread but can't look at ice cream without feeling woozy and tired.

Part of remaking your relationship to food is understanding these very personal reactions, both emotional and physical. I can't tell you what yours are, but I can show you the tools I used to discover mine.

The Sherri Steps: A Checklist
Am I hungry?

If you've learned to identify what hunger feels like, this question can make simple work of the Sherri Steps. If you're not hungry, don't eat.

No, really: Am I hungry?

It's always worth asking yourself this question twice.

Why do I want to eat this?

If you're not eating because of hunger, then why are you? You may still decide to go ahead and eat that cookie that's tempting you, but by asking yourself this question you'll gain another bit of insight about *why* you eat. And that information can help you the next time you're faced with temptation.

Is this a safe food, or a dangerous food, or somewhere in between?

Don't kid yourself about what you're eating. You may decide to eat a "dangerous" food from time to time. We all do it. But acknowledge the food for what it is and the value it has for your nourishment and your health. Calling out "bad" foods will help you resist them.

Is there some other food that I can combine with this food to lower its impact on my blood sugar?

Combining foods is a great way to give yourself a little break on the rules without a lot of negative consequences. You can

lessen the impact of a high-glycemic treat by combining it with some protein to slow the digestion process.

What else have I eaten today?

This is a really important question. No single food choice exists in a vacuum. That ice-cream cone you're contemplating? A day when you've already indulged your sweet tooth is not the right day to hit up the ice-cream truck for another snack. On the other hand, if you've been staying on track all week and getting your exercise, a single scoop of mocha chip is okay in the bigger picture.

How will it feel to eat this?

One thing I've learned is that it's easy to overestimate the pleasure that eating a "forbidden" food will give. The first bite or two may be heavenly, but often it's a quick trip downhill to just okay after that. When you're tempted by one of your off-limits foods, don't just think about the first bite. Think about the third. The tenth. If you decide to go ahead and eat your treat, this step works really well at helping you eat less of the tempting food in question. If the first bite tastes the best, why not stop after that one?

How will this food make me feel *after* I've eaten it?

If you're paying attention to how foods make you feel, you know whether sugar makes you feel edgy and distracted, or fried foods make you feel down in the dumps. Before you eat the food in front of you, ask yourself: Am I okay with how I'm going to feel when I'm done eating?

What will this food enable me to do?

Food is energy. Food is also tasty and meant to be enjoyed. But food is, most importantly, fuel. What foods make your mind feel clearer? Your body stronger? This is a very real connection that you will soon tap into in a regular way.

What will this food *prevent* me from doing?

The sugar rush from that cupcake you're eyeing may make you feel like a million bucks for a few minutes . . . but just you wait. Looking at food in the context of your whole day, not just your daily diet, helps keep things in perspective. If a sugar crash means NOT having the energy to go to the park with your kids? Just say no.

Can my body handle this food today, *right now*?

Finally, pull the pieces together. Given where you are in the moment, is the food that is tempting you an indulgence you can handle?

. .

WHAT I DO: WRITE IT DOWN!

You've heard me talk about keeping a journal to record your blood sugar. You can also use the journal as a way to keep track of what you are eating. Writing it down will help you be mindful of portion control and also with eating on a regular schedule. How about writing down not just what you eat but how that food makes you feel? When I first started tracking my feelings about food, I felt kind of overwhelmed by what I was discovering.

Studies show that we eat less when we keep a running tally of our daily intake. A food journal can also be a huge help when you're working through your steps. Deciding whether to eat that treat in front of you is a whole lot simpler when you can flip open your food notebook and make a quick assessment of where that treat fits in your overall eating for the day or the last few days. And writing down when something makes you feel lousy might be a good reminder to avoid it next time you are faced with that food. I used to think that food kept me from feeling. Uh, nope. Food made me feel lots of ways. It helped me to write these feelings down. It can be as simple as a note to self: *potatoes—bloated and bitchy,* or *bite of birthday cake and I need a nap.*

. .

I'd like to share a couple of stories with you about how these steps work for me in my everyday life. Here are some instances where I used my steps to work through decisions about food, with very different results.

Whoopi had a birthday not long ago, and the cast and crew at *The View* were celebrating. Now I love Whoopi, but what I remember most about that day was my close proximity to her GIANT red velvet birthday cake. Everyone around me was in a festive, let's-dig-in kind of mood. There I was, hanging out, smiling at everyone, trying to act normal. Meanwhile, my mind was racing: *Do I or don't I have a piece of that cake?* It's all I could think about. I could feel the impulse to grab a piece and inhale it before I had time to think it through.

I took a deep breath. And I asked myself, am I hungry? Well, I had a pretty good lunch right after we finished taping at noon, and it's only one thirty. So I'm not hungry, not really. Next I imagined what it would be like to eat a piece of that

cake. I could taste its sweet lusciousness in my mouth. I could feel its sticky smoothness go down my throat. The first couple of bites will be bliss, for sure. But after that? I fast-forward to an hour after eating that cake. I would have a headache. I would feel cranky. I'd be sleepy. I wouldn't have the energy to go home and help Jeffrey with his homework, or dance around the room with him. I decided not to have that cake. Success! Temptation avoided. . . .

But not for long . . . another afternoon, temptation and I met again in a dark alley. This time I was at a charity event, where trays and trays of delectable sweet things were piled high into a fabulous—and dangerous—array of temptation. Tucked among the raspberry cream swirls and chocolate éclairs, I saw that there was a small fruit tart. I worked my Sherri Steps again. I weighed in my mind the short-term pleasure of the treat against the longer-term ramifications of eating that tart. I thought about what I'd eaten so far that day. Turns out, I'd been good and had stayed right on track with my eating for the past few days. My energy level felt good. Plus, the party was the last thing on my schedule for the day—afterward I was headed home to put Jeffrey to bed and spend a quiet night with Sal.

I decided: one small tart, filled with fresh fruit, was something my body could handle that day. I ate that tart and enjoyed every bite, guilt-free!

The Takeaway: Work Your Steps!

✔ Identify your food weaknesses.

✔ Learn what hungry feels like.

✔ Manage your stress.

✔ Know your body and how you react to trigger foods.

✔ Use these questions to explore your real relationship with food. If my questions don't work exactly right for you, then create your own.

Am I hungry?

No, really: Am I hungry?

Why do I want to eat this?

Is this a safe food, or a dangerous food, or somewhere in between?

Is there some other food that I can combine with this food to lower its impact on my blood sugar?

What else have I eaten today?

How will it feel to eat this?

How will this food make me feel *after* I've eaten it?

What will this food enable me to do?

What will this food *prevent* me from doing?

Can my body handle this food today, *right now*?

Motivation

Like a lot of people, I learned about work from my mom and dad. I was raised by two incredibly hardworking parents, both of whom held down multiple jobs for years to support me and my sisters, to make sure our lives were comfortable and secure. These weren't cushy jobs, either. A lot of the work they did was physically tough and draining. My mom cleaned other people's houses. Do you know how hard that is on the body?

I remember how worn out I used to feel at the end of a day spent as her helper on the job—sore knees, achy wrists, a worn-out back—and I was a high-energy kid at the time. My dad worked as a cafeteria manager at a hospital during the day and then hightailed it off to another job waiting tables in the evenings. Both of my parents had sales jobs on the side to make extra money. My mom sold art. My father? He sold Mary Kay cosmetics.

My father was a charming man. Ladies who loved Mary Kay? They also loved my dad. My father was unreasonably good at selling Mary Kay loot. He moved a freight ton of blue eye shadow and mascara back in the day. For both my parents, their drive to work hard was the same. Their shared

motivation was our family. It wasn't until I had a child myself that I truly understood the love and devotion that pushed my parents to work those endless hours. I've been lucky enough to be able to thank my father, one parent to another, for everything he did for me during all those years. I was not so lucky with my mom, of course. Diabetes took her long before I became a mother myself, years before I was grown up enough to see her labor and toil for what it was: pure love.

The lessons I learned from my parents about working hard have helped me immeasurably in my career. In my business—television and film—working multiple jobs is just what you do. When the work is plentiful, you take it. You take on as much work as you can fit into a day or a week or a month. That phone is ringing? You pick it up and say, "Yes, I'll be there." Because someday—and you never know when that day is gonna come—the work might just go away. I hope that day for me is a long way off. Look at Betty White! She's got a full plate at age ninety-one! No wonder she's one of my idols!

But show business is shifty and unpredictable. These days, I'm busier than I've ever been, but I know that it can all disappear in a snap, so I am working extra hard while I can. When I was younger I blew through my paychecks as soon as I got them. Now I've grown up, wised up, and become a mom. Just like my parents were when they were raising me and my two sisters, I'm driven every day to work hard by the thought of making my son's present and future secure.

Yet somehow, for a long time I never was able to apply that same kind of motivation to my health. To be honest, I never even thought about it. When it came to eating and exercise, for many years I thought I could eke out the results without doing

the work. So many years—and so many failed diets—later, I can see now that my biggest problem was my motivation.

Well, what's wrong with wanting to look good, you ask? Nothing at all. I still want to look good. I want my husband to find me sexy and attractive. Please, let's be honest: I want complete strangers to find me sexy and attractive. I work on television, where the ten-pound rule is not only true, I think it's more like twenty or thirty pounds. So there's nothing wrong with wanting to look good. And if wearing skinny jeans well can help to motivate you to make healthful, reasonable choices with your diet and exercise, then go for it.

But looking good wasn't enough for me. The vision of myself with a flat stomach, flaunting around in a skimpy bathing suit, never was as compelling to me as the sight of a deep-dish pizza. Milk and cookies—or better yet, milkshakes and cookies—always won over tiny miniskirts and a trim middle. When looking good was my primary motivation, I always failed to keep up with diet and exercise—usually because the novelty wore off or I got the job and now it was time to relax and reward myself. I'd start out strong, have a few good days or weeks when I ate without bingeing and hit up the gym every day. But when the novelty wore off, I'd always give up. I'd abandon the gym and the salad, and fall back into the same old unhealthy patterns.

But underneath, I think there was something else that made me slack off the diet and exercise I knew was good for me: I didn't really believe that I could change my ways.

What finally uprooted that big fat lie? Becoming a mother, first of all. Then, becoming a single mother. When it was me and my son together, just the two of us, I could no longer deny

the risks I was taking by ignoring my health. They were staring up at me in those adorable, loving eyes and round toddler cheeks. My motivation? Looking good fell to the bottom of the list. Staying alive to parent my child went right to the top. When I had my baby in front of me to inspire and motivate me, when I started to make the changes and realize I was making real, lasting changes that I could live with, I finally, truly believed that it was all possible.

What Drives *You*? Finding Your Motivation

Whether you're diabetic or prediabetic, or you want to lose weight to improve your health and avoid the Big D altogether, you're making some important changes to your everyday life. Motivation is the fuel you'll need to power these changes. Just like our bodies respond differently to food—what sends your blood sugar soaring is different from mine—we are all motivated by different sources. I can't tell you what, exactly, will keep you motivated—the answer to that is going to be very personal—but I will help you find that inner place and will share with you what works best to lift me up and keep me going.

Imagery

Imagery has been a huge help to me to stay motivated. For me, the most powerfully motivating images have to do with my son, Jeffrey. When I'm feeling tempted by food or feeling like I'd rather skip a workout, I go right to images of my son growing up without his mother because I didn't take care of my health. Imagining these situations isn't easy—it hurts. But that's part of the point.

I close my eyes and envision Jeffrey needing me—and me not being there. I imagine the everyday moments and the big milestones my son will go through during his life. What would they look like without me?

I see Jeffrey coming home from school in the afternoons. He busts through the door, all legs and arms and elbows swinging, shouting at the top of his lungs, racing to the kitchen for a snack. Who is there to greet him if it's not me? When he settles in at the kitchen table with his school books, who is there to help him with his homework? (Yeah . . . gotta be straight with you: this one never quite works the way I want it to. Jeffrey needs his mommy for many things, I know, but algebra might be something I can't help with.)

I picture Jeffrey after he wakes up from a bad dream, or when he's home sick from school. He's tired and scared, curled up in his bed looking very young and very vulnerable. I imagine him reaching out for someone to hold him. And I ask myself: Do I want to be the one there to comfort him in those moments?

I imagine Jeffrey at his graduation ceremonies, from high school and college. I see him horsing around with his buddies as they march down the aisle, cheering for his friends as they accept their diplomas, giving the crowd a goofy bow as he walks across the stage to accept his own. When he is up there on that stage and searches the crowd for his family, is he looking for me? Am I cheering him on, waving my arms and hollering his name right there in the audience? Or will he spend those days with his mother only as a memory, thinking, *I wish she could have been here to see me. . . .*

I imagine his wedding day. This is a tough one. It's hard

enough to think about my baby being a grown man. I'm not ready for that! I want to savor every day he's a little boy. But I do it anyway, because it brings my reasons for living right into focus.

I imagine my son as a man, tall and handsome and smiling. He's nervous, standing in front of a church full of people. He might be fidgeting a little in his tuxedo, but he'll also be laughing and smiling with the friends who stand up with him while he waits for his bride to walk down the aisle. Will I be in the front pew, holding court in an embarrassingly bright-colored dress and crying like a complete mess? Or will he be lighting a candle to mark my absence and trusting that I can see from heaven what's happening on this important day?

These scenes aren't easy to think about. But they keep me focused. They are the punch to the gut that I sometimes need to keep taking care of myself.

Who are the people in your life you'd like to stick around for?

Answer that question and you'll be well on your way to finding some deep and serious sources of inspiration and motivation to get healthy and stay healthy.

How imagery works

There's nothing fancy or complicated about using imagery. It doesn't need to take a lot of time. You don't need any special training. You can do it anywhere, whether you're alone in your apartment or in a crowded room.

Imagery is a lot like daydreaming. I don't know about you, but I'm a wicked daydreamer. I always have been. I was the kid in class who stared out the window, thinking about all the trouble she was going to get into as soon as that bell rang.

I was the legal secretary who pushed papers across her desk while in her head she was horsing around onstage. Today my daydreams are about simple stuff. I'm no different than any mom: I daydream about sleep. When I was flying back and forth between NYC and LA, racing from rehearsals and performances for *Dancing with the Stars* to get a flight back to host *The View* the next morning, I distinctly remember daydreaming about a hot bath that would last for about a day and a half.

Imagery doesn't have to be about another person. You can use this same technique to envision all sorts of bright spots you'd like your very own future to include.

YOUR DREAM BOARD

Use imagery to create pictures of the dreams for your life that you'd like to make real. Then, use those pictures to help keep yourself motivated and on track, day by day, as you work to change your diet and your health. Get creative, and think big! I'm living proof that the scope of the dreams you can achieve is only limited by your imagination. And sometimes dreams have a way of surpassing even those things you can imagine.

Here are some ideas to get you started. Think about:

Places you want to travel to

What are the sights you want to see in the world? How do you want to feel when you're traveling, passport in hand?

Special moments with your sweetheart

Whether it is dancing together at a fancy party or playing around on the beach—what are the special moments you'd

like to share with your sweetie? Imagine yourself feeling sexy and energized and healthy during all those special times with your true love.

Changes to your work life

Are you an office dweller who secretly longs to work outdoors? An accountant who'd like to teach yoga? Take it from a former legal temp: you can make the leap you dream of making. Your stamina, your energy level, and your health can support you in these dreams.

Your fitness goals

Imagine yourself . . .

> running a 5K race.
>
> swimming ten or twenty or thirty laps in the pool.
>
> hiking a mountain.

No matter what your dreams are, you're going to need your health to achieve them.

Can you think of a better dream than living a long life?

. .

Watch this way: four ways to use imagery

Here are some everyday situations where simple imagery can make a big difference, helping you to stay motivated with the changes you're making.

To relax and focus before a workout

This can be especially helpful when you're just starting to make exercise a routine in your life, or if you're trying something new. Remember how I used to show up at the gym and

only get as far as the juice bar? I wish I could go back and tell that scared girl to take a deep breath and relax. I would tell her to close her eyes and imagine herself walking into the workout room, head held high, feeling good. Feeling good 'cause she knows she's taking her health in her hands, and that's a powerful thing to do. Imagine herself stepping up onto the treadmill feeling prepared, not afraid.

Scared to start a workout routine? Intimidated by the gym scene? Worried you won't be able to follow along in dance class? Don't make the mistake I did. Don't let your fears stop you from just STARTING something. Use imagery to see yourself having fun and feeling good while exercising. Start with the basics: imagine yourself walking, playing tennis, or dancing. Rehearse that image of yourself again and again.

Before a meal

When you're first trying to establish new eating habits, using imagery can help strengthen your resolve to eat differently. While you're preparing your food, take a moment or two to see yourself eating: You're savoring your meal, not shoveling it in and instantly looking for more. You're taking the time to taste your food. You're aware of beginning to feel full and you listen to that feeling. You put down your fork and push your plate away, feeling satisfied, but not stuffed. Take a moment to imagine how proud and good it feels to eat well, and take care of your health at the same time.

In situations where you're vulnerable to food

Imagery also works well in combination with the Sherri Steps. When you find yourself faced with temptation, don't

just think your way through your steps—imagine your way through them. Picture yourself eating the food you're tempted by, and imagine how you'll feel after you've eaten it. Imagine the tiredness you'll feel twenty minutes after scarfing down a candy bar or a packet of cookies. Have you learned from paying attention to the way food makes you feel that over-eating makes you feel guilty? Go ahead and picture yourself with those painful feelings of shame. Now look again at that tempting food. Ask yourself: Is it worth it?

To manage stress

As I've already explained, stress is a huge trigger for me when it comes to making bad food choices. It doesn't take much to get me stressed, and in the past that led me straight to the food that would do nothing but make me feel worse. Visual-ization can be a powerful tool in managing stress, too—and science backs me up here. Research has proven that visualiza-tion can reduce stress levels by lowering blood pressure and increasing a sense of relaxation in the body and mind. Vi-sualization also increases performance—yes, every time you imagine yourself hitting that tennis ball or walking up those stairs you are strengthening your ability to do so. Visualiza-tion is a form of mental practice, and as the old adage says, practice makes perfect.

HOW IMAGERY HELPS REDUCE STRESS

You can use imagery in a couple of different ways to cope with stress.

Imagine yourself taking action.

Sometimes when I find myself in a stressful situation, I'll use imagery to picture myself taking action to deal with this situation in a direct, grown-up, confident way. If I'm stressed out about a fight I had with a friend or a tense exchange with someone at work, I'll take a moment to envision myself working to resolve the problem at hand, and feeling good while doing it. This calms me. It also helps push me toward dealing with my stressful situation directly rather than coping with a deep bowl of pasta.

Imagine yourself relaxed.

When stress is making me tense, I'll use imagery as a pure relaxation tool. This works really well in situations where you don't have a lot of control. When I'm stuck in traffic on the way to the airport and feeling my blood pressure rise, I close my eyes and picture myself in a hammock on the beach, with a soft breeze blowing.

Experiment with the type of images that work best for you. There's no right way to do this. What's most important is that you have images at the ready, so that when you feel yourself getting stressed, you're prepared.

Create Your Team

If you followed me on *Dancing with the Stars*, you might know that Val and I had a pretty enthusiastic cheering section going. This was Team Sherri and they were awesome. Team Sherri had T-shirts and hash tags on Twitter. The truth is Team Sherri has been around for a long time, in a different version, and without the cute T-shirts. I've had a team rooting for me every step of the way in my diabetes journey. And they

have been a profound source of motivation, inspiration, and encouragement for me. Don't get any funny ideas here: when I talk about Team Sherri, I'm not talking about an entourage, à la Brangelina. You might see me on television, but trust me: my entourage consists primarily of the folks I ride the subway with every day.

Nope, my team is my family: my husband and my son, my dad, my sisters, nieces and nephews. My team is my friends: friends from as far back as childhood, friends I've made every step along the way through my life. Elisabeth, Whoopi, Joy, and Barbara are on my team. Val is on my team. (So is that other cute Chmerkovskiy brother, Maks! I'm a lucky girl.) My team is my doctors. My Twitter peeps are my team, every last tweeting one of them. Heading up my team? God.

It can feel daunting to face the changes you're facing. The amount of work involved in breaking old, bad habits and replacing them with new, healthy ones is substantial. I have never felt as alone as when I was facing down my diabetes. I was sick. I was scared—of so many things. Scared of dying. Scared of being hungry. Scared I wouldn't be able to lose weight, to stick to a new regimen. Scared of giving up the foods that I was addicted to, that I had used to comfort me. Scared of working up a sweat, of going to the gym. Scared I would fail as a mother. Scared my son would live out his childhood without me. Any of this sound familiar?

Making changes is scary. It took me a few times before I could look past my fear to what was really at stake before I had the courage to really start making changes.

Your fears may not be exactly what mine were. We've all got our own weaknesses, our own vulnerabilities, our own jour-

neys that brought us to this place. And that's what we have in common. We've all arrived at a place where we know we need to change. Not for a little while, not just until those skinny jeans fit or until our high-school reunion comes and goes. This time, we're talking about change for good.

So, whether you're trying to lose weight or you're working to turn your prediabetes around, or you're facing a new life of managing your diabetes, it's time to create your team. This is really just another way of saying that you should take a look around you. Who are the people in your family who can support and encourage you to make these important changes in your life? Those folks who just popped into your head? Recruit 'em.

Who are the friends—old or new—who will take a phone call when you're down, who'll go to the doctor with you when you need a hand to hold, who'll cheer you on as you drop pounds and add miles to your life? Sign those folks up.

Your doctors are on your team. Don't forget them, and for the love of Oprah, don't ignore their advice. Your doctor may not be your best bud, but he or she is rooting for you. Not too long ago I went to my doctor for a regular check-in and she told me I have the blood pressure of a ten-year-old. Now that felt *good*. After all the hard work I've been putting in for all these years, it's thrilling to hear things like this from the very experts I used to fear and do my best to avoid. Thrilling—and also motivating. I left that appointment flying high, and feeling like I could just keep climbing. Add your doc to the list of people on your team.

Now think about how you can widen your circle. Your team doesn't need to include fifty or five hundred or five thousand

Twitter followers, unless you want it to. Creating your team is about looking around your life and recognizing the good people in it, the people who are ready to support you as soon as you let them. Reach out to those folks and let them in a little bit closer. Do the same for them. And please remember that I'm here for you, too.

Self-Talk . . . and Praying It Out

Prayer motivates me. Talking to God helps me stay on track and makes me want to work harder. It also clarifies what's really important to me. I don't talk to God about wanting a twenty-nine-inch waist. I talk to God about wanting to live a long life so I can take care of my child. I talk to him about staying on track with my diet and exercise so I can show Jeffrey, and my nieces and nephews, what living a healthy life looks like, so they don't have to stumble on their own way toward good health like I have. Okay, okay, every now and then, I might bring up the subject of a little divine assistance with my waistline.

All the time I spend talking to God is time I'm not tempted to listen to the negative voice in my head—the one that tells me my goals are too ambitious, my dreams are too big. That's the voice that used to send me to the refrigerator or the junk-food aisle. That's the voice my conversations with God help me to silence.

You don't have to talk to God. You may not share my beliefs. That's perfectly fine. But you do need to be able to replace that naysaying, tear-you-down voice in your head. The voice that fixates on your shortcomings and ignores your strengths—the one that magnifies your failures and forgets all about your ac-

complishments. Yes, that one. This one will rise up and always try to bite your butt.

Motivation, I've found, is not just about building myself up. Finding support wherever you can, celebrating your progress, cheering yourself on are all important parts of staying motivated. But in order to really stay motivated to make these kinds of long-term changes to your health, you also need to work at getting rid of the negative self-talk that brings you down. I'm talking about that naysaying voice that tells you that you can't do something. I struggled with that voice for many years. And I still do. But I've gotten a lot better at silencing that voice in my head that says no to a goal or a dream I'm determined to achieve. It doesn't mean that new things don't frighten me. They do. I've just decided to do it scared, remember?

So you need to have your other voice ready and waiting.

I know this lesson well. During *DWTS*, I was always terrified. Even when I knew millions were rooting for me, I still felt doubtful—*Why am I on this show? I'm not a dancer. I'm not as thin or pretty as Maria or Karina.* And on and on.

Then I'd say to myself, "You are special, Sherri. You bring the funny. You bring your smile. You bring the light."

We may not all bring the funny, but we can all bring the light of our own specialness. Now, right this minute, think about your specialness. Think about your light. Write down a phrase or two to answer the negative. Say the words aloud. Say the words aloud again. And remember them whenever you need a lift.

WRITE NOTES TO YOURSELF

I have packets of sticky notes around the house and at my office. I use them for grocery and to-do lists and reminders. I also use them to keep me motivated. I'll leave myself messages on the fridge—*You have the power to make yourself well!* is currently stuck to that door. If I come across an inspiring quote, I'll stick it to my bathroom mirror or on the wall of my dressing room. You never know when temptation is going to strike. Simple motivational messages—you know what works best for you—can help keep you feeling positive, energized, and focused.

Here are some of my notes to myself.

Get up, girl!

Go wiggle your butt!

Today is going to be a beautiful day!

Make today a beautiful day!

I know you're tired, but you can do it!

Social Media

I'm telling you, I was made for Twitter. Or Twitter was made for me. Either way, I'm a Twitter-head, a complete tweet freak. It's an instant shout-out, any time of day or night, and a way to connect immediately with people in a circle that can span wider than you ever imagined. I connect with my tweet peeps for encouragement, support, prayers, and laughs. The folks I tweet to and from are blunt, funny, and kind. They keep me honest, and they build me up when I'm flagging.

My followers and I tweet talk about every subject under

the sun—the challenges of staying healthy, of being working parents, of relationships. I tweet when I need a boost, if I'm dragging during a workout or tired after a long day. I tweet when something good happens, when I'm feeling great and want to share that joy with others. I tweet to show love for the people who inspire me. It's like a big, funny, slightly random group therapy session! I love it!

I know some of the people I talk with on Twitter in person, but most of them are strangers to me in actual life. Every now and then I'll meet someone who follows me on Twitter and we have a moment. It's a funny thing, like meeting a friend you already know. I'm so enamored of chatting with my Twitter community that Sal sometimes has to remind me late at night that it's time to power down and come to bed.

Social media like Twitter and Facebook gives us all a place to go for instant feedback and support. There's a great give-and-take that goes on in social media. When I'm looking for a motivation boost, Twitter is sometimes the quickest way to reach out to others. Especially when it's an odd hour of day or night.

I remember a Monday morning not long after finishing *Dancing with the Stars*. I was still wiped out, sore from my shoulders to my heels, and, to be honest, pretty sad about having been eliminated from the competition. I was feeling low. Six a.m. came pretty early that Monday when I roused myself out of bed to meet up with my trainer, Kira. We've been working together a few times a week for a few years. I dragged myself out of bed that morning, before it was even really light out. Sal was sleeping happily, still, blissfully unaware that I'd left our cozy bed. All I wanted to do was crawl back into bed

and curl up next to him. Instead, I grabbed my phone and sent out this tweet:

> Listening 2 sounds of @SalfromtheD & Jeffrey as they sleep—waiting 4 my cab 2 go see @Kirastokesfit— wondering why I'm not snoring with them.

Before my cab pulled up to the curb, I had this tweet in response, from none other than Ms. Kira, my trainer—and tweeter—extraordinaire:

> @SherriEShepherd: Because you want so badly to be healthy for both of them . . . and yourself. See u soon xo

Talk about putting it in perspective! That tweet moment turned my mood from one of dreading my workout to feeling psyched and determined. I worked hard that day, harder than I might have otherwise. And I was rewarded with this—again from Kira—shortly after my workout ended:

> Just need to say how proud I am of @SherriEShepherd for how far she's come since our 1st training session 2 years ago #inspiring

It's easy to think of this kind of communication as instant and also disposable. But let me tell you, that tweet from Kira is one I won't forget.

Engaging on social media sites like Twitter and Facebook is easy and doesn't cost a thing. They can open up whole new communities for support and motivation. This way of joining a community also helps to take the focus off yourself a little—you can help others on those platforms, too, and you learn from hearing from others that no one is alone in their struggles.

SOME OF MY TWEETS

Just arrived in NYC. All I can think about is burying my face in Jeffrey's neck. Geesh what the heck was my life like before I had a child!

Waiting to go onstage . . . instead of going over my set I'm wondering if Jeffrey went to the potty & brushed his teeth #motherguilt

So excited. At the doctor and she said I have the blood pressure of a 10 year old. Exercise! Water! = Great health!

Worked out . . . can't describe the feeling as I left the gym. I actually wanted to stay. Feels good feeling good. #health

I love my sis, Lisa—raised 5 kids, put herself through nursing school—true hero cuz she does it scared every day.

USE MUSIC TO MOTIVATE YOU

Is there any better mood booster—or motivator—than music? I keep my phone full of my favorite songs, ready to lift me up when I need a kick to get myself to the gym. Listening to music while working out can also help you push a little harder, exercise a little longer, and feel happier while you're doing it! I love to listen to CeeLo, Beyoncé, and gospel when I'm about to quit. I also love to listen to what I call "sexy" music—Natalie Cole is one of my favorites. When I'm working out and listening to her voice ring, I feel so good and think I look so good. I imagine walking in the front door in front of my husband!

CARRY PICTURES OF WHAT FIRES YOU UP

Remember when we used to carry photos in our wallets? (If you're too young to remember this, I'm pretty sure it's past your bedtime.) These days we can carry around whole photo albums on our phones. I keep pictures of Jeffrey and of the two of us together on my phone. When I'm feeling tired or down, if I'm wavering about whether to walk through the park on my way home or take the train, I'll pull up a photo of my little man—and remember what my efforts to stay healthy are really all about. Keep yourself armed with photos of what motivates you the most: this could be your kid or your parents, your cat or your parakeet, sights from the dream vacation you're going to take. Whatever gets you in the mood to take care of yourself, take a picture, and study it!

And You're Not Too Old!

You're never too old for change. Don't let anybody tell you otherwise, most especially yourself. I've made nearly all the positive changes to my diet, exercise, and health in my forties. I can't afford to think of fifties or sixties as too old for anything—except maybe skydiving or waterskiing. This time, now and going forward, is my prime time. It can be yours, too, whether you are twenty-five or sixty-five.

Whenever I think about age as a reason not to do something, I think about my life as a mom. I had a baby—and promptly became a single mother—in the very last gasps of my thirties. There are certainly things about being a mother that must be easier for younger women. And I'm not even talking

about the fallout—and I mean actual fallout—to one's boobs. Becoming a mother in my late thirties robbed my poor, suddenly life-giving breasts of the very last of their glory days. No question. No, I mean things like running around for hours with your kid before getting tired and needing a break. Or having people think you're the babysitter, not the mommy. That sounds like it would be a lot of fun, right? Nobody is ever gonna mistake me for the babysitter. Heck, if Sal and I ever had another child, I'd have to keep vigilant against being mistaken for the grandma!

But then I think about who I was when I was twenty-three, or twenty-five, or even thirty. I was a lot of fun, but I was also an idiot. A full-blown fool. By the time I became a mother, I had finally started to smarten up, to wise up to some of the basic wisdoms of life that I'd ignored for so long.

I am a good mother to my son, in a way that I never could have been in my twenties, or even a good part of my thirties. It's no coincidence that I finally was able to take control of my health around this time as well. I understood the stakes, finally.

This is the true power behind getting older. Sure, your bad habits have been around longer, but you're smarter than you were ten years ago. Or twenty. And you know how precious each day is, so you don't want to waste a single moment.

And You're Not Too Fat!

I know how this feels. When I was at my heaviest, I didn't want people to see me. I was embarrassed. The last thing I wanted was to go to the gym, where everybody looked great, or so I imagined from my perch on the couch. Turns out, when you

go to the gym, you'll see all types of bodies. And everybody there is too busy worrying about how their own butt looks in workout pants to give a %&*# about how your backside looks.

I'd love to be able to go back to my fattest self and tell her the truth: that she's going to start feeling better—and different—sooner than she can possibly imagine. That she doesn't have to parade into the gym in tight spandex. That she doesn't have to go to the gym at all. All she's got to do is move a little bit every day, and stick to eating the foods that are good for her body. That she doesn't even have to do it all at once: she can make small changes every day, and these changes will accumulate to major results. That she'll be happier—and healthier—than she could ever have dreamed if she'd just do it scared for a little while. That it's never, ever too late to change.

I can't go back and tell fat Sherri those things. So I'm telling you instead: You can do it. You will do it. And you will feel so much better for it.

It's Not Too Expensive!

Making these changes takes a lot of work, I won't deny that. The trick is to break up the work into small steps, and tackle them one by one. But what these changes to your diet and your exercise don't require is a lot of money. You don't need a gym membership to exercise. You don't even need any equipment or special clothes. A pair of comfortable sneakers or walking shoes, some loose-fitting clothes you can move around in, and you're good to go. Same goes for the changes to your diet.

Eating healthfully doesn't have to be more expensive, especially if you're willing to roll up your sleeves and do a lit-

tle chopping and stirring. Being able to cook for yourself is one way to ensure that you're eating the very best foods for your body—without any mystery ingredients slipped in. It's also good for the pocketbook because eating at home is a lot cheaper than eating out. If you've never cooked before, now is the time to learn. Start simple. Make a salad. Make some soup. Buy a copy of one of these popular healthy cookbooks— the *Betty Crocker Healthy Heart Cookbook* or *Cooking Light Complete Cookbook*. You don't have to go full-on Julia Child right away. You can also find some tasty but healthy recipes for those of us with the Big D or prediabetes on the websites of Paula Dean (pauladean.com) or Rachael Ray (rachaelray.com). Both of these master chefs have slimmed down many of their delicious recipes, making them suitable for us!

There is nothing like the feeling of getting healthy. This is the secret motivator that you can't really discover until you start. The changes that happen to your body and your mind as a result of exercise make you want more. You might not believe me now, but trust me: you start exercising and eating right, and you're gonna start to want to exercise and eat right. I promise. Been there, done that, and it feels sooo good!

Forgiveness

I have a lot of experience with forgiveness. That's because I've messed up. A lot. I have whole lifetimes of stumbles and mistakes crammed into my forty-odd years. I've also been on the receiving end of some tough times, when I needed to be the forgiver, not the forgiven. Friends who let me down? Got 'em. Family squabbles? More than a few. Oh, and a (now former) husband who got his mistress pregnant . . . while we were expecting a baby? Uh, check.

Still, it's taken me well into adulthood to really begin to recognize the beauty in the act of forgiving, to understand how forgiveness really works, and how essential it is to living a healthy life. I'm not just talking about the ability to forgive others. That kind of forgiveness is something we all must learn how to do. It can be difficult, and we don't all do it easily or even very well all of the time. But unless you're planning on living a Robinson Crusoe–type existence, alone on a desert island, you're going to be practicing forgiveness on somebody at some point in your life. None of us gets out of this life without having to let go of a hurt or a disappointment caused by someone we love.

But there's another kind of forgiveness. One that's harder in

many ways than the forgiveness of others. I'm talking about the ability to forgive yourself. This one's *waaay* trickier. And I do think it's possible to go through life without ever learning how to do this. I know because I was headed on this path for a long time.

Faith, funny, and food. Remember those? Each has taught me something essential about forgiveness. Funny? Well, that's easy. Comedy needs imperfection. I think we all know this instinctively. Perfect just isn't funny. It's our flaws, our mistakes, our oddities that make us laugh. From the time I was a kid goofing off at recess to my first, doing-it-scared steps onstage, I've been using my imperfect life and wildly imperfect choices to get laughs. You'd think with all the attention—celebration, even—of imperfection that goes along with being a comedienne that I'd be a natural at forgiveness. *Yeah, not so much.*

As a comedienne, I accepted my imperfections for the sake of the jokes. This wasn't something I did in my personal life. I could make a roomful of people laugh with jokes about my life as a woman with curves, then go home and stand in front of the mirror, staring at that same body I'd just flaunted in front of strangers, and think nothing but critical, self-loathing thoughts. This usually led me straight to the pantry for some coffee cake. This only led to more self-loathing. It was a cycle that included no room for forgiveness, only anger and criticism. And elastic waistbands.

And I wondered why I couldn't stick to a diet or exercise plan. It's probably no surprise to hear that my relationship with God has taught me many incredible lessons about forgiveness. My faith has brought me so much joy and so much

relief at being accepted and loved unconditionally. I believe we all have our own, individual spiritual path to follow—what makes sense to me in the God department may not do it for you. What I hope for you is that you can experience that feeling of complete and total acceptance and forgiveness, wherever it comes from.

For me, that feeling came from God. But not before I did my best to avoid him for years.

I struggled at times as a child growing up in a strict religion. Not with God, but definitely with church and rules. The Jehovah's Witness faith that I was raised in was a pretty buttoned-up, heads-bowed-in-silent-prayer sort of environment. It was orderly. It was serious. It was awfully solemn and still. For some people, that is the perfect spiritual climate: cool, self-contained, quiet, and tidy. I tried, I really did, but that culture of faith never felt like home to me. All that tidiness didn't match up with the messy tangle of feelings I had inside.

For a long time I thought God and I were finished. Not because I wanted nothing to do with him, but because I couldn't imagine that he—much less a community of faithful people—would want anything to do with me. I'd lived a life full of too many unforgivable acts. I'd made too many mistakes. And I'm not talking about forgetting to return a library book or neglecting to feed a parking meter. I spent years thinking it was too late for me to ever go back to any kind of relationship with God. I'd messed up too many times, on too grand a scale. Sleeping around? Check. Abortions? Check.

It took me well into my thirties before I was so tired of feeling frightened and alone that I went to my knees and called

to him. It was a desperate call, but also a tentative one. *Hey, uh, Lord? Yeah, um, it's me, Sherri. Sorry to bother you. I was just wondering if maybe—*

You're home! Finally! I'm so glad! Now where were we . . . ?

It wasn't until many years later, when I attended a Pentecostal church, that I found a place of faith that spoke to me. If you've never been to a Pentecostal service, it is something to experience. Hands and arms are flying, people are flinging themselves into aisles, and there's plenty of yelling and screaming and speaking in tongues. *Hallelujah!*s and *Yes, Lord!*s are bouncing off the walls. And this is from the congregation! All the while, the preacher is shouting his sermon, or the choir is singing at full tilt. It's hot and it's crowded and it's completely chaotic. When I walked in that first Sunday, I knew I was home. This was the kind of church that was made for me.

Getting back to God was like walking into an embrace that had been waiting right there for me to fold myself into. It was the best hug ever. And the very best part? Once he's got you, he doesn't let go. I understood in that moment, and in countless moments since then, what true forgiveness means. It's not that God plays dumb or pretends not to see our mistakes. He sees every one. He's just not in the business of judging. God doesn't keep score. The God I know sure doesn't. He's just love, all the time, no matter what.

I don't expect anyone to pray or believe as I do. I learned through my own crooked path back to faith that there's nobody but you and God in your relationship. You don't need a

pastor or a priest to translate or to manage that relationship for you. You certainly don't need me telling you how.

What I will tell you is that if you want God in your life, he's already there.

My journey back to faith showed me how true forgiveness works. It's made me a gentler person with others, a better mother, wife, daughter, and friend. But I still had things to learn about forgiveness.

My stubbornness around my health was a tough shell for even God to crack. And the negative, critical voice in my head—the one that told me I was too weak to change, too in love with bad food to let it go, too lazy to work out and lose weight? For a long time I chose to listen to *that voice* instead of to God. Or to anyone else who might be talking sense to me about my health. It took my diabetes diagnosis, the Big D—and a warning from God that had turned from a whisper to a roar—to wake me up to the changes I needed to make if I wanted to stay alive. I'm talking about losing weight and changing my eating habits. I'm talking about daily exercise and a new, balanced relationship to food. I'm talking about managing stress and finding ways every day to stay motivated.

And I'm also talking about forgiving myself for the times when I don't follow the plan, when I eat poorly or stay in bed instead of working out. When I let stress or fatigue drive me to overeat. As much as I've dedicated myself to changing the habits that made me sick and were threatening my life, I've also had to learn how to be gentle and compassionate with myself for not doing it all perfectly, all the time. Because NO ONE is perfect all the time. Do you hear me?

The ability to forgive . . . *yourself*: it's the last—and maybe the most important—piece of Plan D. It's the piece that allows you to let go of a mistake and fall right back into your routine. It's the piece that lets you concentrate on things that make you feel good—losing weight, eating well, getting physically fit—instead of being dragged down by that old, tired voice in your head that dedicates itself to making you feel bad.

Ready to learn how to be a whole lot kinder to yourself?

Plan to Forgive Yourself

If you wait until after you've strayed from your diet or exercise plan to think about how you're going to cope with falling off your program, it will be too late. When it comes to forgiveness, you're trying to change some deeply ingrained habits of being hard on yourself.

Think of that negative, hypercritical voice in your head in the same way as you think about the fatty, sugar-filled foods that you're trying to give the heave-ho. That voice is a bad habit. It's dangerous to your health, to the extent that it prevents you from feeling powerful and capable enough to kick your old habits out the door and usher in some new ones.

And like the eating habits you're now working to change, that negative inner voice is a habit you've probably had for a long time. I did. I spent many years tearing myself down inside my own head. That voice held me back from change and prevented me from showing myself compassion at the very times I needed it most.

And just like I had to work my way step by step through my food issues and my aversion to exercise, I also had to learn

how to forgive myself, to let go of my mistakes. It didn't happen overnight.

Just like you're going to plan your meals, schedule your exercise, and be ready to work your steps, you're also going to plan to forgive yourself and be kind to yourself when you stray from the plan. You have to be prepared and have the feelings of forgiveness at the ready.

Developing your forgiveness strategies
Treat yourself like you'd treat your best friend.

So let's say your closest friend calls you, crying. She's so upset she can barely speak. Suppose she had a terrible fight with her boyfriend. She was so sad that she followed it up with a stop for some cheesecake. Not a piece of cheesecake, a whole dang cheesecake. And she ate that thing up. Now she's feeling sick and very low. Upset about the boyfriend and now mad at herself for diving into that cheesecake. What was she thinking? What would you say? You might point out to her that she's dropped twelve pounds in the past year. You'd point out how hard she's working at everything in her life: at her job, at taking care of her family, at keeping her house running, at her relationships. You might remind her that she's been managing to get to the gym three days a week, just about every week—even that time she had a cold and PMS *at the same time. That,* you tell her, *was impressive.* You get my point, don't you? We're quick to give others credit for all the things they do right and to put their shortcomings in context. We jump into action when our loved ones need a pep talk or a shoulder to cry on. Try doing it for yourself!

It's okay. It's not that bad. It will pass. You didn't do anything wrong.

How many times have you said words like these to other people? And yet we're so reluctant to say them to ourselves. When you find yourself zeroing in for some serious self-hate, stop. Now imagine you're about to talk not to yourself but to that friend.

I practice this little trick all the time. It instantly changes the script in my head.

REPLAY YOUR DAY THE RIGHT WAY

Why is it that our "failures" get so much more attention than our successes? We all do so many things "right" during any given day, and yet it's the stuff that's "wrong" that we spend so much time thinking about.

One way I've found to help myself be more forgiving with my slipups is to pay a lot more attention to the things I'm doing well every day. At night when I'm winding down, saying my prayers, and getting ready to fall happily into bed at last, I've added another step to the routine. I take a moment or two and give myself credit for what I did that day.

This isn't about grand, sweeping accomplishments. Let's face it, those are special occasions. Most of us know how to celebrate big milestones. I'm talking about little, everyday milestones that we're not so great at recognizing. What do I mean by small milestones? I didn't take even a bite of the donuts in the office kitchen. I took the stairs

instead of the elevator. I said hello and made eye contact with the old man at the corner grocery store instead of whizzing on by. When I replay my day, I can remind myself that these small gestures—some about food and taking care of myself, others about being more attuned to all the good in the world—make me feel good about myself.

Becoming conscious of the good things your do—for yourself and for others—doesn't require a lot of energy or planning. Believe me, at the end of the day, I'm not good for much but the simplest of routines. So while I'm brushing my teeth and washing my face, I replay the day, focusing on what went *right*. Until I started doing this, I had no idea how many small moments of victory there are during the day!

. .

Dig a little deeper.

If there's one thing I've learned through my journey with diabetes, it's that there's almost always something going on *underneath* the impulse to eat. Especially when it comes to bingeing on high-fat and high-sugar foods. Back when I used to reach for the biggest bag of chips I could lay my hands on or indulge in three-in-a-row Pinkberries, I wasn't doing it because I was hungry. Sure, hunger might have played a part— especially if I'd been trying to lose weight by denying myself decent food. But after the tenth handful of chips or the second slab of cake, there wasn't much cause for me to be hungry.

And yet I still ate. And I always beat myself up.

I told myself I was hopeless. I convinced myself I had no willpower when it came to food, no power at all to change things about my eating and my lifestyle that weren't working.

Finally I learned that the negative, shaming voice in my head was telling lies. But it took a long time for me to really heal that person inside who wanted to be covered up with food.

We each have our own story. We each have had our share of pain, loneliness, and suffering. When we use food to stamp out or bury feelings, more than likely there is some reason that we're doing it. Perhaps it's a trauma; perhaps it's a childhood spent taking care of someone like a parent instead of being cared for. When children grow up and even their simplest needs are not met, they will look for comfort and solace elsewhere. And many times this is found in food.

So as you go through your steps (whether you call them your Sherri Steps or not) and begin to ask yourself those powerful questions before making your food choices, tune in to some of the memories that may wash over you. Begin to take account of the painful events, the feelings of resentment or injury you hold on to. If those are past events, you may want to let go of the feelings. Are they really any good for you now anyhow?

For those of you who have suffered loss, maybe you want to look at more self-enhancing ways to fill the loss. Maybe it's time to put food in its place so it doesn't take you down with it.

Here's the whole truth: sometimes your steps won't work. Sometimes you'll ask yourself all the right questions, examine your motives thoroughly, think about your health and your future and your blood sugar and your A1C levels . . . and you'll still dive into that piece of chocolate cake. Maybe twice. It happens to me and it will happen to you. So, now what?

Don't get sidetracked by berating yourself for slipping up. You've got better, more important things to do. Go back to your steps and ask yourself again: *why this food, why now?* You aren't asking these questions with shame or recrimina-

tion. You are just doing so with a desire to understand yourself better, so you can do better the next time you're in a similar situation.

What better way to salvage a fall off the healthy-eating wagon than to learn from your tumble? The more you know, the better able you are to say, "No thanks," the next time temptation comes your way.

Don't avoid your mistakes.

Oh, this is well-traveled territory with me. I used to spend so much time trying to avoid/deny/bury in the backyard of my psyche the mistakes I've made. Overspent on my credit card? Just don't open the bill. Gave the runaround to a guy I wasn't into? Just keep screening his calls. Ate my way through a family-size bag of chocolate chip cookies in one sitting? Stuff that bag down to the bottom of the garbage can and don't look back.

I'm sure it won't shock you to hear that this avoidance strategy never worked out in the end. That bill I refused to open? I still had to pay it, only with extra fees and penalties for lateness. The guy whose calls I avoided? Pretty quickly he moved on and stopped calling. Smart man. I was the one who carried around that dull, lousy feeling of having been unworthy. I'd chase that feeling down with yet another pancake breakfast with a side of bacon and sausage.

It's taken me to middle age to get here, but I now, finally, understand that just trying to wish away something difficult won't make it go away. Neither can a super-sized soda and a bucket of popcorn. I know now that owning up to a mistake is far easier, in the end, than pretending it never happened or that you weren't involved. I've also learned to push myself in

this area: to own up to my missteps as soon as they happen. Yes, when faced with the choice between fruit salad and fried dough, I ate that cruller. Trying to convince myself it didn't count because I ate it so darn quickly won't stop my blood sugar from rising. So I write it down in my notebook, the food journal I keep to help me keep track of what and when and how much I've eaten for the day. And yeah, I write it down in pen, so it can't be erased. I'm able to see it alongside all the other better, more healthful choices I made that day. And then I move on.

GIVE YOURSELF A PICKUP LINE

Nope, I'm not talking about that kind of pickup line. As in, *Your legs must be tired, 'cause you've been running through my head all night.* Ouch. I'm talking about a pick-me-up line, something quick and handy to have ready to say to yourself when you're struggling to give yourself a break. One of my favorites is *Jesus, take the wheel!*

Think of the negative self-talk in your head as a tape playing on a loop. Creating a pickup line for the moments when you feel yourself teetering on the edge of your resolve can help. They don't have to be complicated, and they certainly don't need to be original. Simple, familiar words are sometimes the most powerful kind:

You're forgiven.

You're sorry. It's okay to let it go.

You did the best you could. It's enough.

This is one pickup line you can deliver with pride. And mean every word.

Tell someone about it.

Shame thrives in secret. Some kind of magical thing happens when you bring those shameful things of yours out into the light of day—they start to wither.

One of the best ways to give shameful feelings the boot out of your life is to tell someone about the very thing you're ashamed of. Comedians, we do this all the time, usually to a whole roomful of people at once. Failures, embarrassments, secret grudges, and shameful moments: they are all fodder for excellent material. What's the most embarrassing thing that's happened to me lately? When I fell on my ass on *DWTS*! That's definitely going in the new stand-up routine. *Walked around for an hour with my skirt tucked into my panties?* I'll be talking about that at the *View* table. We look to the secrets of our imperfect lives in order to turn them into something funny to share. And people laugh—well, hopefully they laugh—because they recognize something familiar in those ridiculous moments of mine. In those moments, through that laughter, we're giving ourselves permission to be weird and, more important, to be imperfect.

That's what telling a friend about your struggles with your diet or your exercise regimen can do. Unlike me, you don't have to tell a roomful of strangers or a TV audience of millions.

Call a friend.

Tweet it.

Talk to your partner.

Tell God.

Sharing our weaknesses, swapping stories of our setbacks and shortcomings, it helps to remove the hold that they have

over us. Don't let the things that make you feel ashamed take over in your mind and heart. Remember that team I told you to build? Reach out to them. Send a group e-mail with the subject line: *Oops, I did it again.* I'll bet your friends have got some flub-ups of their own they'd like to get off their chests. Have a laugh over them, shrug them off, and get on with your business.

Think big.

I know, I know. I've spent most of this book telling you to take it step by step, to break up big goals into little pieces, to stay in the moment. Now I'm telling you to chuck all that stuff and think about the big picture. The really big picture. When it comes to forgiving yourself, thinking big can actually be useful. Here's why.

In the heat of the moment, it's easy to lose perspective. Small mistakes start to feel like giant ones. Temporary detours off the straight and narrow seem irreversible.

Back when I was the greatest American yo-yo dieter, this used to happen to me all the time. I'd start a diet and the first time I cheated or strayed from the program was also the last time because I'd just quit. Part of the problem was that I'd try to do too much, too fast. *Eight hundred calories a day! Grapefruit juice and Skittles for a week!* But I also couldn't keep my shortcomings in perspective. A fall off the program—however ridiculous the program was to begin with—was failure. The end. I couldn't see my missteps for what they were: momentary blips in a very big picture.

Now when I'm tempted to make a big, dramatic fuss about a bad day of eating or a workout I phoned in (or skipped al-

together), I try to think about the whole picture of my healthy life. Not in days, but weeks, months, and years—whatever it takes to give me the jolt of perspective that will keep me from wasting time beating myself up for a slipup.

Should I have eaten those chocolate-dipped cookies that called out to me from the craft services table? Nope. But does their presence in my belly mean my diet and exercise program isn't working, or that I've undone all the good of my week of healthy living?

Nope again.

How Grateful Are You?

Gratitude takes practice, just like anything else. And being grateful for the gifts of our lives is one powerful way to counter the negativity that can so easily overtake our minds. So, take stock of what makes you feel lucky. This isn't about toys or clothes or bling. I'm talking about the things you can be grateful for no matter what the economy is doing, whether your bank account is flush or empty, whether you're just making your way in the world or you've been around the block a few times.

To help remind yourself of all that you have to be grateful for, try to spend some time each day thinking about these things:

Be grateful for your community.

Who are the people who make you feel lucky to be alive? Who are the folks who make you laugh? Take a moment and see their smiling faces in your mind. Now ask yourself: How

would these people want you to treat yourself? Would they want you to be angry with yourself for every little mistake you make? Or would they want you to be as kind to yourself as you are to others?

Be grateful for your abilities.

I bet you can make a list of your shortcomings with your eyes closed. I certainly can. Sadly, it's a lot harder for most of us to make a list of the things we do well. Well, I'm telling you to start working on that list. This isn't about bragging. It's about being able to recognize your strengths and abilities—and then giving thanks for them.

What's on my list? I'm grateful that I like to learn and thankful for having an open mind. I'm friendly and I'm warm, and I'm thankful for those things. And yeah, I'm funny. Thank goodness. I gotta pay my bills. . . . What are you good at?

Be grateful for your body.

This was a real revelation for me. Until recently, I had never thought about giving thanks for my body—I was too busy critiquing it. We spend so much time beating ourselves up for the way we look, for the belly bulge or the flabby arms or that stubborn double chin. The truth is, our bodies are remarkable. They are worth celebrating. And worth taking care of, so we're able to live well in our bodies for a long, long time.

Instead of critiquing your flaws, really stop for a moment and think about how much your body does. How well it works. How it carries you through all your long days. Those arms you

wish were more toned? They're the arms that pick up your child when he comes looking for a hug.

Take a moment to remember how good and strong your body feels after you exercise, how clean and healthy it feels when you're eating nourishing foods.

nine

Putting It Together: Living Like Sherri for a Week

Seven Days of Meals and Seven Days of Exercise

So are you ready to live like me for a week? There's probably a lot about our lives that is already pretty similar. Sometimes I wake up late, I can't find my notes for work, the clothes my kid wants to wear to school—no, *must* wear to school—are always, without fail, in the laundry. My husband and I pass each other in the hallway sometimes and look at each other like Lucy and Desi, Abbott and Costello, or just two wide-eyed idiots.

I love my life.

I also love that I've found a diet and exercise routine that suits my life, one that I can maintain through a week's unexpected ups and downs. I've never—ever—had this kind of success eating well and exercising. I've never felt this healthy and energized, hopeful and positive, sexy and strong. I'm excited

for you to live like me for a week, not because my life is easy—I never promised you a cakewalk, remember—but because living this way feels so good.

My week is no cakewalk. It's way better. And guess what? It sometimes involves *actual cake*. Let me tell you a few things you won't find:

- Seven days of eating and exercise that go exactly as planned. That might be someone's life, but it's sure not mine.

- A week without treats. As I've been saying all along, you get to indulge a little on my plan—you just have to keep your indulgences small and under control.

- An exercise plan that forces you to go to the gym every day—or at all. My week of exercise includes everything from spin class to samba dancing to playing at the beach. It doesn't involve complicated equipment, and it doesn't ask for hours of your time. What it does ask is that you be willing to try new things, to work up a sweat, and to commit to some physical activity on most every day.

Here's what you will find:

- A seven-day plan of meals that will help guide you as you adjust to serving yourself reasonable portions that will keep your hunger at bay and your blood sugar steady, and won't undermine all your hard work. I've also included a day-to-day journal of how I make my food choices, how the food I eat at one meal influences the choices I make at the next meal, how food and exercise blend with my life (my family, my friends, and my work), and how I plan for my indulgences—and how I handle unexpected temptations. I hope it is helpful to you.

Know Your Serving Sizes

I used to be completely delusional about serving sizes. I'd crack open that cereal box and pour myself a giant bowl of sugary sweet, crisp, nutty squares, and go to town. A serving was however much cereal would fit in the bowl, rising just to the top of the rim after I splashed in the milk. At dinner, I'd order a bowl of pasta the size of a swimming pool. A serving was however much I could eat before feeling completely stuffed—and then a little more for good measure. I usually cleaned my plate. And I wondered why it was so hard for me to lose weight and keep it off.

In order to manage your portions and to feed your body regularly without giving your system too much food at once (remember, overeating elevates blood sugar), you need to know what reasonable servings are. You may need or want to do some measuring at first, while you're getting used to watching your serving sizes. I always measure my fats, like olive oil or butter. Over time, you'll be able to trust your eyeball to do the measuring for you.

You won't eat everything on this list every day. There may be some foods here you prefer not to eat at all, based on your tastes and the choices you make about diet in consultation with your doctor. What's more, you will use serving sizes differently depending on the type of food you're considering. When it comes to fats and starches, knowing your serving sizes is a way to ensure that you're not eating too much of these foods with any single meal. Knowing what a half-cup serving of potatoes looks like helps to keep me honest and in line. If I'm eating these kinds of foods in reasonable servings, that means I get

to keep eating them—I don't have to give them up altogether. The same is true for lean meats. A serving of pork or chicken is three ounces—about the size of my palm. If I hadn't taken the time to familiarize myself with serving sizes, I might still be eating two or three times that much meat with a meal.

On the other hand, knowing the basic serving sizes of low-glycemic foods like greens and other nonstarchy vegetables can help you make certain you're getting enough of these nutritious, low-calorie, high-fiber foods. If I'm having a salad as a main course, I might include two cups of fresh greens—that's two servings—along with another cup of mixed fresh vegetables like carrots, bell peppers, mushrooms, and cucumbers. In the case of these foods, I'm not worried about limiting my servings, I just want to have a sense of how well I'm doing and how the amount of nonstarchy vegetables I'm getting in a single meal contributes to my daily goals.

To that salad, I also might add a serving of beans, sprinkling a half cup of lentils, chickpeas, or kidney beans into my colorful bowl. Beans are a great protein substitute. They are also high in fiber, making them a powerhouse food for us glycemic-conscious eaters. Beans are not low in calories, though. Knowing the amount of a serving size of beans helps me take advantage of all their health benefits—and their yummy flavor—without piling on too many calories to my meal.

I think of serving sizes like the building blocks that used to clutter up my kid's bedroom floor. I use them, in combination with the glycemic scale, to build balanced meals: balanced in their combination of healthy carbohydrates, lean proteins, and fats, and balanced also in the amount of food I'm eating at any given sitting. Here's a sample of serving sizes of some everyday foods.

Fats and oils

Butter: 1–2 teaspoons

Cream cheese: 1 tablespoon

Prepared salad dressing: 1 tablespoon

Vegetable oils: 1–2 teaspoons

Fish, meat, poultry, and other proteins

Canned tuna: ½ cup

Egg: 1 egg

Fish: 2–3 ounces

Pork: 2–3 ounces

Poultry: 2–3 ounces

Red meat: 2–3 ounces

Tofu: 4 ounces

Low-fat dairy

Cheese: 2 ounces

Cottage cheese: ¾ cup

Milk: 8 ounces (1 cup)

Yogurt: 1 cup

Bread, cereal, and grains*

Bagel: ½ small

Bread: 1 slice

Cooked cereal: ½ cup

Crackers: 4–6 crackers

Dry cereal: ¾ cup

English muffin: ½ muffin

Pasta: ⅓ cup

Pita: ½ large, or 1 small

Rice: ⅓ cup

Tortillas: one 6-inch tortilla

**Remember: as much as possible, go for the whole wheat or whole grain version of bread, crackers, and muffins; they will contain much more fiber and lower GI.*

Starchy vegetables

Peas, corn: ½ cup cooked

Potato: 1 small, or ½ cup

Nonstarchy vegetables

Cooked vegetables: ½ cup

Raw, leafy, and other nonstarchy vegetables:
1–2 cups per serving

Vegetable juice: ½ cup

Fruits

Cooked or canned fruit: ½ cup (avoid canned
fruit that has added sugar)

Dried fruit: ¼ cup

Fresh fruit: 1 medium-size piece

Fruit juice: ½ cup

Beans, legumes, and nuts

Cooked beans: ½ cup per serving, or more if
you are using the beans as a protein substitute

Nuts: ¼ cup

Peanut butter and other nut butters:
2 tablespoons

Sweets and desserts*

Cake or pastry: 1 small slice, or 1 small

Cookies: 2 small or medium, or 1 large

Ice cream: ½ cup

*These should not be indulged in daily; limit your sweets to one
to three times per week.*

Planning Your Meals for the Week

Every Sunday, I sit down and plan my meals for the week. Before I had diabetes, I never even thought about meal planning. I just ate whatever was around, however much I wanted. And we all know how that turned out. Now I plot my course for the week when it comes to the food I'm going to eat.

Meal planning means less stress. I want to eat well for my health, and I want to feed my family food that will nourish and protect them. I also want us all to eat foods we like! Being diabetic or trying to lose weight doesn't mean giving up the simple enjoyment of food. By eating healthfully, you get to enjoy foods without guilt or risking your health. Planning meals ahead of time gives me the chance to meet all my food goals: good-for-us, great-tasting food on the table every night of the week. For me, this means peace of mind.

Meal planning helps me stay on track with my eating. I love to improvise in my work. Improvising with my eating? That doesn't work out so well for me. I've learned that in order to make healthy choices, I need control and a plan to follow. When I know what dinner is going to be—and I have the groceries already tucked away in the fridge, ready to go—it's a lot harder to justify a last-minute takeout order. Without a meal

plan for the week, I'd be cooking—and eating—on the fly. And I know, after years of learning the hard way, that this kind of make-it-up-as-you-go eating routine doesn't make much sense.

I've also discovered that planning meals in advance actually saves me time during the rest of the week. Those thirty minutes or so I spend on Sunday afternoon putting a plan together for the rest of the week means I don't have to come home after a busy day of work and scramble around figuring out what's for dinner. It means I get to skip that last-minute run to the store for ingredients. And all that translates into more time with Jeffrey and Sal—to take a walk around the neighborhood or help Jeffrey with his homework or play a game together.

Tips for planning a week of meals
Build meals around the foods you like.
We've all got our favorite meals. That was true back when you ate whatever you wanted (*Hello, barbecue and corn bread*) and it is still true now that you're starting to eat healthfully. As you're trying new foods and new ways to prepare them, you're going to discover new favorite meals. Those meals should be the foundation of your meal plan. The more you cook them, the easier and faster your preparation time will be—and the more time you'll have to spend out of the kitchen!

Add one new meal a week.
Keeping variety in your diet is the way you'll keep from getting bored. Boredom leads to a wandering eye. By experimenting with at least one new meal a week, you can mix things up a

bit. You'll also broaden your tastes for good-for-you foods—and some of these new meals will hopefully become favorites and staples in your repertoire.

Make your grocery list while planning your meals.

You're already taking the time to plan out your meals—now elevate yourself to the ranks of the super-organized and make your grocery list for the week at the same time. This is a few extra minutes very well spent. You've got your recipes right there in front of you. You'll cut down on the chances of leaving something off the list and having to double back to the grocery store for the blueberries your kid can't live without in his cereal or lunch box.

If you want to become a truly bionic meal planner, you can always organize your grocery list according to the layout and flow of your supermarket: produce first, then dairy, then bulk and grains. You do this? You're my hero.

Keep your pantry stocked with staples.

Always keeping on hand some of those basic foods you use regularly means you'll always have a fallback plan in place for when your perfectly organized plan goes not so perfectly. And you know it will! You don't have to hoard a month's worth of food in your cupboards. Just keep your most-used items on hand, and you'll have what you need to create a few healthy favorites without blinking an eye. I always have eggs and apples and hummus in the fridge, peanut butter and brown rice and black beans on the pantry shelves, frozen veggies and fruit in the freezer.

Ditch the plan every now and then.

Let's face it, sometimes you just want to live a little, to be spontaneous. Just like we've got to make room for straying from our healthy eating every once in a while, we've also got to let ourselves mix things up a little bit with meal planning. Give yourself permission to drop the plan every now and then and go out for a meal with your friends, or your sweetie, or your family. Better yet, put these nights out right on your meal plan—and you'll have something to look forward to while you're sticking to your plan all week!

SHERRI'S FAVORITE PANTRY STAPLES

These are the basic foods I have on hand all the time. From these simple, affordable whole foods, I can make any meal of the day a healthy one for me.

Beans
Lentils, black beans, and chickpeas are among my favorites.

Eggs
Inexpensive, quick, and delicious. I'm never without eggs.

Yogurt
I'm partial to nonfat plain Greek yogurt, but any no-sugar-added, low-fat, or no-fat yogurt deserves a place in your pantry.

Healthy whole grains
I keep my pantry stocked with quinoa, barley, and brown rice.

Garlic and onions
These flavor stars are also rich in antioxidants and good for the heart. They are the base of so many of my favorite

homemade meals, from chilis and stews to vegetable
casseroles.

Canned tomatoes
Research shows that cooked tomatoes have even more
potent health benefits than fresh. I use canned tomatoes
for soups and salsas, and with meats and fish.

Frozen fruit and vegetables
Peaches and berries are great fruits for smoothies and in
oatmeal or yogurt. I keep frozen broccoli, cauliflower, and
spinach on hand for stir-fries and egg-white scrambles.

Nuts and nut butter
Peanut butter is a longtime staple in my pantry.
Nowadays, I choose the no-sugar-added kind. I've also
added almond butter to my list of nutty favorites. I keep
raw nuts like walnuts, pistachios, and almonds for healthy
snacking and crunchy garnishes for salads, smoothies, and
my morning oatmeal.

Leafy greens
I keep in my fridge crunchy lettuces like romaine for salad.
I always have spinach greens in there as well—they're
great raw or cooked!

Apples
My favorite fruit. Apples are terrific as a snack combined
with a little protein, like cheese or peanut butter. I also dice
them and toss them in my salad.

Citrus fruit
I like oranges and grapefruit for eating, and I keep
lemons and lime for flavor in cooking and to add to
water and tea.

Shopping smart

Shopping can also be hazardous to your health. Consider these tips to keep you on track.

Go prepared.

I've been known to wander through the supermarket, talking to myself. This usually happens when I haven't bothered to make a list. (Okay, fine: it happens even when I have a list! What can I tell you, I'm a talker—even when nobody's listening. I'm already working on my crazy old lady routine, for forty years down the road.) My babbling-to-self aside: your grocery list is important! It's your road map and your protection against the many temptations there are to be found in the inner aisles of your supermarket. You've made a list based on the meals you've planned for the week. Now stick to the list, and you'll get through your grocery run with everything you need to eat healthfully for the week—and nothing you don't. If you like to do one big shop for the week, one list will do. If you prefer to shop every few days, just divvy up that list according to your meal plan, so you'll always be prepared.

Don't go there . . .

Down that aisle, I mean. You know the one. The aisle of irresistible temptation. For me, it's the chips aisle, with those long rows of puffy bags of crunchy, salty, fatty snacks. I am a different woman now in many ways than I was before I made these changes to my diet. But salt-and-vinegar potato chips still make me go weak in the knees. They, along with a few other foods, are like my kryptonite. Maybe yours is ice cream

or cheese or pastries. The grocery store is organized by grouping similar types of foods together. Make this work to your advantage, to help keep you from the tempting foods that can derail your diet and send your blood sugar soaring. If you're planning meals that are based on simple, whole, low-glycemic foods, then what legitimate business do you really have in the donut section of the store? Sightseeing? I don't think so. Just don't go there.

Pick your time wisely.

I hit up the supermarket in the evenings. After eight o'clock, my local market is deliciously empty . . . of people. I can get in, get the stuff on my list, and get out. At that time, there are no crowds to make me cranky and suddenly in the mood for a sugary snack to make me "feel better." No standing in long lines, staring at the candy and chips and cookie packs they put there to tempt us into a last-minute purchase. If late-night grocery shopping isn't your thing, try going at other off-hours—early morning or midafternoon on a weekday, late in the day on the weekends.

Shop alone.

I realize this isn't always possible. Sometimes we have to shop with our kids in tow—or, worse yet, our husbands. (Sorry, guys, but admit it: you can be bigger babies than the actual babies in the family. When Sal comes with me to the grocery store he's like a wandering toddler.) When and if you can, try to shop alone. Take a late lunch from work. Hand your kids to your man and head off alone on a Saturday afternoon. Shopping alone speeds up the task. Plus, you spare yourself the

negotiations over junk food and sweets that inevitably come up with your shopping companions—especially if those companions happen to be very short and big fans of cartoons and video games. It's enough for you to manage your own temptations without adding your child's desperate pleas for choco-candy cereal or robot-shaped cookie sandwiches. 'Cause let's face it: nobody's kid is begging for celery.

Eat before you go.

This is the classic bit of shopping advice—and it couldn't be more important. Going to the grocery story hungry is like dating active felons. You're just asking for trouble. It's happened to me plenty of times. And I mean both—the hungry shopping AND the felon dating. I've tromped off to the grocery store on a busy day without realizing how long it had been since I'd eaten. The moment I enter those sliding glass doors, boom! I am a quivering, shaking, hungry mess. All I can think about is what I'm going to eat and how quickly I can get it into my mouth. This is NOT how you want your grocery shopping to go down. Before you do your shopping, make sure you've eaten something, enough to satisfy your hunger and keep you from lathering at the mouth when you walk by the deli counter.

Living la Vida Sherri: Seven Days of Eating and Exercise

What you're not going to see here is a perfectly laid-out, perfectly executed eating plan. You're also not going to see an exercise plan designed for a robot or someone with a nanny and a housekeeper.

You are going to see a week of eating and exercise that includes a balance of foods and a daily dose of exercise. This

is a week's worth of activity and eating that includes a lot of variety . . . and a little indulging. Eating at home, eating out, eating at work. Horsing around with my kid and my husband, working out at the gym, squeezing in a few extra minutes of exercise on my way to work. That's what my life is about. My REAL life.

I've also included some of my favorite recipes for dishes that I love to make at home. These are some of my—and my family's—favorite meals. They're simple and balanced, with complex carbohydrates, lean proteins, and healthy fats—in the right amounts, to fill you up while keeping your blood sugar rising slowly and moderately. They're packed with flavorful ingredients that will make you wonder why you ever thought you needed all that bad fat and salt and sugar to make food taste good.

You'll also find tips for how to keep your exercise routine feeling like fun, not drudgery, and for how to eat and drink smart when you're working out. Welcome to my crazy, healthy life! Here we go!

LOVE YOUR LEFTOVERS

I've always loved leftovers. I used to love having cold pizza in the morning, or a slice of my mom's lasagna for lunch the day after a family dinner. Leftover takeout was always hanging out in my fridge, back when my primary cooking utensil was the telephone. My eating has changed completely since then, but my love of leftovers hasn't. I still love 'em, and I still use 'em. Here's why you should, too.

Leftovers save time.
Using your leftovers from last night's dinner in today's lunch, or tomorrow's breakfast, cuts down on your prep

time for those meals. I plan to cook extra of my favorite foods so that I have them on hand to eat throughout the week. A big pot of beans, an extra few servings of slow-cooking, steel-cut oatmeal, a pan of roasted veggies that go right into the fridge: these are some of my favorite "planned" leftovers.

Leftovers save money.

This one's easy. Using up what you've got in the fridge cuts down on your grocery bills, plain and simple. I love eating well AND having it be cost effective. I'm a bargain shopper at heart, so this gives me a thrill, sort of like finding a cute dress on the clearance rack at a fancy department store.

Leftover healthy food is still healthy food.

Using your healthy leftovers is a great way to ensure that you eat as well the next day as you did the night before. Those cooked greens that you ate with chicken last night? Scrambled with an egg and an egg white, they become the base of a tasty breakfast. That pot of rice and beans you simmered over the weekend? That's a few healthy, high-fiber lunches already made and ready to take to work.

. .

Your Week of Snacks, Meals, and Exercise

Monday

Monday mornings come just a bit earlier than other mornings, don't they? I don't like to have to fuss around with breakfast on a Monday—but I want to start the week off right, so I use one of my stick-to-it tricks. The night before, I make a pot

of oatmeal. It bubbles away on the stove while Sal and I are cleaning up from dinner, or sitting around the table talking. All I have to do is heat it up in the morning! This is especially helpful since I'm exercising first thing today. After my blessedly quick and quiet breakfast, I kiss my sleeping family goodbye and hightail it to the gym.

Monday's breakfast: oatmeal with mixed berries and almonds

½ cup oatmeal, cooked

½ cup berries—pulled right from the freezer, and heated up with my oat cereal

1 tablespoon nuts, sprinkled on top

. .

WEEKDAY TIP FOR MONDAY: COOK AHEAD

My meal prep for the workweek actually starts on the weekend. On Sunday afternoons, I like to cook a few basic dishes that I know will get eaten during the week. I simmer a pot of beans: black beans or kidney beans, usually. Then I have them on hand to toss into other dishes I will cook during the week. I will also roast a whole chicken, or a turkey breast, so I have a ready source of lean protein to add to soups, stir-fry, or salads. These cooking tasks don't take a lot of time: I can do them while I'm making my meal plan for the week or doing chores around the house. They are a great time-saver, and they help ensure we'll be eating great-tasting, low-glycemic, highly nutritious food all week long!

. .

Exercise

I'm heading to the gym this morning before work. I like to get a gym workout done first thing during the week. Otherwise, it is all too easy to push exercise down the road and decide to make time tomorrow. I try to remember that when it comes to taking care of my body and protecting my health, there is no tomorrow: today is all I've got.

Monday's exercise

Five-minute warm-up

Twenty minutes of strength training using machines and free weights

Thirty minutes of cardio: today it's fifteen minutes on the elliptical machine and another fifteen on the treadmill.

The last thing I want is my stomach rumbling when I'm sitting at the *View* table. My growling stomach is loud, people. You could probably hear it sitting on your couch at home. I make sure to have a snack before taping, so my tummy isn't rumbling and my blood sugar isn't plummeting.

Since my breakfast wasn't heavy on protein, I make sure that my snack packs a protein punch. Eggs are a great source of protein. They're one of my pantry staples.

Monday's morning snack

1 hard-boiled egg

1 apple, sliced

I'm on the hunt for a vegetable-filled lunch today. Gotta get those veggie servings in! I've found that making sure my week

gets off to a healthy start really makes a difference in how the rest of the week goes. Doing well with my diet and exercise on Monday sets the tone for the rest of the week. I strike gold in the lunch department: the cafeteria at work has a yummy, tomatoey minestrone soup. It is heavy on the vegetables, with a healthy tomato broth and lots of good-for-me beans. Plus, there are a few knobs of pasta noodles mixed in, making this soup healthy with just a little indulgence! It's okay to have a little pasta here and there, and this soup is the perfect way to have a taste without making pasta the star of my meal and gobbling up a whole plate. I grab a whole grain roll—pass on the butter, I'll just dunk it—and head back to my office.

Monday's lunch: vegetable minestrone with a whole wheat roll

1½ cups minestrone soup

1 medium-size whole grain roll

I'm running from one job to the next today before picking up Jeffrey from school in the midafternoon. So much for easing into this week! Before I start scurrying from one thing to the next, I make sure to have a snack with me for the afternoon. Some fruit and a little protein will keep my blood sugar steady and fill me up without weighing me down. I make my own fruit-and-nut mix, so I can control the amount of sugar and salt. My homemade version is toasty, crunchy, and just a little sweet. I keep a stash of this healthy, no-sugar-added fruit-and-nut mix in my office for just this kind of day. Today's version contains a mixture of toasted walnuts and almonds, with raisins and some chopped apricots.

Monday's afternoon snack

1 small banana

¼ cup dried-fruit-and-nut mix

Just like with breakfast, I don't like to have to fuss over dinner on the first night of the week. Because I did some advance cooking over the weekend and baked a chicken (or chicken breasts), I get to come home to a meal that's already under way. Plus, it's one of Jeffrey's favorites: chicken fajitas. I do a quick cooking of peppers, onions, and zucchini strips on the stove, and throw the already cooked chicken in at the end to warm up. Meanwhile, I'm heating some whole wheat tortillas in the toaster oven. My bottomless salad bowl is full to the brim, so all I have to do is pull out the bowl and give my healthy homemade dressing a shake. It's good for family morale to start the week with a meal that everybody likes but doesn't require a lot of effort from Mama.

Monday's dinner: chicken fajitas

3 ounces chicken, cut into strips

1 cup sautéed vegetables: peppers, onions, zucchini

one 6-inch whole wheat tortilla

Green salad

Tuesday

I love a savory breakfast. I also love using leftovers in breakfast. It saves time. It saves money. And good food almost always tastes even better the next day! Tuesday's breakfast uses those yummy veggies from last night's fajita fest in a healthy

scramble. It's a surprisingly quick breakfast—again, every-thing cooks in one pan and it takes only a few minutes. While I'm scrambling my eggs and veggies, I toast a mini pita bread and melt a little bit of low-fat cheese on top. Sal loves this breakfast so much it gets him out of bed!

Tuesday's breakfast: egg-white scramble with sautéed vegetables and a cheesy pita toast

2 egg whites

½ cup sautéed veggies

1 teaspoon butter, for cooking

1 small whole wheat round pita

1 tablespoon low-fat cheese, shredded

. .

WEEKDAY TIP FOR TUESDAY: VEGGIES FOR BREAKFAST

When you're planning your meals, think about ways you can include some vegetables at breakfast once or twice a week. Having vegetables in the morning is one way to ensure your breakfast is a healthy one, and it also gives you a head start on meeting your veggie servings for the day. When you go out for breakfast, order something—like an omelet or a frittata—with vegetables in it!

. .

I didn't have any fruit with breakfast, so I make sure my snack gets me some fresh fruit. While going over my notes for the show, I nibble on one of my favorite snacks: apples with peanut butter. I make sure to use natural, no-sugar-added

peanut butter. It actually tastes a lot more like peanuts than the sugar-filled stuff!

Tuesday's morning snack

1 apple, sliced

1 tablespoon natural peanut butter

It's easy to get in the habit of buying lunch every day. I'm as guilty of this as the next person. But I try to avoid this habit, for a few reasons. First, it gets expensive, quick! I've got plenty of other ideas about how to spend my money, thanks very much. Just ask Sal. Also, packing a lunch means I know exactly what I'm putting in my body. Store and deli and restaurant food can look and sound healthy, wholesome, and waistline friendly, but there can be tons of hidden fats, salt, and other ingredients that can throw your diet off course. Don't be afraid to ask how something is prepared before you buy it. But if you brown-bag it, you don't have to ask. For today's lunch I pack a generous serving of salad from the supply in my fridge and add some chicken slices and a sprinkling of sliced almonds. I tuck a whole wheat pita in there, and I'm good to go.

Tuesday's lunch: green salad with chicken and almonds

2 cups green salad

3 ounces chicken

¼ cup almonds

1 whole wheat pita

1 tablespoon olive-oil-and-vinegar dressing

Somebody at the *View* offices brought in cookies to share with the crew and cast. This kind of stuff happens all the time. It's somebody's birthday. Someone else is getting married. Somebody else just got promoted. And we always seem to want to celebrate with sweets—cakes, cookies, cupcakes. Whether you're diabetic, prediabetic, or trying to lose weight, you don't have to avoid these treats altogether. You just can't say yes all the time. I scope out these cookies making the rounds. They're tempting, for sure. But I work my steps. My lunch was really satisfying and filling, so I'm not feeling particularly hungry. I know there are going to be other tempting indulgences coming my way this week, so I decide to pass. An hour or so later, when I'm feeling hungry, I have a small bag of my homemade popcorn. It's a little cheesy, a little salty, and it hits the spot.

Tuesday's afternoon snack

1 cup homemade popcorn, sprinkled with Parmesan cheese and chili powder

For tonight's dinner I'll start using the kidney beans I cooked over the weekend. You can use any kind of bean that you like. If you don't want to cook them yourself, go ahead and use canned beans. I keep a can or two of beans in my pantry for nights when I need to turn around dinner extra fast.

I love pork, and I used to eat only the fattiest pork: strips of bacon, fat barbecued ribs. I thought I'd have to give up pork altogether when I started this new way of eating. I was wrong. I didn't have to give up my favorite meat, I just had to start eating leaner versions of it. Pork tenderloin is now one of my

favorite meals. It cooks great in the oven or on the grill, and it's juicy and flavorful, especially after it's been marinated. For a quick and delicious marinade I use olive oil or sesame oil and apple cider vinegar, with a handful of fresh herbs that I keep in the fridge. I always cook more than what Sal, Jeffrey, and I need for our meal—you'll see this pork make a delicious return later in the week. While the pork is roasting in the oven, I cook some rice to go with those beans. A few spoonfuls of fresh, pre-made salsa I picked up at the grocery store goes in with the rice and beans to make a tangy, tasty side dish for our pork. Some-times I spread the salsa right over the pork as well.

Tuesday's dinner: pork tenderloin with rice and beans

3 ounces pork, oven cooked

1 cup rice and beans

2–3 tablespoons salsa

Exercise

Sal and I have a dance class tonight! I loved to dance before I was on *Dancing with the Stars*. Now? I'm obsessed! This is one of the great things that happens when you start moving and trying new things: you find new passions. I don't feel like waiting for the end of the day to get a little exercise, so I add some extra time to my walk to the subway by skipping the stop closest to my house, and walking to the next stop on the line. This adds fifteen minutes of cardio to my day, and I get to people-watch in my neighborhood as I go.

Tuesday's exercise

Fifteen-minute walk and forty-minute dance class

On your own: hit up a Zumba or a cardio-dance class at your local gym or YMCA. Do a workout to a cardio-dance DVD.

At home: put on some music and dance for fifteen minutes while you clean your house.

Find fifteen minutes in your day to walk: walk to work instead of driving. Take a fifteen-minute walk at lunch or after dinner. Take a quick five-minute walk after breakfast, lunch, and dinner.

Wednesday

On mornings when I'm working out first thing, I like to eat my breakfast while I'm doing other stuff to get ready and get myself out the door. So this morning's breakfast comes in a glass. But this is nothing like those liquid diets I once did. It's a glass full of vitamins, a balance of carbohydrates, protein, and fat, with plenty of fiber. I blend low-fat plain yogurt with frozen berries, crushed ice, and a few nuts for some extra protein. Then I drink my yummy, good-for-me breakfast while I wander the house looking for my other shoe.

Wednesday's breakfast: yogurt-berry-peach smoothie

1 cup low-fat yogurt

½ cup frozen fruit: I love the combination of berries and peaches

1 tablespoon almonds or other nuts

1 teaspoon cinnamon

Exercise

Wednesday is another gym day for me. I schedule my gym time in the mornings, so the day doesn't get away from me. I love the feeling of having completed a workout while the day is just starting. You might think that exercising in the early morning will make you tired for your day. Actually, it's just the opposite. Exercising early in the day can make you feel more energized, not less. My workout at the gym today is circuit training. This is a great way of working out that combines cardio and strength training at the same time. A circuit includes several exercises—you do each one for a short period of time and then move right on to the next and then the next. After you've completed one full circuit, you do another!

Wednesday's exercise

Thirty minutes of circuit training at the gym

On your own: sign up to learn how to use the circuit machines at your gym.

Work out with a DVD that combines strength and cardio—most of them do! I think of working out on my own as my do-it-yourself option: it takes place at the gym or elsewhere and may include equipment, but no trainer. When I work out at home, I do a very low-maintenance version of the exercise. This is great for those of you who don't want to go to the gym at all or don't want to or can't invest in a gym membership.

At home: strength-training walk (you can also hike or jog!)

Walk (or jog) for fifteen to thirty minutes. Stop every five minutes and do a quick strength-training workout.

Do ten squats: Stand with your feet hip-width apart. Bend your knees and drop into a squat position. Send your bum right out behind you! You don't have to go far—do as much as you can.

Do ten standing push-ups, using a tree or a telephone pole. Stand arm's length from the tree, with your palms against the tree. Bend your arms and move toward the tree, keeping your back straight. Straighten your arms to come out of the push-up.

Since I ate—or drank, really—my breakfast pretty early this morning and I worked out, by midmorning I'm ready for a snack. I grab one of my favorite snacks: hummus. I eat it with veggies, spread on whole grain toast or pita, or right off the spoon! Today I have some hummus with a few whole grain sesame crackers. It's a crunchy, smooth snack that's all good: good tasting and good for me.

Wednesday's morning snack

¼ cup hummus

6 round whole grain sesame crackers

Today I have a work lunch, a sit-down meal with a group of people. I used to feel nervous when I'd go to restaurants. Would I be able to avoid temptation? Would I find something decent for me to eat that I actually liked? What happens when someone else chooses the restaurant? I've learned that I can

always make a menu work to my advantage, using a few basic strategies. I look for meals in the appetizer section, to help with portion control. I ask for stuff on the side—dressings, sauces. These are often the most fat-laden part of the meal, and keeping them separate allows me to control how much I consume. I've also learned to speak up and ask questions: about how a meal is prepared and what its ingredients are.

Today we hit up a bistro with a pretty full menu. I find two appetizers—a salad and a small plate of grilled shrimp with a fruit salsa—that together make a great, satisfying, and low-glycemic lunch. And unlike some of my lunch companions who opted for heavy bowls of pasta, I won't be feeling like I need a nap in a couple of hours.

Wednesday's lunch: salad and shrimp

Garden salad

Grilled shrimp with a pineapple salsa

Seltzer with lime wedge

You can make my bistro lunch at home, no problem. Pick up some frozen shrimp at the grocery store, or buy it already cooked. When you're in the mood for a salad like this, just pull a few shrimp from the freezer, reheat them, and toss them with your standard salad greens and favorite dressing!

Wednesday's dinner is a simple, unfussy meal of roasted salmon, veggies, and quinoa. Doesn't sound simple? It is! Quinoa is not only one of the healthiest grains you can eat, packed with fiber and protein, it also cooks up in a snap. I cook the quinoa while I'm preparing the salmon and veggies for roasting and preheating the oven. I can roast the fish and the vegetables at the same time. Since they cook in the oven, I don't

have to stand over the stove—and while dinner's cooking, I get to spend time with my kid.

Wednesday's dinner: roasted salmon, veggies, and quinoa

3 ounces salmon, roasted

1 cup roasted vegetables (bell peppers, zucchini, onions)

½ cup quinoa

Green salad

. .

WEEKDAY TIP FOR WEDNESDAY: TAKE YOUR WEIGHTS HOME

You don't have to belong to a gym to get all the benefits of strength training. You can bring weight training home. Invest in a set of light hand weights for upper body strength training. They're not too expensive. Or make your own with stuff you have around the house: grab a couple of food cans, use a pair of unopened water bottles. Take a milk jug or an empty water bottle and fill it with dirt or sand to give it some weight. As you get stronger, you can add weight by filling the container more.

. .

Thursday

I don't have to be out the door right away today, so I've got a little more time for breakfast. I put that time to good use and give myself a midweek breakfast treat. Bacon! Okay, it's turkey bacon—but it's still exciting! Turkey bacon, chicken

sausage—these products provide a lot of the great flavors of their fatty cousins but without all the fat. If you can't imagine a world without bacon—and I hear you on this—give one of these alternatives a try sometime. Alongside a runny egg over toast? This is a heavenly breakfast.

Thursday's breakfast: soft-boiled egg on toast with turkey bacon

- **1 egg, soft boiled for 5 minutes**
- **1 slice whole grain toast**
- **3 slices turkey bacon**
- **1 medium orange, cut into slices**

Exercise

Since my morning doesn't start too early, Jeffrey and I have an impromptu dance party on the living room rug before he goes off to school. We bust a few moves to some deep cuts from the 1980s. I love that my son will grow up knowing all the words to *Thriller*.

I'd been hoping to get to a new dance class this afternoon, but the day got away from me; I've got so much to do and squeezing in a workout class just isn't going to happen.

So instead, I text a friend and we make plans to meet in the park for a walk. I add a little extra time to my walk by actually walking to meet up with her, instead of taking the subway or a cab. We set ourselves a pretty brisk pace and egg each other on when one of us starts to slow down. We also gab the entire time. Our walk—and my workout—is over before I know it. Exercising with a friend can make you work out lon-

ger and harder than you might on your own. It's also more fun than always working out alone!

Thursday's exercise

A ten-minute dance-off with my boy

A thirty-minute walk (with a five-to-ten-minute bonus warm-up)

On your own: ask a friend to go for a walk or a hike.

At home: dance for fifteen minutes while you're getting ready for work, or after you get your kids off to school.

My breakfast keeps me pretty full for the morning, so I have a light snack just to make sure my blood sugar doesn't sag and I don't get too hungry.

Thursday's morning snack

1 medium pear

A small handful of nuts

My lunch today is easy, fast, and healthy. Oh, and totally delicious. While not-so-patiently waiting for my breakfast to be ready, I threw some leftovers from last night's dinner into a to-go bowl. A mixture of quinoa, chopped roasted veggies, and pieces of salmon make a super tasty lunch salad that's hearty, and a perfect balance of carbs, protein, and fat. You can eat this straight from the fridge, or you can heat this made-from-leftovers salad in the microwave at work or in a sauté pan at home. It's a perfect lunch.

Thursday's lunch: quinoa, veggie, and salmon salad

½ cup quinoa

1 cup roasted veggies (bell peppers, zucchini, onions)

3 ounces salmon

2 teaspoons salad dressing

My afternoon is a busy one—busier than I expected it to be. A meeting gets moved up, which means my exercise plans change at the last minute, which means I'm off schedule and winging it for the afternoon. You know how it goes. We put stuff on our calendars, we chart our meals and schedule our workouts, and then life actually happens and things just go differently than we planned. I do manage to squeeze some exercise in—a walk with a friend—and we stop for a fruit popsicle at the food truck just outside the park. This is not one of those neon popsicle treats from childhood. It's full of good whole fruit. I've been good this week—there is time for a little indulging!

Thursday's afternoon snack

1 strawberry whole-fruit popsicle

Because it's that kind of day, I get home later than usual on Thursday. The last thing I want to do is hang out in the kitchen cooking for an hour—but I'm hungry; my kid is hungry; my man is hungry. We gotta eat! This is exactly the situation that would once have sent me running in the direction of a fast-food place or an oversize takeout order. Not tonight. Tonight is all about compromise. A few minutes in the kitchen and we can have a fun, tasty meal that's also right on plan. Nights like this one are perfect for my ten-minute chili. Everybody

puts in ten minutes of labor, and we get a delicious, healthy chili.

Here's how it goes. I put Sal to work chopping an onion and a couple of cloves of garlic. I set Jeffrey up with herbs and spices. He pulls the leaves off a sprig of fresh oregano. He "measures" out the cumin and smoky paprika into a bowl. (I handle the chili powder, since that stuff is spicy.) Meanwhile, I take what's left of Tuesday night's pork tenderloin and shred it. It all goes in a big pot, along with the beans I have on hand and a big can of diced tomatoes. By the time we've cleaned ourselves up and set the table, we've got a yummy bean chili with pork for our dinner together.

You could also do this one-pot, one-bowl meal with ground turkey, lean ground pork, or shredded chicken.

Thursday's dinner: chili with beans and shredded pork

1½ cups chili

1 tablespoon, about 1 ounce, low-fat cheese

Toasted whole wheat pitas or baked tortilla chips

. .

WEEKDAY TIP FOR THURSDAY: GET YOUR FAMILY INVOLVED

I have enough to do without having to fix different meals for different members of the family. As I've worked to develop these new eating habits, Sal and Jeffrey have been right there with me—trying new foods, cooking and helping in the kitchen, getting out for exercise. I want my family to eat and exercise this way, for their own good health.

. .

Friday

I know I'm going to be going out for dinner tonight—Sal and I have a date! I love our Friday-night dates. Since we're going to an Italian restaurant we both love, I want to be able to indulge just a little bit this evening. That doesn't mean I'm going to skimp on my meals during the day. Far from it. It just means I'm going to make my choices today with that dinner in mind. That way, if something a little naughty catches my eye (I mean something aside from my husband), I'll have given myself the room to go off my diet while sticking to my plan.

I go to one of my standby breakfasts: yogurt with fresh fruit. A plain low-fat yogurt has protein, good carbs, and just the right amount of fat. I add whatever I have on hand: half a banana, chopped apple or pear, a half cup of fresh or frozen mango or peaches (bananas and mangoes are in the midrange of GI, so I need to watch the quantity). I sprinkle some cinnamon and nuts on top, and I'm a happy camper.

Friday's breakfast: yogurt with fruit and nuts

1 cup low-fat yogurt

¾ cup fresh or frozen fruit

¼ cup sliced almonds or other nuts

Sprinkle of cinnamon

(If you want a little extra sweetness, go ahead and add 1 teaspoon of honey. I find the fruit sweetens this enough for me.)

WEEKDAY TIP FOR FRIDAY: SPRINKLE ON SOME CINNAMON

Not only is cinnamon a great flavor booster, spicy and aromatic, it also has health benefits. Studies have shown that cinnamon can help lower blood pressure and cholesterol, and that it may help the body use insulin more effectively. I sprinkle cinnamon everywhere—on my cereal, my smoothies, and my yogurt.

I've got a lot of prep work to do for today's taping, so I spend most of the morning at my desk. Whenever I sit for long stretches of time, I take mini-breaks—two or three minutes maximum, every half hour or so—just to stretch or take a quick walk around the office. Research shows that sitting for extended periods of time is associated with a number of health risks, including cardiovascular problems and larger waist size. (Remember, belly fat is the worst kind of fat you can carry on your body.) Breaking up long stretches of sitting with quick breaks can help guard against these health risks. I'll take any advantage I can get, in terms of protecting my health and my waistline, and this is an easy one to accomplish.

I use one of my breaks to have a snack before we head to the *View* soundstage. It's one of my favorites: fresh melon with cottage cheese. I know, sounds like classic diet food from the '70s, right? Well, some throwbacks are worth keeping around, and this is one of them. (Also on that distinguished list of throwbacks worth reviving? *The Love Boat* and disco dancing. Who's with me on this?) Mixing sweet and juicy melon

chunks with creamy low-fat cottage cheese creates a delicious contrast of flavors and textures. I buy the single-serving containers of cottage cheese, so my portion is already controlled for me, and stir in yummy melon chunks I've either prepared at home or bought precut from the store. I like to sprinkle just a little chili powder over the whole delicious mixture. Yep, chili powder. It's a hit of spice and heat that boosts the flavor of this healthy, low-glycemic snack.

Friday's morning snack

1 cup fresh cantaloupe or other melon

¾ cup low-fat cottage cheese

A dash of chili powder

With my dinner plans in mind, I'm heading for the salad bar today to cover lunch. Navigating the salad bar sounds like an easy, safe thing for a diabetic to do, right? Well, yes and no. There's a lot of good stuff there, but a typical salad bar can get you into trouble if you're not paying attention. Amid all the crunchy, vitamin-rich, low-carb offerings there are some things you want to avoid or have only in small portions. That cottage cheese? It's most definitely full-fat, so if you have any, make it a small helping, not a giant one. Those crunchy rice sticks or crispy croutons? It's too hard for me to eat just a few of these starchy, salty salad add-ons, so I just skip 'em altogether and opt for a small wheat roll or some rye crackers instead. In addition to the bottled and packaged dressings that are available, most salad bars also have bottles of oil and vinegar on hand. I use these to dress my salad—this way, I can control my portion and avoid the sugars, fats, and salt that often lurk in processed dressings.

Friday's lunch: salad bar salad

2 cups salad greens and raw veggies

½ cup bean salad

1 hard-boiled egg

1 tablespoon salad dressing—a careful splash of olive oil and red wine vinegar

4 rye crackers

I'm racing around on Friday afternoon, so I need a snack that can travel. Instead of hitting up the vending machine, I grab some of my handy fruit-and-nut mixture to go.

Friday's afternoon snack

⅓ cup homemade fruit-and-nut mix

Exercise

Friday is my last gym workout of the week. I try not to do the same thing at the gym every time I go. I get bored easily. Plus, giving your body new challenges is important for your long-term success in getting fit and losing weight. If you do the same workout for the same amount of time every day, not only will you be bored, but your workouts will also become less effective. As you become fit, you'll have to work less hard to achieve the same results. The fifteen-minute walk on the treadmill that used to make you wheeze and sweat now feels pretty manageable? That's a sign it's time to switch things up. Changing aspects of your workout—adding time to that treadmill session, alternating cycling with a Zumba class— can help keep you working hard and burning calories. What's more, if you're doing a single exercise routine over and over again, you're working the same sets of muscles in the same

way, every time—and missing out on working others. Varying your routine allows you to work different muscle combinations and provides other muscles time to rest and recover, improving your whole-body fitness.

So today, instead of a cardio-strength combination, I take an afternoon spin class. This class is a blast—and a seriously challenging workout! It relies on the interval training that is so important in boosting fitness and metabolism.

Friday's workout

Thirty-minute spin class at the gym

On your own: ride the stationary bike at the gym for fifteen to thirty minutes. Include an interval—a short burst of speed—every five minutes.

At home: go for a bike ride! Go with your kids, a friend, or on your own. Every five minutes, pick up your pace to get the benefits of interval training.

WEEKDAY TIP FOR FRIDAY: DEVELOP A DRINKING HABIT

As you know by now, I only drink water. I think in many ways, water saved my life. I drink water instead of diet soda. I drink water instead of piña coladas. I drink water, period. So try it for two weeks. Commit to drinking just water and see how good you feel!

Date night has arrived! I've been looking forward to some quiet, grown-up time with my man all week long. We head out to one of our favorite neighborhood restaurants, the kind of place where the owner comes out to say hello and greets her regulars by name. This place has delicious food, a cozy atmosphere, and no fuss.

Sal and I share one of our favorite appetizers—grilled calamari. I order a marinated mushroom salad—mushrooms are a really flavorful food, and when a chef knows how to cook 'em right, like this one does, they are something special. I'm tempted by the pasta dishes—of course. Pasta was one of the foods that I was once powerless to resist. I've learned that it's easier to avoid certain foods altogether than to try to manage them. I can handle a few noodles in my soup, but a whole dish of pasta? That's too much for me. I spot a small plate of crab cakes—perfect! I eat them happily and don't miss that pasta one bit. I especially don't miss feeling heavy, bloated, and tired after my meal with my husband. Romance is alive!

Friday night's dinner

Grilled calamari

Mushroom salad

Crab cakes

If you're in a staying-in kind of mood, try lightening up one of your favorite restaurant or takeout favorites with an at-home version. In Chapter 10, you'll see how to re-create some of your favorite dishes so they're friendly to your waistline and your blood sugar.

Saturday

Weekends are family time for me. I do have to work on plenty of weekends—when I was doing *Dancing with the Stars*, I was in Los Angeles every weekend for rehearsals. I try to have Jeffrey and Sal with me if I can. Sometimes, that doesn't work. But my ideal weekend is a family one: at home, in NYC, with two days to play. We get a lot of exercise just being active. I also make a point to designate some exercise time for just me on at least one weekend day. It feels good, and it gives me flexibility for the rest of the week if something comes up and I can't make a scheduled workout.

Our Saturday breakfast is one designed to get us going and out the door for some fun. Cereal isn't a forbidden food: it's just the high-sugar cereals you want to avoid. My new passion in the morning? Oatmeal. I put berries on oatmeal, cinnamon, raisins, bananas—anything I want! Oatmeal is low-fat and high-fiber, and keeps me satisfied all morning.

Saturday's breakfast: oatmeal with berries and banana

1 cup steel-cut oatmeal

1 cup low-fat or skim milk

½ cup fresh or frozen berries

½ banana

We're headed to the beach today, and we'll plan to eat lunch at the boardwalk. I pack some snacks so that nobody gets too hungry and starts begging for a cotton candy or a funnel cake. You think I'm talking about my seven-year-old? Nope. That'd be me doing the begging, if I don't plan ahead. I pack

some individual servings of low-fat cheese, fruit, and baked tortilla chips, and we're ready to hit the surf!

Saturday's morning snack

1 ounce low-fat cheese

1 medium apple

Exercise

When I have a whole day to spend with my family, there's no way I'm cutting into it by going to the gym. Of course, if you need a break from those crazy people you love, going to the gym can be the perfect mini-getaway! Sal, Jeffrey, and I like to get out of the house and go places on our Saturdays. We also like to veg out and hang around, so we do some of that, too. It's all about balance. This Saturday at the beach is a family activity that is full of built-in exercise: we play around in the sand, we run in and out of the crashing waves, we walk for long stretches along the shoreline and the boardwalk nearby.

Saturday's exercise

Playing with my family at the beach

On your own/at home: spend thirty minutes doing a family activity. Play at the park, go swimming at the local pool, go for a hike or a walk in the woods.

Eating out isn't always easy. Especially when you're faced with the kind of temptation that lines the boardwalk at the beach, or exists on the menu of your favorite fast-food place. You can make it work for you; you've just got to be smart. Don't let

yourself get too hungry. Keep your portions in control. Share treats with your companions. That's what we do when we stop horsing around on the beach long enough to walk over for lunch. Sal, Jeffrey, and I split an order of French fries. That way, we all get a little of this indulgence without going overboard. Sal and I are having guests for dinner later tonight, and we're serving them beef, so no hamburger for me today. I order a turkey burger, with a few simple modifications. I ask them to hold the cheese and the mayo, and request extra tomato and lettuce. I also compromise on the bread and eat my burger with the just the bottom half of the bun. We chomp away, happy as three clams to be sharing lunch on a sunny day.

Saturday's lunch: turkey burger
A turkey burger on half a bun

A few French fries

After lunch we take a walk on the beach, before packing up our gear to head back home. On the car ride back to the city, I munch on an apple and bask in the feeling of having my son nap against my shoulder. *Thank you, Lord.*

Saturday's afternoon snack
1 medium apple

Sal and I are having a few friends over for dinner, so after we get home we both start getting ready. We're grilling steak—well, Sal is doing the grilling. That man loves to wave a spatula over a hot flame. We don't have beef a lot, but we do include it in our diet—just in smaller portions than we used

to. While Sal is prepping the meat for the grill, I cook some brown rice and make a green salad that's full of fresh veggies from the local market. I'll add some fresh herbs to the rice and dress it with the same olive oil and vinegar dressing that I'm using for the salad. This is an easy way to give your basic grain dish some tang and flavor!

I stopped by a local bakery on my way home from work Friday and picked up a small dark chocolate cake for dessert. It's like I told you right from the start: I still eat dessert! I just don't eat a whole dessert platter anymore. This rich, dense cake is a treat we'll share with our guests—and I'll send them home with the leftover cake, so I don't have it around to tempt me.

Saturday's dinner: grilled rib-eye steak with herbed brown rice and green salad . . . and chocolate cake!

3 ounces rib-eye

½ cup herbed brown rice

2 cups green salad

2 teaspoons olive oil and vinegar dressing, plus what's in the rice

1 small slice chocolate cake

WEEKDAY TIP FOR SATURDAY: MAKE YOUR INDULGENCES COUNT

I had a few opportunities to indulge in sweets this week— including those cookies at the office and that tasty popsicle from the frozen food truck outside the park. Both times, I said no to the most indulgent treat and found a healthier

alternative. Saturday night, I let myself have a really delicious, really well-made piece of cake. It tasted great and I shared it with friends I love. This is a far cry from the lonely bingeing I used to do. It's important to learn how to say no to rich, sweet, and fatty foods. It's also important to learn how to say yes, occasionally. Pick your time and place—and your food, too!

. .

Exercise

Since we're having people over for dinner, I spend a half hour or so cleaning around the house in the afternoon. I put some music on and dance while I'm cleaning. I stop every couple of minutes to do some basic strength-training exercises: squats and lunges, bicep curls and shoulder presses. Once you learn some basic strength-training moves, you can add them to almost any activity or workout.

On your own/at home: find an everyday activity you can combine with strength training—yard work or gardening, housecleaning, grocery shopping (lift those bags!).

Sunday

On Sundays, we sleep in. Or at least we try to! With a little boy in the house who jumps out of bed and hits the ground running, it's not always easy. Actually, Jeffrey's pretty good—if he wakes up before seven thirty, he turns on the TV and watches some early-morning cartoons. But after seven thirty, forget it! We're up.

We like to leave our Sundays open, time for hanging as a family and taking it easy. Our day is mostly built around church. We like to go out for a late breakfast/early lunch after

church, and this midday meal makes the way I eat on Sundays a little bit different from other days.

Even though we're going to be having brunch, I don't want to wait until then to eat something. That would be bad for my blood sugar and dangerous for my appetite and eating choices. Remember, it's important not to let yourself get too hungry! I think I'll probably want to eat eggs at brunch, so I head in another direction for my small, early-morning snack. Yogurt with a little whole grain cereal and a few strawberries mixed in is the perfect get-me-going mini-breakfast to tide me over until our after-church brunch.

Sunday's mini-breakfast: yogurt with cereal and fruit

- **1 cup no-fat plain yogurt**
- **¼ cup whole grain, low-sugar cereal**
- **½ cup fresh or frozen berries**

Sal, Jeffrey, and I walk from church over to our favorite brunch place. It helps when you're eating out to have a few places that are familiar to you—you know the menu and what offerings will work within your plan and what modifications they are willing to make if you ask. Our regular brunch spot is famous for its omelets—they're big and stuffed with good-ies. A little too big, and a little too stuffed for me. That much food will tire me out for the rest of the day and will send my blood sugar up, up, up. So what do I do? I order an omelet, of course!

Now wait. I make a few requests that lighten up my omelet considerably. I ask for an egg-white omelet instead of a whole-egg omelet. I have them hold the home fries—that one's tough,

but it's worth it! I choose an omelet that is full of cooked vegetables and ask them to use half the amount of cheese they normally would. I add an order of vegetarian sausage. If you've never tried it, you should! It's full of good-for-you lean protein, and it tastes pretty darn good! And this comes from a woman who thought pork sausage was a basic food group.

Sunday's brunch: mushroom-and-spinach omelet, with vegetarian sausage and fruit salad

1 egg-white omelet with mushrooms, spinach, and cheese

3 links vegetarian sausage

⅓ cup fresh fruit salad

We make our way home after brunch and settle in for some relaxing. We love our lazy Sunday afternoons! I'll do some prep for the week later in the day, including some simple cooking that will give me a head start on next week. But first, I chill out. Read a magazine; play a game with Jeffrey. Noodle around on the computer and definitely check in with my Twitter folks. If I'm feeling motivated, I might do a little yoga or pop in a Pilates workout DVD for some at-home exercise. But I don't push it. Giving yourself downtime is important to your long-term success—you can't just go, go, go all the time without a break. You'll increase your chances of sticking with your routine if you build in time to relax.

Brunch was a pretty big meal, and we eat dinner on the early side on Sundays, so I have a light snack in the middle of the afternoon, just to tide me over and keep me from getting too hungry.

Sunday's afternoon snack

¼ cup hummus

1 carrot, cut into pieces

Sunday dinner is a pretty simple, quiet affair in our house. I don't want to spend my afternoon in the kitchen; I'd rather be loafing around with Sal and Jeffrey on the couch, and maybe heading over to the park in the afternoon if it's nice outside. This Sunday I make my time count twice: I roast a chicken for us for dinner and roast a second one to have on hand for the week ahead. I roast some vegetables alongside the chickens, so we'll have that with with some leftover herbed rice from last night's dinner. It's a simple, satisfying meal to finish off a fun, relaxing weekend.

Sunday's dinner: roast chicken with broccoli, cauliflower, and herbed rice

3 ounces chicken, skin removed

½ cup herbed rice

1 cup roasted broccoli and cauliflower

Green salad

Exercise

If Saturdays are a high-activity day for my family, Sundays are just the opposite. On Sundays we keep things pretty low-key and open. The one thing we know we'll be doing, wherever we are? Going to church as a family. But other than that, we like to see what the day brings. Having exercised all week, I can keep this day open to whatever comes, without feeling

guilty. I might do a little yoga or stretching, or pop in a Pilates DVD.

We eat dinner a little earlier on Sundays than the rest of the week, and that leads to another Sunday tradition: an after-dinner walk. Unless the weather's really bad, Sal, Jeffrey, and I will take a walk after dinner on most Sundays. (If the weather is bad, we'll huddle up and play a board game!) It's a lovely way to end one week and look forward to the next: with the two people I love most in the world.

Sunday's exercise

A walk around the neighborhood with my family

At home/on your own: spend fifteen minutes doing some gentle, easy activity. Stretch, practice a little yoga, putter in your garden, walk your dog around the block. Whatever you do, be grateful for all that's good in your life—including the way you're working to get healthy!

WEEKDAY TIP FOR SUNDAY: BE THANKFUL FOR THE GIFTS IN YOUR LIFE

Practicing gratitude feels good, and it helps to keep you healthy.

ten

Making It Your Own

I've talked a lot about what changed for me after my diabetes diagnosis and how my new understanding of the risks to my health led me to this plan. The single biggest reason I've been able to stick with this plan for three years and counting? I made sure, every step of the way, that I was creating a plan that suited my life. I mean my actual life, not my fantasy life.

In my fantasy life, I wake up at eleven and someone draws me a bath. In my actual life, I'm hauling myself out of bed in the dark and fumbling for the hot-water nozzle on the shower. In my fantasy life, I have all the time in the world for exercise, in between spa appointments and long lunches. In my actual life, the babysitter cancels when I'm trying to squeeze in a workout before heading to work.

In my fantasy life, cheeseburgers are a powerful weight-loss tool, and British rising star Idris Elba comes over to my house to read me romance novels aloud. Shirtless. I'm still married to Sal in that one, and in that fantasy he's fine with my book dates with Idris.

Phew. Excuse me a moment while I get past that lovely

daydream. Okay, back to reality. And that's the point, isn't it? Fantasyland is fun to visit, but we've got to live in reality. And for any eating and exercise plan to work, it had to fit my day-to-day reality, which can get pretty crazy. I didn't expect too much of myself. I didn't just keep my goals and my expectations reasonable. I went further than that. I built room for mistakes right into my program. I didn't expect myself not to cheat: I taught myself to cheat well. I found ways to make my new habits fun. I played around with my new foods until I found new favorites to replace the old ones. Then I kept on experimenting, so my eating options always felt fresh and open-ended. I tried all different kinds of exercise and made sure that playing with my family and my friends was part of my workout routine.

Just like it was for me, if a diet and exercise plan is going to work for you, over the long term, to help you control your diabetes—or avoid getting the disease altogether—then you've got to fashion a plan that fits the reality of your life and suits your strengths and weaknesses. It also has to work with your crazy schedule, whatever it looks like.

If I can do it—and stick to it—so can you. None of the health and energy and joy I've discovered on my diabetes journey is beyond your reach. I've shown you my plan. The last thing I'm going to do before we close this book is help you make it yours.

What's Your Challenge?

We all have different challenges when it comes to eating and exercising. The foods that tempt you are different than those that tempt me. My blood glucose responds differently to cer-

tain foods than yours does. I'd much rather work out first thing in the morning than have to force myself to go to the gym after a long day. You might feel primed for exercise late in the day.

That said, there are some challenges that a lot of us have in common.

If your challenge is . . . *portion control*

Focus on eating often.

That's right—the trick to learning how to control your portions is to eat frequently. The catch is this: you've got to keep the amounts in check. Eating often doesn't mean eating more: it just means eating frequently.

Measure your food.

It's no good eyeballing a portion size if your eyeballs tell you that a serving of potatoes is whatever you can lift on a plate. I know from experience: we're capable of kidding ourselves *big time* when it comes to portion sizes. Restaurants don't help, what with their huge plates and king-size helpings. If you find that keeping portions in check is a problem for you, then measure your food. You'll do two things: you'll keep your portions in check, and you'll teach yourself to recognize what sensible portions REALLY look like.

Give yourself a wide variety of foods, including treats.

In my experience, denying yourself the foods you like only results in a big ol' binge down the road. Allowing ourselves to eat small amounts of some of our favorite foods on a regular basis means we're just not as likely to go overboard from deprivation.

I used to be terrified of being hungry. It took a little practice, but eating often, allowing myself to indulge a little, and keeping myself honest by measuring certain foods taught me I had nothing to fear.

If your challenge is . . . *eating breakfast every day*

I always used to skip breakfast. I'd wake up late and all I could think about was getting coffee into my body and not being late for work. Then, around midmorning, I'd feel awful. Cranky. Tired. A little shaky. Oh, and HUNGRY. This would lead to a ravenous search for the quickest meal I could find. This was never a healthy meal, of course.

Now, I eat breakfast faithfully. I eat breakfast because I need to in order to keep my blood sugar from dropping. I eat breakfast because now that I'm no longer overeating all day long and into the night, I wake up in the morning hungry and ready for a meal that will get my metabolism fired up and fuel me through the first part of my day.

Still not a breakfast person?

That's okay. If eating first thing in the morning just isn't your thing, try making some simple compromises and adjustments.

Break up breakfast.

If you tend to wake up not feeling hungry, don't force yourself to eat a full meal right away. You can break your breakfast up into a couple of mini-meals that you eat during the first part of the morning. Try having a piece of fruit and a glass of low-fat milk within an hour or so of waking. Then, midmorning,

have a slice of whole grain toast with peanut butter, or a bowl of yogurt with a handful of fruit and nuts mixed in.

Work out in the morning.

I do some of my workouts first thing in the morning. It's not always easy—I'm not an early riser by nature—but it's always worth it. On mornings when I'm working out, I eat a small amount before the workout—enough so my blood sugar won't drop too low. Then I eat again after my workout is complete. That's a meal I'm always ready for—working out makes me hungry.

If your challenge is . . . *late-night snacking*

Working in comedy, I became a night owl. This also meant I became a late-night eater. It wasn't unusual for me to eat like a hummingbird during the day and like a vulture at night. Nighttime eating is a problem for a lot of people, and it can throw a thoughtful daytime diet completely off course. Are you a Jekyll and Hyde eater—good during the day and very bad at night? Here are some of the things that I've found work to help break this habit.

Make sure you're eating enough during the day.

If you've eaten according to plan during the day, there's no reason to feel particularly hungry after the sun goes down. Yet a lot of us do. Acknowledging your late-night eating as a habit that has little to do with hunger or sustenance is an important step. But first, make sure you're eating enough during the day.

Give yourself a cut-off time.

Make a promise to not eat after eight p.m. This will give you time for dinner and a small, post-dinner snack.

Drink a glass of water or a cup of tea.

This may not sound like fun when you're craving a stack of double-stuffed cookies. But think how much better you'll feel the next morning when you haven't eaten all those cookies! Drinking water or tea can help curb the empty-stomach sensation that's a part of your late-night cravings.

Brush your teeth.

This one works really well for me. I don't know if it's because of the rules we had growing up as kids—no eating after brushing—or if it's just that food seems less appetizing when you think about eating it with a toothpaste mouth. Whatever the reason, brushing your teeth can send a signal to your brain—and your tummy—that the kitchen is closed for the night.

Find other ways to treat yourself.

The impulses to eat are a habit to break. Like with any habit, it's a whole lot easier to break an old one if you introduce some new ones. Find new ways to spend your evening time before bed that don't involve food. Get some light exercise. Take a walk in the moonlight with your honey. Indulge in a long, hot soak in the tub. Cuddle up with your sweetie and watch a movie—just do it without food as an accompaniment.

Go to bed earlier.

It's common sense, right? The later you stay awake, the more likely you are to give in to the temptation for a late-night

snack, or to become actually hungry again. Rather than staying up late watching TV, grab a book and get under the covers. Make a pass at your bedmate. This is a strategy that can do wonders not only for your waistline, but also for your love life.

If your challenge is . . . *picky eating*

Make the most of what you do like.

If the changes you're making to your diet have left you with only a small pool of good-for-you foods that you really like, you've got to get creative about how you cook them and how you combine them. If the only leafy green vegetable you can swallow is spinach, you're going to get awfully tired of spinach salads if that's all you ever make for yourself. Sauté that spinach with onions and garlic. Add that spinach to an egg-white omelet. Slow cook that spinach with tomatoes and spices and ladle that saucy goodness over a piece of chicken or fish. While you're working to expand the selection of foods you like, make sure you're using the healthy foods you do like in different ways.

Commit to trying at least one new food a week.

Most of the time we hear about picky eating, it's in reference to kids. And there's a reason for that. Children can be completely weird and random about what they will and will not eat. I remember a phase where Jeffrey would eat only broccoli and French fries, all the time. Then one day, he turned to me and said, "I hate French fries! Take them off my plate!" Kids, the mini-dictators in our lives.

But as grown-ups, we can be picky eaters, too—especially when we're swapping out all sorts of old standbys that we've

eaten for years and replacing them with new foods, many that we're trying for the first time. That inner tyrant—errr, I mean child—in all of us sometimes returns.

Negotiate a truce with your inner six-year-old. Agree to try one new food a week from your lists of diabetic- and weight-friendly, low-glycemic foods. Focus on your troublesome areas. If you're having trouble with finding a selection of vegetables you like, make a promise to eat one new veggie a week. If without pasta your life feels empty, then focus on trying different whole grains and legumes. You'll encounter some misses, but you'll also find some hits, and these can get worked right in to your regular repertoire of healthy eating.

Don't just try something once.

If you're a parent, you know how this goes. Your kid hates something for what feels like forever and then . . . it's over. With Jeffrey it was tomatoes. I couldn't get him to stand in the same room as a tomato. Tomato sauce on the table, much less on his plate? A full-on tantrum ensued. And then one night, he slurped down some tomato soup without a peep.

Even as adults, our tastes continue to change. If you try lentils and don't like them, give it a while and try again. You can and will develop a taste for many of the new foods that you don't instantly love. This happened to me with tofu. Over a period of months, I went from looking at it cross-eyed to trying it and not feeling it to thinking, *Huh, this isn't so bad.* Now I love it!

If your challenge is . . . *trouble sticking to an exercise routine*

If this is your challenge, you are not alone. I was right where you are, for many years. The most important thing to remember is that making exercise a regular—ideally, daily—part of your life is a process that takes time. If you're having trouble sticking with the routine you've set out for yourself, you may be trying to do too much, too soon. If your goals are reasonable and you're still having trouble, try making some of these adjustments, which have more to do with your mind-set than any routine.

Remember, exercise is not optional.

If you want to lose weight and keep it off while eating a healthy, reasonable diet, you must exercise. If you want to reverse your insulin resistance and manage your diabetes without medication, you must exercise. If you're prediabetic and you want to stop insulin resistance before it leads to full-blown diabetes, you'd better get moving with some exercise. You don't have to become an ultra-marathon runner. But you need to make physical activity a regular part of your life.

As long as you think of exercise as optional, you give yourself the option of not doing it. Making exercise not just a priority but an essential component of your daily life means that you don't wait for time to appear in your schedule. You make the time. And you stick to it.

Remember that exercise boosts your energy.

One of the hardest things to do is start a workout when you feel tired. Our inclination when we're feeling worn out is to sit down, stretch out, and relax, not to move more. The truth is, regular and moderate exercise will give you more energy, not less. If you're feeling tired, a walk or a jog, a playful run around the park with your kids, or a trip to the gym is the best thing you can do for not just your health but also your energy level.

Remember, you don't have to join a gym.

I go to the gym a few times a week. The gym used to terrify and baffle me. I was self-conscious. I felt like to belong at the gym—I mean to really belong—you had to already be in shape. That couldn't be further from the truth. If you're feeling weird about working out around other people, I strongly encourage you to challenge that feeling, and give it a try anyway. Remember my favorite phrase, "Do it scared"? This is one thing that's *really* worth doing scared. At the same time, there's no part of your exercise goals that requires a gym. If you don't want to spend the money on a membership, or can't, then make your workouts happen at home and outside your house. Just make sure you make them happen.

Here's one last tip, one I use all the time:

Commit to simply starting your workout.

Go ahead and tell yourself that it's okay if you want to stop after ten steps. Sometimes just getting started is the toughest part of exercise. Once you get going, you'll reconnect with how good it feels to move. You'll remember that it's only a twenty-minute walk, and you'll remember how manageable that is for

you. Bottom line: once you're moving, it's a lot harder to find a reason to stop.

. .

INDULGING SMART: HOW TO EAT FAST FOOD

Eat a salad and a small treat.
Most every fast-food place has a salad or fresh-vegetable option. So take advantage of it. Fill up on this stuff and leave a little room on your tray for indulging.

Hold the special sauces and the mayo.
Keeping the extra goo off your pasta and meat will help control calories, fat, and hidden sugars. Stick with the veggie toppings—lettuces, onion, tomato.

Don't supersize.
Do I need to say this? I probably do. I certainly needed to hear it when I was first making changes to my diet. Keep your fast-food indulgences small (in portion size) and rare (in frequency) and you can get away with the occasional pass through the drive-thru lane.

Skip the soda.
Part of indulging smart is learning how to compromise. Say yes to a small treat from your favorite fast-food place, but drink water instead of soda. You'll spare yourself all that sugar and all those empty calories.

. .

INDULGING SMART: HOW TO DRINK ALCOHOL

I was never much of a drinker, even before my diagnosis. So this was one habit I didn't have to break. But I know people who love their glass of wine at night. If that sounds like you . . .

Talk to your doctor.
A safe decision about whether you should drink can only be made with your doctor. Alcohol can cause low blood sugar; it also can interfere with diabetes medications. The easiest thing is to skip booze altogether. If you're thinking about drinking, have an honest conversation with your doctor and listen to his or her advice.

Make it occasional, not every day.
Even if you get the okay from your doc to have a drink, it's important to keep it an occasional indulgence, not an everyday ritual. In addition to its effects on your blood sugar, drinking regularly will make it a lot harder to lose weight. If you decide to drink, stick to special occasions.

Stick to one, and sip.
Order a drink you really like and make it last. If you're out for a long night of socializing, after you've had your one, switch to club soda and lemon, or seltzer with lime. You'll still have something to drink and hold in your hand. The only thing you'll be without is a headache the next day.

Eat while you drink.
Drinking on an empty stomach is never a good idea, especially for a diabetic. Having a drink with food will slow the absorption of alcohol into your bloodstream and lessen its impact on your blood sugar. If you're planning to

have a drink someplace and you're not sure if there will be food, then eat before you go out.

Hold the sugar.
Stay away from those fruity, slushy drinks that are full of extra sugar. I'm talking margaritas, daiquiris, and the like. Here's a quick rule of thumb: if it comes with an umbrella, it's probably not your best choice. Also, use alternatives to mixers like fruit juice and soda. Try club soda or seltzer instead of cola or juice.

. .

My Secret Weapons

When it came to changing my diet, I was afraid food would never taste as good as it had when I ate whatever I wanted. I was wrong—really wrong—about that. Looking back, I realize I didn't really taste much at all back in those days. I could pack away enormous amounts of food, but I didn't stop to taste much of it.

My eating habits before my diabetes diagnosis were about a lot of things—including a stubborn, dangerous compulsion to eat whether I was hungry or not. But one thing they weren't much about? How food tasted. Oh, sure, I loved the salty blast that hit my tongue when I ate fried foods, or the sugary shot that came from eating sweets. But beyond that? I didn't think much about flavor or texture. And even if I had, I was wolfing too quickly to find out much about how my food tasted.

Now I think about flavor all the time, when I'm making food for myself and when I'm ordering out at a restaurant. Not relying on fat, salt, and sugar has opened my mind—and exposed my taste buds—to a whole range of flavors that make my healthy eating interesting and satisfying. I have an ever-

growing tool kit of strategies to maximize the flavor of my food, without adding sugar or fat or lots of extra salt. I think of them as my secret weapons in the kitchen!

Sesame oil

This nut oil is potent stuff! Not only does it have a deep, rich taste of sesame, but it also has been shown to help lower blood pressure. I use sesame oil regularly. It's a cooking base for vegetables and lean meats. It's a great addition to salad dressing. Do you love the flavor of that sauce-drenched sesame chicken from your local Chinese takeout? Try using a little bit of toasted sesame oil on a veggie stir-fry.

Fresh herbs

I keep a jar full of fresh herbs in my refrigerator, so I always have some on hand. Fresh herbs are full of flavor. I use them in cooked foods and fresh foods, in desserts, and even in my tea! They're easy to experiment with—just grab a few leaves and toss them in whatever you're making. I love to use rosemary and oregano when I'm cooking beans. I add thyme to my tomato soup. I toss parsley and dill into a fresh salad—or salad dressing. I even brew my tea with a sprig of mint!

Citrus

Who knew you could use every part of an orange? I didn't. But I do now. My fruit drawer is overflowing with citrus. I keep lemons and limes, oranges and grapefruit. I peel an orange and eat it, of course. But I also cut lemon slices and drop them in my water and my tea. I squeeze the juice of a lime and add it to chopped-up tomatoes and onions for a quick salsa. I grate

citrus zest—that's the colored part of the skin—into fresh salads or salad dressing. These bright citrus flavors are a great, healthy way to perk up your taste buds.

Mushrooms

As a kid I was never a mushroom eater. I thought they looked weird, and I was sure they tasted terrible. This I just *knew*, without ever actually tasting one. It took me until middle age, but I've finally come around to mushrooms, in a big way. Mushrooms add a deep, almost meaty flavor to dishes. If you're a meat lover who's trying to cut down, mushrooms are your friend. I scramble them with eggs, or I sauté them with lots of fresh herbs and toss them with quinoa. I stuff them with roasted veggies in a whole wheat pita for a delicious, portable lunch.

Low-fat or no-fat Greek yogurt

There's a Greek yogurt cult forming, and I'm a proud, head-bobbing member. If you've never tried it, you're in for a treat. It's richer than regular yogurt, and thicker and creamier, too. I eat this yummy yogurt with fruit for breakfast and for dessert. But it's not just good with sweet stuff. I also mix Greek yogurt with fresh herbs and garlic for a delicious, healthy dip. I use that same stuff on my dinner plate as a topping for fish or chicken.

Hey, Lighten Up!

Just because you're giving up the mongo-sized servings of takeout and frequent trips to the pizza place doesn't mean you have to let go of your favorite dishes. With a little creativity

in the kitchen and some portion control on your plate, you can still have lighter, healthier versions of some of your favorite meals. Here are a few of mine, along with suggestions for lightening things up.

Meatloaf

Oh, meatloaf. The baked brick of meaty goodness that takes me back to childhood. All that red meat and fat has got to go, but meatloaf itself can stick around in a new form. Swap out ground beef for ground turkey and you've got a much lighter, waistline-friendly version. Instead of serving this with mashed potatoes, try cooking up some flavorful dark greens, like collards or spinach, to go alongside. Another low-glycemic side dish that's a tasty alternative to potatoes? Steamed, mashed cauliflower. Trust me, this is a rich, hearty, and flavorful dish that will make you forget all about those starchy spuds.

Chinese takeout

I used to grab takeout from my favorite Chinese place at least a couple of times a week. I've stopped that habit—but luckily for my taste buds, I've replaced it with a new one. I cook up a bunch of broccoli with lots of garlic and toss it with a little leftover chicken or pork. Low-sodium soy sauce, a couple drops of sesame oil, and the whole thing goes over brown rice. Heavenly. And good for me.

Pizza

Instead of ordering a pie the size of Rhode Island, try making your own healthy versions at home. Toast whole grain pita or

flatbread to make a crisp crust, then spread some fresh to-matoes, or tomato sauce and lots of veggies. Top with low-fat cheese and pop that baby in the oven. Add a little fresh—or dried—oregano for that pizza-parlor flavor!

Mac and cheese

This is a tough one, right? Not if you're willing to swap out pasta for a whole grain like brown rice or barley for a cheesy, hearty casserole that's just as comforting as your old mac 'n' cheese standby. Instead of mixing pasta with a mountain of cheese, try using rice with a whole bunch of vegetables—I love to use spinach, onions, and mushrooms—and some low-fat mozzarella. Bake the whole delicious mess in the oven just like you would your old version, until it's bubbling, and pre-pare to enjoy!

Burgers

Swap out the all-beef patty for a turkey burger. Try a salmon burger or a veggie burger. Use half a whole grain bun, and pile the veggies high on top.

Eat Well, Cheat Well

Just like I had to learn how to eat well, I also had to learn how to cheat well. I knew when I set my mind to creating a new life for myself that my plan had to include room to be a little bad. This is what works for me.

Plan for your indulgences.

Plan to cheat? You bet. You know it's gonna happen—we all stray from the straight-and-narrow plan now and then—so

why not make it part of the plan itself? Take a look at your week: is there a birthday celebration coming up, hosted by someone who's bound to be whipping up a great cake? Maybe that's a time you'd like to splurge on a little slice of something sweet. Are you planning a dinner out with friends at everyone's favorite steakhouse, where the menu is beef, beef, and more beef? Oh, and potatoes. When you're mapping out your meals, give yourself a little license with this one, to indulge in some expertly cooked steak and a pile of potato-y goodness. Just keep those portions under control!

By choosing when you're going to cheat your plan, you give yourself the chance to adjust your other food choices to help minimize the impact of indulging. What's more, when you know you've got an indulgence coming up, it can be easier to say no to other temptations that arise along the way.

Of course, sometimes this kind of orderly cheating just isn't possible. Temptation sneaks up and surprises you, and before you know it, you've got cookie crumbs on your shirt and you're wondering what happened. I know. I've been there. Do your best—it will make a difference—and use these other cheat-well strategies to help you keep your more spontaneous cheating under control.

Set your portion before you start eating.

So, you're about to dive into a tempting snack, a full-on treat that's nowhere near the good-for-you list. Before you rip open that bag of chips or dive with both hands into that plate of cookies, stop. I'm not telling you not to eat your treat. I am telling you that you can spare yourself a lot of guilt and calories and blood sugar problems if you limit your portion size. Give

yourself permission to eat that pie that looks so delicious— just not permission to eat as much as you can or want. Just because you are cheating doesn't mean you have to throw out all the rules. Measure your portions, even when you're being bad. Don't wait until the fiftieth potato chip to decide how many of those crunchy little devils you're going to eat. Dump a nice little serving into a bowl, then fold that bag up and put it away. Preferably someplace tough to reach!

Don't keep your worst temptations on hand—or on your cheat list.

If that potato chip bag just won't stay in the cupboard, no matter how high and hard to reach you stash it, it's probably not a food you should have around at all. We all have foods that just do us in, that we can't seem to say *no* to, or say *enough* to once we've started eating them. For me, one of these foods is definitely Doritos. Once I start eating them, I can't stop.

This isn't cheating smart. This is bingeing, and it's bad for your blood sugar, bad for your waistline, and bad for your morale. If you're working your steps and examining your relationship to food in new ways, you've probably come upon a food or two that falls into this category. How will you know if a food shouldn't be on your cheat list? If you can't ever seem to say no to this food, that's a sign. If you try to manage your portions and you just keep going back for more, that's another. I tried having Doritos in the house for just occasional treats. Occasional treats soon turned into looking for that Doritos bag every day. And once that bag was open, I just couldn't ever seem to close it, not until I was licking Doritos dust off my fingers and tipping that bag upside down to see if maybe

one or two little chips had escaped me. Basically, Doritos need to take a restraining order out against me. So, yeah, there are no more Doritos in the house.

Do keep snacks you like on hand.

You're trying lots of new foods these days. Some new favorite foods are popping up to replace the old foods you've mostly removed from your diet. So stock up on the stuff you like, so you'll have it on hand when you get a hankering for something snacky.

I always have hummus on hand, for dipping with veggies or a few rye crackers. That's an easy, good-for-me snack that has prevented me many times from hitting up the vending machine or making a snack run to the corner store. Popcorn is another one. I pop it on the stove at home and add a little salt and some spices—I've tried everything from cinnamon to hot sauce. If I'm at work and find myself on the prowl for a treat, I'll have a single-serving bag of some reduced-fat popcorn. I don't eat popcorn every day. I keep it in the occasional treat category, perfect for a midday or midweek indulgence that doesn't throw me off course.

There's a lot of middle ground between the very best-for-you foods and the worst of the worst. Somewhere in that broad range of foods are some snacks you can work into your eating routine, foods that will satisfy your cravings for something a little sweet or a little crunchy—but won't throw your diet off the rails.

Make your cheats count.

I say if you're gonna cheat, do it up right. I'm not talking about quantity. I'm talking about quality. Think back to my seven days of eating: remember that chocolate cake? That was a really high-quality, flavorful cheat treat. It was a dense, rich, super-chocolaty torte, made by someone who knew what they were doing in a pastry kitchen. A small sliver of that cake went a long way, satisfying my desire for sweetness and making me feel I'd really treated myself. I got way more satisfaction from the taste and the experience of eating that beautiful piece of cake in the company of friends than I would have if I'd used up my cheat pass to gobble down a king-size candy bar from a vending machine. When you're going to cheat, look for ways to make the most of the experience: Go for maximum flavor. Take your time and savor every bite.

Don't beat yourself up when these tips don't work.

I've put a lot of time and effort into changing my approach to eating and exercise. All these tips and strategies and suggestions I'm giving you? I use them all myself, all the time. I've gotten pretty good at them, I'm proud to say. I don't binge like the old days anymore. I know I can't, my health is too precious and precarious to afford an old-school pig-out. And still, sometimes my new ways just don't work, and I find myself eating too much of the wrong kind of food. Sometimes all the planning and strategizing and giving yourself healthy options just aren't enough to keep you from overdoing it. That's when forgiving yourself really counts the most.

INDULGING SMART: GOOD-FOR-YOU FRUIT DESSERTS

Yogurt with fresh berries

Plain, low-fat Greek yogurt tastes incredibly rich and creamy. It's also full of protein and low in sugar. Stir in your favorite berries. If you're in the mood for a little crunch, sprinkle in a little whole grain cereal.

Frozen fruit shake

I keep bananas in the freezer just for this purpose. Zap a half of a banana in the blender with a splash of low-fat milk or soy milk, for a tasty frozen treat.

Whole-fruit popsicles

You can find brands with no added sugar at your supermarket. They're tart and sweet and taste like summer. Grab one instead of ice cream for a hot-weather treat.

Fruit and cheese

Ooh la la! This not-too-sweet dessert is the perfect combination of high-fiber carb and protein. An apple or pear with a few pieces of cheddar or goat cheese is a filling—and very French—way to end a meal.

This eating and exercise plan is meant to last you a lifetime. It is about making you feel well inside and out, keeping your prediabetes or diabetes at bay, and giving you a new sense of wonder for all that you can be. Enjoy!

AFTERWORD

I am my mother's daughter. I have her laugh and her eyebrows, her stubbornness and her gene for strict parenting. And yes, I also have her disease.

It's difficult for me to think about the ways my mother struggled with diabetes. I'd much rather remember her smiling, bright-eyed, and strong than reeling from headache and fatigue, or trembling from uncontrolled blood sugar, or hooked up to machines in a hospital bed. I think about how tired and in pain she was as her disease progressed, and I imagine how different things might have been for my mom if she'd been able to learn all that I have about diabetes and its dangerous course, before it was too late. I think about how frightened she was, and I wonder what might have been if she'd lived in a culture and an age where diabetes was spoken of openly and honestly, not whispered about and avoided.

My mother didn't struggle with managing her diabetes because she was weak-willed or lazy. Far from it. My mom was fierce. She raised three rambunctious, rebellious, strong-willed daughters and kept them on the (mostly) straight and narrow while working her tail off nearly every day of her adult

life. My mom could wrap you in love and scare the freckles off you in the same breath. She couldn't manage her diabetes not because she wasn't strong enough but because she didn't really understand her disease. She couldn't manage her diabetes because she was never able to get past the fear she felt about the ways her body was betraying her.

I wish so much I could whisk back in time and take her by the hand to gently teach her all that I've learned. Instead, I honor my mother by doing all that I can to protect my own health, by making smart choice after smart choice, day after day. I also honor my mom by being kind to myself when my choices aren't so smart.

I honor my mother by teaching her grandchild all that he needs to know to live a long, healthy, and balanced life and to avoid the dreadful disease that took hers. She'll never know him, but Jeffrey knows her—through pictures and stories, and also through our family's daily journey to deep, sustainable health.

I honor Mom by sharing my story and my crooked, hope-filled path to health with you so that you'll take up the cause, for yourself and for the people who love you. Be the first in your family to break the cycle of bad habits—poor diet and inactivity, denial and fear—that put so many of us on the road to diabetes. Be the first to break that cycle and be sure to invite the others to come along with you on the journey.

I know my mom would be so proud of me and how far I've come in learning how to take care of myself. I think about how she'd feel if she could see my life now, and I can feel the warmth of her love. But as hard as it is to remember my mother's long and painful struggle with diabetes, it's too important

to ignore. I don't ever want to forget her struggle. It is my most potent warning of what my own future could be if I ever stopped taking care of myself the way I do today. That's my mom—still wrapping me in love and scaring the freckles off me at the same time. All these years later, and she's still looking out for me like only she could.

Thanks, Mom. This one's for you.

INDEX

A1C test, 39, 50, 51, 57
African Americans, 5, 48, 52
age, 44–45, 202–3
alcohol, 109, 284–85
American Diabetes Association, 39
amputations, 4, 5, 9
anger, 7
apple body shape, 37, 41–42, 46

baked goods/pastries, 96–97, 109, 110, 231
beans/legumes, 93, 97, 113–14, 121, 130, 228, 230, 234, 241
beverages, 27, 70, 101, 109–10, 283, 284–85
binges, 8, 12–13, 14–15, 18
bladder infections, 54
blindness, 4, 64–65
blood clots, 37, 43
blood pressure, 9, 45, 47, 53, 59, 62
blood sugar, 9, 18, 34–35
 food in managing, 104, 112, 125–27
 testing, 20–21, 23–24, 26, 38–39, 46, 50, 51, 55–58
blurry vision, 5, 18–19, 53, 54, 58, 62
body fat, 37, 41–42, 46, 137, 259
body shape, 37, 41–42, 46, 259
breads, 96, 109, 229–30

breakfast
 as challenge, 276–77
 planning for, 124–25, 276–77
 sample 7 days, 240–41, 244–45, 249, 253–54, 258, 264–65, 269

caloric values, 91, 95
cancer, 37, 43
candy and sweet treats, 101, 109
carbohydrates. See also glycemic index (GI); glycemic load (GL)
 complex, 35, 112–15
 food-feelings connection, 164–68
 simple, 35, 71, 101, 108–10, 125–26, 166–72
cardiovascular disease, 37, 43, 65
celebrations, 175, 180–81, 247, 290
cereals, 96, 229–30
cholesterol, 37, 45–47, 53, 59, 108, 112
circulation problems, 65, 137
coma, 9, 62, 104
comedy, 6–7, 9, 11–13, 22, 208
commitment to change, 77–78
complex carbohydrates, 35, 112–15
complications of diabetes, 4–5, 9–11, 62–66, 104
cookbooks, 205
cooking times, 93

crackers, 96, 130
cravings, 71, 104–5, 119, 164–68,
 169–72, 180–81, 236–37, 247

dairy, 99, 106–7, 115, 229, 234
dance, 2, 5–6, 26, 133–34, 136, 141,
 143, 155–56, 157, 158–62, 249
Dancing with the Stars, 2, 26,
 133–34, 136, 158–62, 193, 197,
 199–200
death from diabetes, 9–10, 11, 26,
 62–64, 295–97
Deen, Paula, 205
desserts
 healthy, 293
 indulging in quality, 267
 portion size, 231
Diabetes Risk Test, 39
diagnosis
 of diabetes, 1–4, 21–22, 24–25,
 27–28, 31–32, 38–39, 51,
 53–54, 87–88
 of insulin resistance/metabolic
 syndrome, 46
 of prediabetes, 3, 18–19, 30,
 38–39, 49, 50–51
diets and dieting, 13, 16, 67–68,
 120, 220. *See also* Plan D
 eating plan
dinner, sample 7 days, 244,
 247–48, 252–53, 257, 263,
 266–67, 271
doctors, 20–21, 38–39, 46, 50, 51,
 57, 59, 195, 284

eggs, 234, 242, 244–45, 254, 270
ethnicity, 47–48, 51–52
evening routine, 124–25, 214–15,
 277–79
exercise. *See* Plan D exercise
 plan
eye exams, 59

Facebook, 199, 200
family history of diabetes, 4–5,
 8–9, 18–19, 29–30, 47–48, 53,
 85–86, 295–97
fast food, 8, 27, 105–11, 265–66,
 283

fasting plasma glucose test (FPG),
 38, 50, 51
fatigue, 5, 24, 50, 53, 54, 62,
 165–66
fats and oils
 choosing, 94–95, 116–19, 121,
 286
 cooking, 107, 108, 117–18, 286
 glycemic values, 92
 to limit or avoid, 105–8, 116
 portion size, 229
fear, 25–28, 194–95
fiber, 33, 35, 71, 72, 90, 92–93, 112
focus, 78–81
food. *See* Plan D eating plan *and
 specific food groups*
food journal, 179–80
foot check, 59
forgiveness, 70, 207–23. *See also*
 God, relationship with
 gratitude, 221–23, 272
 of others, 207–8
 of self, 207–8, 212–21, 293–94
fruit, 72, 95, 98–99
 to avoid, 109
 to enjoy, 113, 129–30, 230, 244,
 286–87, 294
 pantry staples, 235
 portion size, 230
 in snacks, 242, 244, 246, 255,
 256, 260, 261, 265, 266

gestational diabetes, 32
glucose, 34–35, 37–38, 94. *See also*
 blood sugar; sugars
glucose meter, 23–24, 26, 55–58
glycated hemoglobin. *See* A1C
 test
glycation, 65
glycemic index (GI), 88–97, 99,
 101–3, 125–27
glycemic load (GL), 88–97, 99,
 101–3, 125–27
glycogen, 37
glycolated hemoglobin. *See* A1C
 test
glycosylation, 65
God, relationship with, 14–15,
 21–22, 171–72, 196–97, 208–11

gratitude, 221–23, 272
grief, 10
Griffin, Eddie, 25–26

HbA1C. *See* A1C test
HDL (good) cholesterol, 46, 47, 108
heart attack, 37, 43, 65
hemoglobin A1C. *See* A1C test
Hispanics, 48, 52
humor, 82–83
hunger, 31, 173–74, 177
hydration, 27, 47, 152, 262, 278
hypoglycemia, 62

imagery, 186–93
Indians, 48, 52
indulgences, 8, 9, 70, 103–11, 164–68, 267–68, 289–90
infections, 54
inflammation, 37, 43
insulin, 11, 30–31, 34, 36–37, 60–61, 104
insulin resistance, 30–31, 33–34, 36–37, 40–42, 44, 45–47, 136–37, 281

Jackson, Michael, 14
Jehovah's Witness church, 5–6, 13–14, 209
junk food, 8, 105, 107

kidney disease or deterioration, 54, 58, 59, 62, 65

LDL (bad) cholesterol, 45, 47, 108, 112
leftovers, 239–40
living with diabetes, 55–61. *See also entries beginning with* Plan D
lunch, sample 7 days, 242–43, 246–47, 252, 256, 266, 269–70

meal planning, 124–25, 231–38, 241, 276–77
medications, 60–61
metabolic syndrome. *See* insulin resistance

metabolism, 33–34, 137, 154–55
moodiness, 37, 57, 165–66
morning routine, 80, 124–25, 154–55, 276–77
motivation tools, 183–205
music, 144, 156, 201, 249, 268

Native Alaskans/Native Americans, 48, 52
nerve damage, 9, 24, 53, 54, 63–65
notes to self, 198
numbness, 53
nuts and seeds, 118, 129–30, 230, 235, 244

oral glucose tolerance test (OGTT), 38–39, 50, 51

Pacific Islanders, 48, 52
pain, 9, 63–64
pancreas, 36–37
pantry staples, 233, 234–35
pasta and noodles, 93, 97, 102, 289
pear body shape, 41–42, 259
picky eating, 279–80
pictures/photographs, 202
Plan D
 origins of, 24–25
 personal challenges, 274–85
 three keys, 69–76, 84. *See also* Plan D eating plan; Plan D exercise plan; Plan D relationship with food
Plan D eating plan, 69, 70–72, 85–132
 basics, 132
 combining foods, 125–27, 177–78
 costs, 204–5
 foods to avoid, 70, 86–87, 103–11, 164–68, 169–72, 236–37, 291–92
 foods to enjoy, 70–72, 87, 111–19
 getting started, 84, 87–88, 119
 glycemic index/glycemic load, 88–103
 imagery, 191–92
 leftovers, 239–40
 lightening up favorites, 287–89

Plan D eating plan (*cont.*)
 meal planning, 231–38, 241
 pantry staples, 233, 234–35
 portion sizes, 120–22, 124,
 227–31, 275–76, 290–91
 sample 7 days, 238–39, 240–72
 shopping tips, 233, 236–38
 timing meals and snacks,
 123–24
Plan D exercise plan, 69, 72–74,
 133–62
 aerobic exercise/cardio, 141–42,
 145, 146–49, 159
 basics, 162
 daily exercise as goal, 72–74,
 135–36, 153–54
 exercise as challenge, 281–83
 getting started, 84, 137–39,
 153–57
 hydration, 152
 imagery, 190–91
 interval training, 143–44,
 146–49, 159
 mini-breaks, 157, 259
 real-life workouts, 73–74,
 139–40, 141, 144–49, 150–52,
 155–57
 sample 7 days, 238–39, 242,
 248–49, 250–51, 254–55,
 261–62, 265, 268, 271–72
 strength training, 142–43, 145,
 146–49, 253
 stretching, 159–60
 technique in, 160–61
 timing of workouts, 154–55, 157
 workout buddies, 161–62
Plan D relationship with food, 69,
 74–76
 basics, 181–82
 food-feelings connection,
 164–68, 215–17
 getting started, 84, 169–74
 hunger and, 173–74
 questions/Sherri Steps, 75–76,
 167–74, 177–79, 215–17
 stress and, 170, 174, 175–76,
 192–93
portion sizes, 120–22, 124, 227–31,
 275–76, 290–91

practice, 81–82
prediabetes, 3, 18–19, 30–31,
 37–39, 44, 49–51
pregnancy, 16–17, 32
processed foods, 93, 95, 105,
 107–8, 236–37
proteins
 choosing, 72, 94–95, 100, 106,
 115–16, 229
 with each meal and snack, 115,
 119, 121
 lightening up favorites,
 288–89
 to limit or avoid, 106, 116
 in plate method of portion
 control, 121
 portion size, 228, 229
 saturated fats in, 106

Ray, Rachael, 205
record keeping
 food journal, 179–80
 glucose meter readings, 57–58
 responses to food, 58–59, 176,
 179–80
 sample 7 days journal, 240–72
reflection, 81–82
 on mistakes, 217–18
 notes to self, 198
 questions/Sherri Steps, 75–76,
 167–74, 177–79, 215–17
 responses to food, 58–59, 176,
 179–80
 sample 7 days journal, 240–72
relaxation, 193
resistance to change, 68, 133–34,
 135, 149–50, 185–86, 202–5
restaurant meals, 95, 122, 252,
 263, 265–66, 269–70, 275,
 288–89
risk factors for diabetes, 39,
 40–45, 51–52
 age, 44–45
 blood pressure, 45
 blood sugar, 43
 body shape, 37, 41–42, 46,
 259
 cholesterol, 37, 45, 53
 ethnicity, 47–48, 51–52

family history, 4–5, 8–9, 18–19, 29–30, 47–48, 53, 85–86, 295–97
insulin resistance, 45–47
lack of exercise, 43–44, 50, 259
poor diet, 3, 8–11, 23, 42–43, 62–63, 85–86, 87–88
weight, 37, 40–42, 49–50, 54

salad bars, 260–61
salad dressing, 117, 127, 131, 244
saturated fats, 105–8, 117
self-talk, 196–98, 218
serving sizes, 120–22, 124, 227–31, 275–76, 290–91
shame, 166–68, 219–20
Sherri Steps, 75–76, 167–74, 177–79, 215–17
shopping tips, 233, 236–38
simple carbohydrates, 35, 71, 101, 108–10, 125–26, 166–72
skin infections, 54
sleep, 9, 57, 63–64, 104, 278–79
snacks, 101, 292
 as challenge, 277–79
 examples, 129–30
 high-fat, 107
 late-night, 277–79
 planning, 128–30
 sample 7 days, 242–44, 246, 247, 251–52, 255, 256–57, 259–60, 261, 265, 266, 270–71
 timing, 123–24, 174
social media, 80, 198–201
Southeast Asians, 48, 52
stress, 19–20, 170, 174, 175–76, 192–93
stroke, 37, 43, 45, 65
sugars, 71, 108–10, 166–72. *See also* blood sugar; carbohydrates; simple carbohydrates
support system, 134, 160–61, 193–96, 199–200, 221–22
sweeteners, 101
symptoms of diabetes, 31, 52–55

tests and testing, 20–21, 23–24, 26, 38–39, 46, 50, 51, 55–59. *See also* diagnosis

thirst, 20, 24, 31, 53, 54, 104
time management, 79–80
tingling in fingers and toes, 24, 53, 54
trainers, 73, 138, 160–61, 199–200
trans fats, 108
trends in diabetes, 32, 40, 44
triglycerides, 46, 47
Twitter, 198–201
types of diabetes, 30, 31–32, 60–61

University of Michigan Medical School, 48
urination, 20, 31, 53, 54

vegetables, 71, 95, 97–98
 bottomless salad bowl, 131–32, 244
 with each meal, 126–27
 to enjoy, 114–15, 228, 230, 234–35, 287
 pantry staples, 234–35
 portion size, 121, 228, 230
 starchy, 102, 110–11, 230
The View, 1–2, 17, 19–20, 21, 22, 23, 56
visualization, 186–93

walking, 73–74, 138, 156, 157, 249, 254–55, 272
water, 27, 47, 152, 262, 278
weight problems
 food-feelings connection, 2, 3, 7, 8, 10, 12–13, 18–20, 23
 motivation to change and, 203–4
 as risk factor, 37, 40–42, 49–50, 54
 yo-yo cycle, 12–13, 220
whole grains, 72, 93, 97, 114, 121, 129, 229–30, 234, 240–41, 247, 264, 292

yogurt, 169–72, 234, 249, 258, 287, 294
yo-yo cycle, 12–13, 220